The Professional's Guide to Modeling

A Comprehensive Look at the Business of Being a Model

D1515325

Roger Talley

Published by The Newmodels Academy
8524 Highway 6 N, #202, Houston, Texas, 77095
ISBN: 978-0-6151-4677-5

Acknowledgements

No book like this is the work of a single individual. Countless people have contributed information, suggestions, critiques and suggested revisions. Their help is much appreciated. Responsibility for any errors, of course, is solely mine.

Thanks must be given by name to some. They are especially due to:

W. P. "Hoot" Gibson, as good a friend as a man could hope for, and without whose selfless assistance and wisdom this book would not have been possible.

Michelle Talley, of whom I am abundantly proud, who sets a personal and professional standard that should be an inspiration to us all.

Kristen Lemke, who made it all enjoyable, and reminded me why it is worthwhile.

Valerie Weiss, the makeup artist for all the pictures in this book, whose talent and good cheer made many a photo shoot successful and a pleasure.

Alicia Clark, a valued co-worker and the cover model for this book.

Anthony Schiano, who taught me so much about commercial acting.

Mike Lyons, who introduced me to fitness modeling, and so much more.

Frank Tamalenus, who got me into the business of being an agent, and provided help and guidance along the way.

Erin Lundgren, who spent so much time talking with me about the fashion industry, and who is a beacon of civility and integrity in the industry.

Veronika Maxtone, the model on the back cover, who has been a wonderful friend and inspiration over the years.

CONTENTS

MAINSTREAM MODELING

SPECIAL MODELING TOPICS

THE PERIPHERY OF MODELING

INTERNET MODELING

INTRODUCTION

When most people think of "models" they think of magazines like *Vogue* or *W* and the apparently glamorous world of fashion modeling. That's not surprising, since fashion models get the most press and look like "models". Theirs are also the names most of us know – Cindy Crawford, Tyra Banks, Giselle Bundchen, and more. That's why most books on modeling deal primarily with fashion modeling.

But a considerable majority of modeling work in the United States is done by commercial models, not fashion models. A very few books have been written from a model's perspective about the commercial end of the business, and none to address what an agent would want his models to know. Part of the purpose of this book is to fix that , and all the other modeling areas that typically get only cursory treatment by other books.

We will examine two very different ways to pursue a career in modeling: "mainstream" (traditional routes to fashion, advertising, promotional and fit modeling) and "Internet modeling". The Internet has created vast new opportunities for models and those who want to work with them to find each other, new ways for models and associated professionals to do business, and even a different modeling culture that has, at times, clashed with the "mainstream."

This book explains how to get a positive start in the business. But we also go into detail about what happens behind the scenes - the processes that make the industry work. You will gain an in-depth knowledge of the business that few aspiring models are ever exposed to. This understanding will help you find your place in the industry and survive once you get there. We also delve into special topics on positive and negative aspects of the industry. These may not be of interest to everyone, but they can prevent a new model from getting into problems.

This book will not explain techniques of make-up, nutrition, fitness, or the craft of modeling itself. To learn about make-up, you should find an experienced make-up artist familiar with styles in the area where you want to model. For nutrition, consult with your physician or a nutritionist, not with modeling books.

Fitness is a special case. Most models need toned bodies, and many will feel the need for an exercise or fitness regime. A common approach is to hire a personal trainer, or simply to join an exercise class in a local gym. That could prove to be a mistake. Trainers and classes often try to mold a person's body to something like what "average people" wished they looked like. That can include bulking up muscle mass in places a model really doesn't need to be bulking up. Fitness advice and training should be taken only from someone who understands *and accepts* the demands of this unusual business.

Finally, there is the craft of modeling itself. The skills a model may need vary widely depending on the kind of modeling. Some of this is taught in specialized classes and seminars; a lot more is best learned through experience with good photographers, or on the job. Many modeling "how to" books written by ex-models seem limited to what the author actually specialized in. The reader has to bear in mind that such books are only useful when they are dealing directly with that particular type and style of modeling – of you can learn how to model from books at all. Personal instruction and experience are much better teachers.

At the end of this book there is a list for suggested additional reading. Those so motivated can find books on the list that deal with all of these other topics.

The "brick-and-mortar" of the modeling industry is Mainstream modeling. We will discuss it first.

MAINSTREAM MODELING

Modeling Specialties

Rule 208: Sometimes the only thing more dangerous than a question is an answer
-- Ferengi Rules of Acquisition

So what kinds of models are there? A lot more than most people know about. If you try to become a kind you aren't suited for, you'll likely spend a lot of time running into walls.

Fashion vs. Commercial vs. Editorial

Pick up the latest issue of Vogue and you will see primarily three types of modeling. If Diana Dondoe is lensing for a Prada ad, then it's a fashion "campaign" (fashion advertising). If Canadian bombshell Daria Werbowy has turned a story on fashion into a pictorial page-turner, then it's (fashion) editorial. Now, set aside Vogue and pick up a copy of Newsweek. The Citibank ad with all the smiling, happy customers in it is "commercial". The distinction between the three really is complex.

The Formal Definitions:

"Fashion" means things related to clothing, accessories and beauty products. "Commercial" means "things done to promote a company or product." "Editorial" means things done to support an article or story in a magazine or book. "Editorial" can be about more than "fashion," although in modeling usually "editorial" is short for "editorial fashion".

In Practice:

"Commercial" can also be about fashion (they sell the clothes by advertising). "Editorial Fashion Agencies" usually consider showroom and catalog work as "commercial;" "Commercial Print Agencies" consider such work "fashion," even though its intent is commercial. All this interlocking of terms is enough to make your head hurt, and the words are used differently depending on who is doing the using.

For people whose experience is in advertising but not fashion, "commercial" models are the people you see in ads for banks, autos, pharmaceuticals and all of the many other products and services that people are used to advertise. We will treat "commercial" in the latter sense, because agencies are aligned that way. An "editorial fashion" agency is very likely to have some "commercial" girls under contract, but they will be very different from what a commercial print agency thinks of as a "commercial model".

Fashion models also work as commercial models, although the reverse is rarely true. Commercial models are used as "extras" in fashion advertising and editorials however.

There are many types of commercial models, and some kinds of modeling that are neither "fashion" nor "commercial."

Fashion Modeling

Editorial Fashion Models

"Editorial fashion models" are the stuff dreams are made of. These are the "high end" models who appear in the big-name fashion magazines and in top-quality clothing and beauty product advertising. Daria Werbowy and Diana Dondoe were among the top names in 2005; Gisele Bundchen has been the closest thing to a new "supermodel" since the beginning of this century. Runway models may double as editorial models, but often they are in a separate division within a fashion agency. But there are other types of fashion model as well, some that most people have never heard of.

"Editorial fashion models" work in New York City (in this country) for the simple reason that relatively little editorial fashion work is booked out of anywhere else. There are exceptions, of course: Miami in winter (but often using New York models), and sometimes Los Angeles or Chicago, but these are just that: exceptions. If you want to be an editorial fashion model, you go to New York. There are lots of opportunities abroad as well (Paris, London, Milan, Tokyo . . .), but only one strong editorial fashion market city in the US.

If you are a female and want to be seen on the cover of a national fashion magazine, sign a lucrative national ad contract, become a "supermodel", or even be a "fashion model", you need the following when you start:

1. Be between 14-19 years old. (Yes, they start that young.)

2. Be between 5'9" and 6' tall with long legs.

3. Be thin. Really, really thin. Something like 105-115 pounds.

4. Don't have especially large breasts (34C is generally the upper bound of acceptable, and 34B is preferred), or lots of stretch marks, tattoos, piercing or highly tanned skin. Dark skin is fine, lots of tan is not fine (except in Miami, which is a whole different world).

5. Be beautiful. Not necessarily pretty, but beautiful. An interesting, beautiful face is at least as good for a fashion model as is an "all American" look.

6. Have the right personality: a strong commitment to modeling (not just an interest in it), an ability to take rejection (something most beautiful girls aren't good at), a thick skin, not a lot of modesty (nobody cares what you don't want someone to see, we have a fashion show to put on . . .) and a lot of self confidence.

7. Be willing to relocate to a major market, with New York City strongly preferred.

8. Be willing to travel to strange locations with no friends there to support you, little money and little help, lots of opportunity for both good and bad things to happen to you.

If you are a male and want to be a fashion model, you need to start relatively young (18-25 or so), be six feet tall and wear a size 40 regular suit with a slim (32 inch) waist and a 34 inch inseam (all give or take an inch). You also need the personality and availability traits of the female fashion models.

If you have all of that, you are a very, very rare person, and you have one chance in a hundred of becoming an editorial fashion model. No more than that. If you are anything else, you need to think about some other kind of modeling.

Fashion modeling is usually a full-time job. You may have a part-time job for a while, but if you achieve any success, that job has to go. The way the agencies work, you don't have time to do anything else. You make a living at fashion modeling or you get out of it.

The Fashion Production Cycle

Modeling begins long before the final production – whether a sleek glossy ad or a runway show. In our description of editorial fashion models above we actually jumped into the middle of the fashion design and marketing process. Models are involved in creating and developing fashions all along; it's just the editorial and runway models that everyone hears of. Most of these other models are supplied by "commercial fashion" agencies rather than "editorial" agencies; some kinds of fashion models don't come from agencies at all. Let's see who they are.

Fit Models

As a designer creates concepts for his new line he will find fabrics to complement them. The next step is to start draping those fabrics on a model for inspiration, followed by drawings, patterns and a rough sample of each dress. A fit model will help along the way, wearing the draft sample as it is fine-tuned through hundreds of changes.

Fit models are similar in dimensions to runway models, although they may come in other sizes later in the production cycle. Often they are older than runway models, may have an education in fashion design and marketing, and have stable, reliable personalities. A fit model may work full or part time for the same design house for several years, and can make very good money at it. A good fit model is part of the creative team, helping make suggestions on fit that can be incorporated into the design.

The most important thing about a fit model is that their dimensions be precise and unvarying. Even a half inch change in waist or hips can disrupt the process that leads to the final show sample or, later, production patterns. Later in the design/production cycle, fit models in many different heights and sizes may be used.

Showroom Models

After samples are created the designer begins marketing his line through shows and advertising. Retail fashion buyers and the press are invited to formal presentations, perhaps in a hotel ballroom or in the designer's

showroom. Models wear the collection in fashion shows. In addition, buyers may make an appointment for a showing just for themselves. Showroom models will wear the line for the buyer, often coming up for a close inspection and interacting with the buyer. It is a less formal, more personal type of modeling than runway.

A showroom model needs to have the height and body type of a runway model, although sometimes the requirements are relaxed a little. Designers may use part-time or hourly models, or they may have one or more full-time models in-house who can present designs to buyers as needed. Hourly showroom models may be new fashion models from editorial agencies who are gaining experience, but showroom models may not be represented by an agency at all. Often they are hired through ads in professional publications like Women's Wear Daily, and they may have light office duties in addition to modeling.

Usually showroom models are not the ones used on formal runway shows or in print advertising, although a designer may use them to produce his look book.

Runway and Campaigns

A major part of marketing a new line is formal fashion shows like Fashion Week in New York or Los Angeles, print advertising and, hopefully, appearance in editorial stories in the major fashion magazines. This is where the traditional "fashion model" shines.

The Road Show

Designers may pack their line up and take it to major retailers around the country for local fashion shows and presentation to buyers. These "trunk shows" might use local models, but often will use the designer's normal showroom models, who may be either long term employees or hired for the tour from agencies in New York or Los Angeles.

Retail Modeling

As the line hits retail stores around the country, the stores (individually or in cooperation with a mall or other stores) may hold local fashion shows, or in-store "tea room" presentations of their new lines. For these shows local models are usually used. These local shows do not demand the full "runway model" specifications; any model who looks good in the sizes delivered to the store may end up modeling in them.

Catalog/Fashion Print Modeling

National and local retailers use models to produce catalogs, magazine ads and newspaper inserts. These models are usually tall (5'8" and up) and slim (not necessarily as rail-thin as an editorial model). But they generally have what the fashion industry calls a "commercial" appearance – attractive, upscale mainstream "All American" good looks.

Plus Models

"Plus" models also are commercial fashion models who usually appear later in the production and marketing cycle, although for some designers they may work the way standard models do. Plus models have the same physical requirements of other fashion models: they need to be tall (5'9" minimum), well proportioned (a ten inch difference between waist and hips), long-legged and beautiful. But they are dress size 10-20, with hips of about 40-46 inches.

The term "Plus Model" is widely misunderstood. Often people who are heavier than "standard" models of any type will incorrectly refer to themselves as "plus models". The term is not properly used in commercial print, glamour or any of the other modeling types. It is a term for fashion models only.

Beauty Models

Many cosmetic and hair product ads feature pictures that are no more than the head and shoulders of the model. You might think that height and body measurements don't matter for such modeling work, since it doesn't show anyway. Sometimes you'd be right – "beauty models" can be "non-standard" fashion models, and do sometimes get selected from more "commercial" agencies. Still, the strong tendency in the high-end beauty product advertising is to use "editorial" faces. For the last decade or two that has meant high cheek bones, chiseled features – very different from the pretty "girl next door" type. Editorial fashion agencies recruit models

with such faces, not only for cosmetic ads, but for all of their editorial and fashion campaign work. They have wide appeal among fashion clients.

But such faces are not used much in commercial print work, which is more about attractive mainstream types. If a person "looks like a model" they may be disqualified from doing most commercial print work. So "editorial faces" that happen to be attached to tall, slim bodies get fashion agencies; the same face on a shorter body may not find any agency.

Commercial Print Modeling

Okay, let's list some more names. . . Oh, wait! We can't! Nobody knows the names of commercial print models. They work in obscurity, playing the roles of other kinds of people.

A "commercial print model" is one who specializes in print advertising (magazines, newspapers, store inserts, posters and billboards and the Internet). They don't get huge fees (although pay can be very good indeed), national recognition or lucrative national ad contracts, but they are the backbone of the modeling industry.

The requirements to be a commercial print model are very different from a fashion model. It can help if you look a lot like a "model," but there is work available in most markets for many other types. Models can be older, shorter, or heavier and need not be pretty or beautiful - "interesting" often will get work, and "generic good looks" is the most common look required. Commercial models are asked to play roles: "young mom," "active retiree," "Doctor," "executive," and they should look like idealized versions of these and other roles. In most markets the hardest demand for an agent to fill is for middle-aged men. In addition there is ample opportunity for "character" models – people who don't have standard good looks, but do have interesting, expressive faces and don't mind playing character roles.

Things that help a commercial print model are acting ability, an outgoing personality, availability for jobs, and good self-presentation skills. The great majority of commercial jobs are booked through agencies, except for those that are given to friends or members of the client's family, or very small jobs where the client feels he can't afford to use an agency.

Relatively few commercial print models make a living at it. It is not a career; it is something they do on an occasional basis while they do something else "full time." Outside of the large markets (New York, Chicago, Miami, Los Angeles and maybe Dallas and Atlanta) it is doubtful that there is any city in America in which more than a dozen people make a good living at modeling, but in virtually all cities and substantial towns there are many, usually hundreds, who are in the modeling market, and who occasionally find work.

Stock Photography

One of the things that your agency may suggest to you (or you may find for yourself) is a "stock photography" assignment. If there is one subject that is likely to cause great disagreement in the modeling business it is agency models shooting stock. There are valid arguments that a model should never shoot stock, and also that they should. Many agencies refuse to accept stock assignments for their models; others will pass stock offers on to the models for a decision.

What Stock Is

No, it isn't pictures shot by photographers with two heads, horns and a tail even though that is the reaction some people have to it. "Stock" photography is a form of commercial photography: pictures taken with no known use in mind and put into a "stockpile" of photos that clients can choose from when they need a picture to illustrate an ad or story. Quite a few photographers make their living entirely from stock photography; many commercial photographers do it to supplement higher-paying commercial jobs. Stock photographs can literally be of anything (usually are not of people), and there is a robust need for models for stock.

Stock normally uses "real people" or "character" models, although some fashion model types may be used from time to time. As a rule it pays much less than a commercial assignment. The photographer is betting that he can find a market for the pictures, but it may be months, years or never when he gets paid. The vast majority of stock photos never sell; it is the few that do which the photographer lives on.

Even though the pay is low, the "usage rights" needed by stock agencies are unlimited. So the model (and model agency) are in the strange position of being asked to accept a lower than normal fee for greater than normal rights. That doesn't sound right, and so begins the debate.

The Argument Against Stock

You won't be making nearly as much money for stock as for other commercial print work, and you won't be getting any renewal or residual money either - all rights are "bought out". But it gets worse.

Neither the model nor the photographer knows the eventual end use of the pictures. In a worst case scenario a model may find that a picture of her was just used on a box of laundry soap, and the next day she gets an offer to be the box cover girl for a competing brand. The job would pay several thousand dollars - but she is disqualified because of that stock job she did for two hundred dollars a few years earlier.

That is what most worries those who argue against doing stock: that for a little money you may give up the opportunity to make a great deal of money later. And truth be told, things like that do happen. The argument is not wrong.

There is another argument against stock as well: you have no control over the products your pictures are used to advertise. It may be something embarrassing (bladder control pads) or worse, something you have a moral objection to.

The Argument For Stock

Which is worth more: a lottery ticket a day before the drawing, or a ten dollar bill? Suppose someone with a hunch offers you ten bucks for a lottery ticket you just bought, and you take the deal. Two days later, if the ticket is a winner, you kick yourself for being so stupid as to sell it and lose all winnings. The great majority of the time, however, the ticket would not have hit, and you would be better off stuffing that ten bucks in your pocket with a smile on your face. Selling the ticket is statistically the right answer, even though once in a long while you may lose out on a big score.

Stock photography can be like that. It is true that someone sometimes loses a big opportunity because they took the smaller, sure money. But those cases are infrequent enough that the mathematics can argue in favor of taking the money and the chance.

Another side of the issue: frequently a stock job will also give you pictures which you can use for your composite card. For those with lots of money who can hire a professional photographer this may not be a big benefit; for those on a restricted budget who cannot afford to get the pictures to get their career started, it may make a huge difference. Certainly it is possible that shooting stock may cost you some future job; but, for a beginning model, the lack of a composite card may cost you several jobs. If stock enables you to jump-start a career that otherwise is languishing, the economics work out in your favor even if you do lose a future job.

Each model has to make an individual choice: to take a few hundred dollars and perhaps some pictures and accept the possibility that they would lose a big job later, or to wait and hope for the big job to come along. Some agencies make that decision for you, others will let you make it for yourself.

Specialty Modeling

Some jobs call for only a small part of the model to show: hands, feet, backs, and legs are among the most common. There are models who specialize in this "parts" work, and there are even specialized agencies for it in large market cities. They must have very attractive hands (thin, long fingers) and feet or other body parts. Specialty models often go to extremes to maintain the appearance of their parts – wearing gloves all day every day, for instance, and frequently applying lotion to keep the skin soft and smooth.

Many specialty models work regular modeling jobs as well. In fact, in many smaller market cities agencies have few if any pure "parts" models. They use their models who also happen to have attractive hands and feet.

A large part of the market for specialty models is TV ads, so they tend to work with agencies which specialize in both print and commercial TV.

Artists' Models

There are two kinds of "artists' models": those who pose for commercial artists for drawings for advertising, and those who pose for "Fine Art". The former are also called "illustration models," since the result of the artist's work is an illustration of a designer's clothes for a catalog or print ad. This type of modeling is less common now than in the past, but is still done to some extent. Illustration models need not be fully qualified as fashion models, but they normally resemble them.

Fine Art is usually for drawing, but can be for painting, sculpture or photography as well. All body types are used, and there is no height requirement. There is more demand for female art models than male, although nearly as many men as women work in the field. The majority of art modeling is nude work. Pay for artists models tends to be quite low: $10-12 per hour is typical of rates for schools or established artists; art photographers or artists shooting "reference pictures" generally pay more in the $25 per hour range. Pay does not change with experience, but more experienced models are more likely to get booked. In addition to attractive physical traits, artist models must be able to find a variety of attractive poses and hold them for an extended period. Flexibility is desirable.

Since there is little money in it, it's rare to find a model agency who supplies models to artists. Models pursuing that specialty will have to self-market. Some illustration modeling is supported by agencies, since there is a client with enough money to make it worth their while.

Glamour Models

There is a common misconception among many aspiring models that "glamour modeling" is like they see in the pages of *Glamour Magazine*. Sorry, those are fashion models or commercial models. A glamour model may do many kinds of work, but all of them are based on the fact that she is pretty and attractive (unlike a fashion model, who may not be pretty, or commercial model, who may not be either pretty or attractive).

Some of them do promotional work: appearing in a bikini at a boat show, or in bars or special events to represent a liquor distributor. Some do "cheesecake" work: appearing in magazines which appeal to a male audience, adorning the product in a magazine (such as cars, boats and motorcycles) or appear in calendars. Many do nude work in magazines, or videos, or in the growing field of web site content. There is also the "glamour commercial model" whose appearance in an ad is intended to drive viewer attention to the page, where a message about the client's product can be snuck in as well. The market for non-nude glamour models certainly exists, but it is rarely something that a model can make a living at, and generally does not pay as well as other modeling work. Most glamour models who do not do nudes will have no more than a few appearances in print, and virtually all of them are in New York, Miami or Los Angeles.

The requirements for being a "glamour model" are different from being a fashion or commercial model - generally any attractive woman with an appealing body can qualify. Preferred age varies by the type of job, but is generally from 18 until the late twenties. Some glamour models have successful careers into their thirties, but they almost always became known prior to that.

There are a very few specialized agencies for glamour models, but they exist in a small number of cities. Few glamour jobs are booked by agencies. Some glamour agencies do handle promotional or trade show jobs, but other glamour assignments generally are booked in other ways: through personal contacts, direct advertising and hiring by the client or photographer, and more recently, through the Internet. It is very common for a model to get such jobs through self-promotion, direct to magazines, clients or photographers. A growing number of them also are getting work through the Internet, using on-line model referral pages or modeling forums.

Fitness Modeling

A specialized subset of glamour models is "fitness models", which are between glamour and commercial print in the marketplace. The fitness model is also a 'tweener: midway between a body builder and a classic glamour model. There are more male than female fitness models, although there is a market for both. There are several specialized magazines (such as Men's Health) that routinely hire fitness models. They also can do some catalog and commercial advertising work.

Most fitness modeling is booked in Los Angeles or New York. There are a few agencies (or divisions of agencies) which specialize in fitness modeling in both cities, but much of the work is booked by non-agency models who self-promote to the magazines and sponsors, and who enter fitness competitions to come to the attention of media members.

Promotional Modeling

There is a question among many in the modeling industry whether "promotional modeling" is modeling at all. Most traditional fashion and print agencies don't deal with it. Promotional models are hired through specialized staffing agencies, through direct contact with clients, or increasingly, from ads placed on the Internet.

Promotional models are used in many ways, from acting as a spokesperson for a product at a trade show to giving out free drinks as a liquor promotion in bars, to passing out flyers in a mall. Promotional models may find themselves wearing funny costumes or storyboards, bikinis or business suits. The common denominator is that they are in front of a lot of people, promoting their client in some way.

Most promotional modeling is very low paying, as modeling jobs go. A typical rate is $15-$25 per hour, or a day rate of $100-$300. Jobs requiring special skills or characteristics can pay more, but that is unusual.

Promotional models don't have to "look like models," although they usually have to be reasonably attractive. More important is a pleasant, outgoing personality, since they will be interacting with the public all day. Physical stamina helps also, since they may be on their feet for an eight hour day, or working into the late hours of the night.

TV Commercials

Although appearing in a TV commercial isn't "modeling" (it's "acting"), it's a logical and common cross-over for models. The majority of commercial print models are also professional actors. That serves two purposes: acting is a supplemental income for when there is a flat spot in modeling, and acting skills are very helpful in modeling. Print ads are usually little slices of a make-believe situation, and the model needs to be able to portray a realistic role in that situation. Acting helps.

TV commercials are the only area of professional acting where lots of training and skill are not necessary. Acting classes are advisable for any model, especially a commercial model who wants to get into TV commercials. But all you need to get started is a short course on auditioning for TV commercials, which shouldn't take more than a weekend and a small amount of money.

Your model agency might have a TV commercial (or "on camera") division or you may need to be listed by a talent agency which specializes in commercial work. Most model agencies, even those with exclusive contracts, will allow this kind of dual representation, although a few will not.

Because Promotional Modeling and TV Commercials are outside what is normally considered modeling, we will discuss them in less detail than the more accepted forms.

What You Need To Be a Model

The will to succeed is important, but the will to prepare is more important.
-- Bobby Knight

A common myth is that all you need to be a model is good looks. It takes a whole lot more:

Location

This can be very expensive, but also is critical. It's possible that you may be flown to a job at client expense some day. It happens. But it only happens after you have been selected for the job – and that happens where the client and the market are. Here's how it typically works: Clients call agencies and tell them their requirements for upcoming jobs. An agency matches those requirements against their files and selects the models they think likely to be chosen for the job. Those people then go on a "go-see" or "casting." There can be only a few or as many as hundreds of models at these go-sees, and the great majority of them won't be hired. This is a competitive business, with lots of competitors and, at any given moment, few winners.

You don't get paid to go to go-sees. That may be okay for someone that lives in the area and can take time off for an hour or so. But it is impossible for someone who lives in Ohio, Texas or even Maryland to commute to castings hoping they will get a job in New York. The economics don't work.

There is a limited amount of "direct booking" of models from comp cards or off an agency website. Most frequently this is for catalog ("commercial fashion") jobs and is relatively unusual for commercial print. Unless you are in a very hard-to-fill category (for instance, a 50-ish Asian or character model, or a high-end editorial fashion model) it's unlikely that you can get much modeling work through an agency without living in their city. Even then, you normally have to establish yourself at their location for a while (weeks to months) before you can be considered for direct booking assignments. The closer you live to your agency the better. Although models do sometimes commute from as much as 100 miles away, it makes a modeling career very difficult.

Attitude

Being a model is like any other job – you have to bring the skills and attitude. Without them, you are doomed to failure. Among the things that help:

1. **Self Discipline**. You have to be able to get to go-sees, shoots, jobs, meetings and appointments, in good condition and able to perform.

2. **Commitment.** Modeling requires your time, resources, and effort and giving up other things you could be doing.

3. **Ability to get along with others**. Models have to work with photographers, art directors, clients, makeup artists, agency staff and other models. Any of them may be able to keep you from getting work, even if you are the person with the best "look" for the job. All of them talk to each other. If you are abrasive, rude or just someone they don't like to work with, you won't work much.

4. **Self Confidence**. No matter what you really think or feel inside, it must appear that you are confident in your ability to be what the client needs. Self doubts need to get left at the door of the go-see or studio.

Availability

Professional modeling happens during business hours. If you can't make yourself available for go-sees and jobs, you can't be a model. That means you need a way to support yourself with lots of flexibility during the work day. Commercial print models typically work as waiters, bartenders, actors, or in night jobs. Fashion models often cannot work at anything else – the business is too demanding of their time. If you have a "day job" with an inflexible schedule you may find that you cannot work as a model.

Looks

Yes, you have to "look like a model", although what that means varies quite a bit. But looks aren't nearly as important as location and attitude in your success.

"Sponsors"

Generally models aren't "discovered" – they work their way into the industry. In a sense, however, some highly successful fashion models are "discovered." It happens like this: someone (or several someones) takes an interest in her, and chooses to give her opportunities over someone else. There are plenty of models and few jobs. Choices have to be made. It is human nature in any business that such choices go to people we like. In the subjective world of modeling, it is all the more true that personal relationships make or break a career.

Models should take advantage of opportunities to gain that kind of sponsorship from people with influence in the industry: agents, art directors, editors, working commercial and fashion photographers. Virtually all of the most successful models have used "sponsors" to achieve their success. But the woods are full of people who want to appear to be able to "sponsor" a model who can't (or won't) really do it. The model's problem is to tell which apparent sponsors are really opportunities for her.

Investment

No matter what you may have read or hear, or what Tyra said, modeling is a business, and like all businesses requires investment – from you. At a minimum, you will need to invest in the following, and your agency probably will not pay for much of it:

1. **Marketing materials** You will need a composite card and may need portfolio pictures and may have to spend $500-$1,500 for them.

2. **"Bag of tricks"** Even though many assignments will have professional makeup artists, some (especially commercial print jobs) will not. You must have the materials and skills to do your own makeup in a variety of styles. On fashion assignments the clothing (except perhaps for foundation garments and shoes) will typically be provided, but on commercial jobs it usually will not. You have to come to the shoot (and perhaps to the go-see to get chosen for the shoot) with a wardrobe and shoes appropriate to the modeling situations. If you do not already have all of these things, you can expect them to cost several hundred dollars or more.

3. **Modeling Skills** It's best if print models have extensive experience in front of a camera. The best way to get this is to do a lot of shooting. Ideally this should be with a photographer who is skilled at working with models in commercial- or fashion-style shots. Still, any kind of experience is helpful, and even shoots with relatively new photographers help you gain self-confidence and posing skill. Frequently models can find less-established photographers who will shoot them free or at modest cost so each can add to their books. Runway models also need to know how to walk. Fashion agencies can provide training at little or no cost to the model. Acting and dance classes are helpful for models.

4. **Advertising** You need to get your pictures in front of photographers, art directors, casting agents, and others that make hiring decisions. Your agency can assist you in this by including you in the agency website or promotional mailers. Agencies must recover their costs from you for these items. Depending on their policy and the degree of promotion that an agency does, the cost to you may run from $50-$1,000 per year, although some agencies pay this themselves as a cost of doing business.

5. **Communications** This is a fast-paced business. If your agent can't find you quickly, you may well lose a job that could pay you thousands of dollars. If your agent can't *reliably* reach you in an hour or less, you can count on losing jobs – and you may lose your agency. There are a variety of solutions: cell phones, beepers, or answering services – but one of these is necessary to a successful modeling career.

6. **Maps** This isn't a large investment (it may cost you $20 or so) but it's very important in large cities. When your agency or a client gives you an address, you should be able to find it and figure out how to get to it on your own. Nobody wants to hand-hold you through each trip to a go-see.

7. **A Passport.** Even commercial models can find themselves booked on jobs overseas, and for fashion it's quite common. If you don't have a passport, you may lose the job.

Pictures

Why Get Pictures?

Whether for fun, experience or to update a portfolio or comp card, print models need to shoot often. Pictures are the soul of a model's professional life. Booking and shooting jobs is a good way to get pictures, but every print model needs to shoot "tests" as well to add variety to their photos.

Your Portfolio

What is a Portfolio?

A model's portfolio is a book containing clear plastic sleeves that a model can slip her pictures into and out of. Originals pictures are best, but everyone understands that they can get damaged or lost as a book is carried or sent around, so good quality laser copies are acceptable.

You may have only one or several different types of portfolios. A model may have a "fashion book," a "commercial book," and a "glamour book," for instance, to show off different aspects of her abilities to different types of clients.

The portfolio will be updated regularly to show your current look, as new pictures become available, and will include new tearsheets when you have them. A model will also include or take out pictures to "fine tune" it for a particular go-see.

Format

For beginning models a portfolio need have only ten pages (enough for 20 pictures) and it's accepted that it may not be full. Only as you get excellent pictures and good tearsheets will the pages all be filled and you think about getting a bigger book.

For the last decade or so in all major and most secondary and smaller markets the standard size for portfolio pictures has been 9"x12". Lately some smaller sizes have been coming into use; your agency may approve a 6"x9" or even 5"x7" portfolio. Sometimes these smaller sizes are produced as "walk-around" versions to be used by the model at go-sees, while larger versions are maintained by the agency to send to clients. In some small market cities 8x10 is used for portfolios. Check with agencies in your area to find out the standard size expected.

Do You Need a Portfolio?

You may not. It depends on the category of modeling you do. History is full of models who spend hundreds or thousands of dollars "building a portfolio" because they thought that's what a model needed to do. They end up with something expensive, time-consuming and useless because they didn't know what they needed. Sadly, modeling school students frequently fall into this category. Their school has them pay for shoots because . . . well, because "that's what models do", and it's how schools make money. So the student ends up with a book full of bad or inappropriate "modeling pictures."

A portfolio should be put together only after getting professional advice or doing a lot of research. For many models a portfolio is not even necessary, especially at the beginning of their careers.

Aspiring Agency Fashion Models

For an unsigned fashion model most agencies will tell you not to put a portfolio together. They see all too many portfolios brought in by models who have spent lots of money buying pictures. Typically the pictures make the model less attractive to them, not more. Virtually any pictures she has done prior to being signed by an agency will be thrown out. The first thing she should try is to get an agency with nothing more than snapshots. *Only if she has diligently tried and failed* with snapshots should she consider putting together a portfolio to take to the agencies. In that unhappy event, models should put together a book as described in the "self marketing fashion models" section.

Commercial Print Models

Here's a truth that applies to the New York City commercial print market and a lot of other cities: Commercial print models don't need portfolios at all! They can get by with only composite cards.

Yes, portfolios are nice to have, but at 90+% of go-sees in NYC the commercial model is never asked for her book. A portfolio isn't necessary to attract the attention of a commercial agency (it might help, but it isn't necessary). There is no reason for a commercial model to have a portfolio done before she gets an agent. It isn't that commercial print models don't have books – they usually do. But they are built over years and largely consist of high-quality tearsheets from work the model has done. Spend money to get a portfolio only if your agency says you need one.

Other Types of Models

Promotional models do not need portfolios, just 8"x10" headshots. Art and Glamour models should have them, and the shots should be of the type the model wants to do. Both "editorial fashion" and "commercial" shots could be out of place in a glamour or art model's book.

Children

Unless a very good booking agency in your area tells you otherwise, children do not need a portfolio. It's an unnecessary expense, and will be outdated quickly anyway.

What Goes Into a Portfolio?

Countless articles and even books have been written on what a portfolio should contain. The truth is, there is no single answer. It depends on what the portfolio is trying to achieve, where it will be used, what kind of work, clients or agency the portfolio is intended to influence and what the model's characteristics are. The only advice for any kind of model is this: *only the very best pictures go into your book.* It is far better to have four outstanding pictures than 20 mediocre ones. The rule is this: ***You are only as good as your worst picture.***

When possible, inclusion of *good* tearsheets is very important to a fashion model. Even so, not all tearsheets are good; small pictures from 1/8th page ads from minor advertisers don't belong in your book or card.

A portfolio should include at least one "head shot" or "beauty shot", and one ¾ or full length shot to show of the general lines of the body.

Fashion Models

Fashion models who want to try self-marketing (which, in a large market, is very difficult) need a book of the same kinds of pictures that would be in an agency model's book. These can be found on composite card samples at print shops that specialize in comp printing, on line at agency web sites, and in looking through editorial fashion magazines.

Commercial Print Models

It never hurts to treat both casting directors and agents as Bears of Very Little Brain when applying to them. Don't make them think too hard to see you as what they need. If they have to say to themselves, "Gee, with a different haircut, more natural makeup and wearing a business suit maybe she could work" as likely as not you won't get selected.

If you are to present a "developed, ready to work" impression to a commercial print agency or client, you need to either learn to be VERY objective in evaluating yourself (do I look like a "mother", or am I too glamorous?), and perhaps in restyling yourself to meet what commercial print wants (typically: conservative, mainstream looks unless you are some special type). Look at non-fashion print ads until you can *honestly, objectively* tell yourself "I could have been in that ad," and then put a shot of yourself playing that role on your comp. Do that several times, for several roles, and you have what you need.

Each agency will have its own style of picture, and it's helpful to look at some cards of people the agency represents before you have your own done. But here are some general guidelines that should apply to most commercial print or small market agencies:

1. The pictures need to be in color. Clients care about coloration; you need to show it to them. Still, if you have an excellent B&W shot there is no reason not to include it.

2. Get a great headshot (beauty shot). Not a good one, an absolutely great one. That is the single most important shot in getting you accepted or hired, and it isn't unreasonable to spend half your time and

resources on it. It should be in color, clear, evenly lit, with a friendly, accessible expression on your face, ideally a smile. If you have good teeth, it's preferable (but not mandatory) to show them.

3. Backgrounds, props and poses need to be chosen to lend a sense of believability to the shot. There is nothing wrong with a picture or two taken against a seamless sheet of paper, but some of the pictures (ideally most of them) should look more like location settings - even if done in the studio. Never, ever shoot with a photographer who wants to use a cloth background. Muslin or sheets, painted or not, look cheesy and are very rarely seen in a commercial book or comp.

4. If you are a woman, pay for a good, print-qualified makeup artist, ideally one who also is proficient with hair. Unless you are a graduate of cosmetology school with a specialization in makeup, don't do your own. Even then it is a bad idea. *If the photographer doesn't provide a makeup artist, don't shoot* - simple and important as that. For men it's less clear-cut, but you will probably need to use powder for shoots.

5. <u>The most common mistake</u>: The first picture is of you wearing an outfit. The second picture is you wearing the same outfit in the same setting, but posed differently. The third picture is of you in the same outfit in a slightly different location, posed differently. The fourth picture . . . (well, you get the point). <u>The second most common mistake</u>: The first picture is of you wearing an outfit. The second picture is you wearing a different outfit in the same setting, but posed differently. The third picture is of you in another outfit in a slightly different location, posed differently. The fourth picture . . . (again, you get the point). Or maybe you don't get the point. Your pictures should show you looking like pretty much anything BUT a model, so get shots that show you doing something other than being a model. "Fashion" is about models, commercial print isn't. Commercial "models" are hired to represent "real people only better", and if your entire book or card is you looking like a model, you have failed. The purpose of the pictures should be to show a role being played by you, not you displaying "another look". The first impression a viewer should have is that it is of a business woman, firefighter, young mom, soccer player (or whatever role you are playing in the shot). Only secondarily should they notice that it is a "picture of you."

6. Get pictures that look like the kind of work you want to do. If you aren't a fashion model, don't get "fashiony" pictures. Wild makeup, strange angles, weird lighting . . . all that stuff is pretty and fun to do, but useless in a commercial print book.

7. Get pictures that show what you have to sell. If you have great legs, make sure at least one picture shows them effectively. If it's your eyes, the same. Unless you have bad teeth, show them in at least one picture.

8. One of the most effective shots that can be in a commercial model's book or card is an "interaction" shot. That's a picture that shows you with a mother, husband, child, co-worker or even an animal or an inanimate object to interact with: a computer screen, for instance. What the shot must show is your ability to portray the emotions that go with that person or thing – your acting ability. The worst kind of "interaction" shot is one that shows two people simply mugging for the camera.

Cheesy glamour (which means glamour pictures shot by almost anyone but a commercial photographer) is not acceptable. For models at the glamour end of the commercial market an excellent glamour shot with good production values can be an asset to a card.

Glamour Models

Mainstream glamour models should have a composite card specifically for that purpose, and a separate card for non-glamour jobs. Some commercial clients will be put off by "glamour" pictures on a model's card; conversely, most commercial print-style shots don't portray a model as glamorously as she should be for glamour jobs.

Specialty Models

A specialty or "parts" model needs a card that shows close-up shots of his hands, feet or whatever he or he specializes in. The shots need to be elegant and stylized, letting clients see the shape of the parts. Most parts cards also have a small head shot of the model for reference, in case the client wants a shot that features the parts, but also shows more of the model.

Child performers or models have less demanding requirements for pictures. Casting directors understand that children change rapidly as they grow up, and do not require full comp cards or portfolios. A professional headshot (8"x10" or even 5"x7"), reproduced in quantity, should be enough for most purposes. Some local agencies even advise using snapshots only for young children, although that is usually not true in major markets.

Actors

Most commercial print agencies also support the performing arts (such as commercials) to some degree. Castings for actors require a headshot, 8"x10" and done in the style used in the commercial market. They should be mass printed (laser or offset) rather than original photographic prints. Often performers have more than one head shot, so that a choice most appropriate to an upcoming casting can be submitted. Until recently they were always black and white; lately color has become more common.

Your Composite Card

A composite card ("comp card") is a cardboard card with a collection of pictures and information about you and your agency (if you do not have an agency, the card lists your contact information). It is sent by agents and models to potential clients as a way of letting them know about the model, and you leave one at go-sees so they can remember you.

Composite cards may have as little as one picture or as many as a dozen or more spread over three pages. The most typical comps are 5 ½ x 8 ½ inches in size, printed on heavy card stock, double sided. They contain a good head shot on one side, three or four other pictures on the reverse, and your measurements and agency or personal contact data. Pictures should be mostly color, but some good-quality B&W shots can be acceptable on comps. When you lay out the card, you should make it so it can be used by an agency when you get one. The agency will want to put their logo or sticker (typically ¾"x2 ½") on the card, and will cover any contact data you have on it. Here is a "standard" layout of the front and back of a card:

Front **Back**

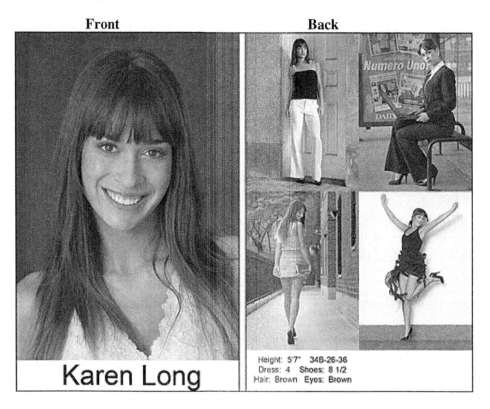

Height: 5'7" 34B-26-36
Dress: 4 Shoes: 8 1/2
Hair: Brown Eyes: Brown

Karen Long

Notice the space left on the card for the model to put her contact information, or for an agency to place their sticker.

The pictures on your card need to reflect your current appearance. If you make a significant change (cut your hair much shorter or color it, gain or lose a lot of weight) you need a new card.

Who Chooses the Shots?

The best person to choose the shots on a card is your agent. He is getting paid for his special expertise in marketing you, and in knowing what pictures will do that best. If you have an agent, use him.

The worst person to choose the pictures is your mother or father (unless one of them works at an advertising agency). Inevitably parents have an idealized vision of what their child looks like, or what they want to see them look like, and they will pick pictures that are close to that vision. It may have nothing to do with the way you need to be presented to the market. You shouldn't pick the shots either, for reasons similar to why your parents shouldn't.

If you don't have an agent, you need to find a friend who works in the advertising, publishing or modeling industry – someone who sees advertising or fashion pictures on a regular basis and knows what they look like. They should be currently working in the field. Styles change, and people with 15-year old experience may have very different views from what the market actually wants.

Getting It Printed

Once you have good quality pictures your agency can assist you in finding printers. If you don't have an agency you will have to do it for yourself. In most cities with a reasonable amount of modeling work there are printing companies that specialize in comp cards and can do them easily and quickly for you. You simply need to bring in your pictures and stats, and they will help you select a pre-made format. If you cannot find such a printer in your area, you may have the layout work done separately and then give it to the printer. Composite cards should be updated as you get better pictures or tearsheets, so it isn't usually necessary to print more than 50-150, depending on how many agencies you have and how much you and they need for marketing.

There are companies on the Internet that specialize in printing comp cards, and offer low prices. Some of them do very good work, but many do not use good enough stock. Be sure to get a sample before you order from such a company, and ensure that the card is sufficiently heavy, and the printing crisp and clear. Flimsy cards or muddy pictures will not help you look professional.

Laser or Offset?

There are two common kinds of mass color printing: laser prints and offset. Both are acceptable, although offset printing on good coated stock gives a smoother, more flattering and professional look to the card. Offset printing involves a setup cost, so only runs of 100 or more cards are cost-effective. Laser cards do not require expensive plates to be made, and they can be economically produced in lower quantity.

Cost of Printing

Local print shops should be able to do a run of 100 color, two-sided comp cards for anywhere from $100 to $175 including layout and setup. Some print shops on the Internet are cheaper; in small cities where few comp cards are printed, it may be more expensive.

Self Printing

These days good inkjet printers can produce pictures every bit as good as an offset or laser printed card. Many models are tempted to print their own comp cards. You can do that, but you should consider the following:

1. Format. People laying out their own cards tend to produce cards with fancy, distinctive graphics, strange fonts and non-standard layouts. That is almost always a bad idea. Get some agency cards to use as examples, and produce a card similar to the simplest of what you find.

2. Card Stock: The biggest failing of self-printed cards is that they are printed on flimsy paper, sometimes two pieces of paper glued together. These look cheap and cheesy; the message being sent is that you aren't sufficiently committed to your craft to invest in professional printing. Clients take those messages to heart. Another pitfall models fall into is printing on glossy stock. Professionally printed comp cards are on a matte surface, not glossy.

3. Picture Placement: There are composition rules which agencies and good print shops know to tell you how to place your pictures. If you don't know those things, get professional advice before making your card.

Promotional Models

Promotional Models often do not need a composite card. It is common to use something like an actor's headshot: an 8x10 glossy.

Other Reasons for Shooting

If you are like most models you like to shoot, and you like the pictures you get from shooting. Even if there is no likelihood that a shoot will result in pictures you can use to market yourself, shooting still may be a good idea. Models need practice in front of a camera; they may want pictures very different from their "professional" shots just for the enjoyment of creating them; they may want to network with photographers in the hope of being remembered when a real, professional job comes along.

You can choose photographers much differently than you would for a "portfolio" shoot. If possible you want to work with photographers that are at or above your level of experience, and to work with increasingly skilled photographers as you progress in your career. You can learn something from almost any photo shoot, but your chances of learning a lot, of getting pictures you really like, or of getting later benefits such as jobs or referrals are greatly improved if you choose high quality photographers. It's easy to waste time with "photographers" who just don't get it and never will - and they tend to find you. Resist the temptation.

Always review the work of the photographers you are considering, and make sure that you would like pictures of yourself shot in their style before booking the shoot.

Finding a Photographer

You can call a fashion agency and ask for names of photographers they work with, but some agencies treat this information as though it belongs in a vault at Fort Knox. Other than referrals from model agencies, you can find photographers through ads in photography, modeling or acting trade journals (or their websites). Examples of such publications include Variety and Backstage. You can also find contact information in books, such as *The Black Book* or websites such as **www.models.com**.

Choosing a Photographer

"Choosing" isn't the same as "finding." Attractive women generally can find photographers to work with, and may find good ones at little cost. Other types of models are more likely to have to pay for good shoots, but should be able to find interested photographers. But not all photographers who are interested in shooting you (paid or not) should be chosen. These pictures are for you, and you need to be sure the team you choose is likely to get you what you need. Many photographers can't, or won't. Your first problem is to assess the photographer's style:

1. Fashion photographers shoot people all the time, but they shoot "fashion style" – which may be entirely different from what you need if you aren't a fashion model.

2. Most commercial photographers don't often shoot models at all; they spend a lot more time on product shots. Those that do shoot a lot of model photography are likely the best choice for commercial and "fashion print" models, but not for editorial fashion models.

3. Glamour photographers shoot people constantly, but "glamour style" is inappropriate for most professional mainstream modeling, and most of them don't know how to do fashion or commercial/lifestyle shots.

4. Portrait and wedding photographers are rarely good choices. They may be very good at what they do, but what is customary and expected in their business is very different from what a professional model's shots need to look like.

5. Specialty photo shops like "Glamour Shots" produce fun souvenirs, but they aren't likely to get you what you need for your book.

6. Art photographers may produce beautiful work, but unless you are an artists' model (or, rarely, a fashion model) what they do won't do you any professional good.

7. "Test Photographers" specialize in shooting specifically for a model's portfolio. Some of them make their sole living at it. Good ones are likely to be the best affordable choice you can make. Sadly, not all of them are good at it, and not all are good at both fashion and commercial styles.

All of this puts a burden on you to know what professional modeling pictures in your specialty look like. Most people don't, and that accounts for all the horribly inappropriate pictures that aspiring models bring into agency offices. If you can't tell the difference, one approach is to seek out a family member or friend who knows these kinds of people who can give you some advice.

Another approach is to go to one of the better mainstream modeling forums on the Internet and ask those kinds of questions. At least some of the people there ought to be able to help. If all else fails, buy some magazines and look carefully at the way models like you are portrayed in fashion (if you are a fashion model) or print ads. That's what your shots need to look like.

Where to Get Tear Sheets

Once you have done some professional print modeling you may have some tearsheets. If they are effective pictures, you will want to put them in your portfolio and on your card.

A fashion model's agency can usually provide her with access to most of her tearsheets. Normally a fashion agency will have a relationship with the fashion magazines, and the magazines may send tearsheets to the agency. The agency may also subscribe to the important fashion magazines, so if they don't get courtesy copies of the tears, they can be taken out of the subscription issues.

It's very different in commercial modeling. A commercial print model's work may show up anywhere: in general interest magazines, annual reports, advertising to the trade, billboards or posters or countless other outlets. That is true to some degree of fashion work, but strongly true for commercial print. Commercial clients usually do not provide copies of the ads to agencies (although they may on special request). That means the model will have the problem of chasing down his work, or of getting a copy from the photographer or ad agency that hired him. Keeping those phone numbers handy helps a lot in building your portfolio.

The Model as Client

Most of the time the model is at the bottom of the photography food chain. But when you are shooting pictures for your own use the roles change. Now, for at least part of the shoot, you are "the client". You need to ensure that the number and type of photographs taken will meet your needs. If what you want is different from the normal style of the photographer, make sure you and he agree that he will shoot and deliver what you need. You need to ask:

1. Prints? How many and what size?
2. What do they cost?
3. A CD of images, or printed on paper? If a CD, at what resolution?
4. All of the pictures shot or a small subset? Who chooses them?
5. Will they be retouched?
6. When should you expect them?
7. Will you be expected to sign a release? If so, what type?
8. Will the photographer give you a copyright waiver so you can use the pictures? If so, what type? If not, what are his policies on your use of the pictures?
9. Will support people like makeup artists and hair stylists be at the shoot, and are they are competent? Ask to see their work!

Cost

There is no single answer to what a "test shoot" should cost. In part it depends on the experience of the photographer and his place in the food chain. Commercial photographers who frequently use models in high-paying jobs demand more than "test photographers". New York prices aren't the same as those in Oklahoma

(sometimes New York is cheaper). Your desirability in the portfolio of the photographer, and your willingness to shoot something they want to do, changes your negotiating position.

It's entirely possible for an appealing model to get a free test from a good photographer. Some New York fashion agencies have a list of photographers who will shoot for free just to have agency fashion models in their books. Even for paid tests, fashion models usually pay less than commercial models do.

The "average" is something like $250-$450 for a fashion model, and double that for a commercial model. Hair, makeup and styling may be extra, or might be part of the package. Additional prints may be extra (and perhaps add a lot more to the bottom line for the shoot). Some photographers charge much more than this; a few of them are even worth it. Some charge much less, and often that is what they are worth too.

Self Marketing

I'm a great believer in luck, and I find the harder I work, the more I have of it.

-- Thomas Jefferson

For mainstream modeling the best way to get work is to have an agency find it for you. But if there are no good agencies where you live, or you haven't been successful at getting represented, it is often possible to find a substantial amount of work on your own. Some models even make a living at it.

Preparation

If you are 5'6" tall or look like the girl next door you aren't going to be an editorial fashion model, no matter how much you might want it. You need to understand what kind of model you look like, and where models like you can find work. If you are the edgy editorial type, you probably need to be in New York. If you are 5'8" tall and have classic, all-American good looks you may be able to model in any substantial city in America. Once you have decided on the kind of model you are, you need to tailor your marketing plan and materials to portray you that way, and be in a location where that kind of model is used.

You have to present yourself as a professional. Do the same things an agency model would: fine tune your appearance and get a good composite card printed in the style of the market you intend to go after. A commercial-print style comp isn't a good choice if you want to be hired by a designer for a runway show; edgy editorial doesn't work for Campbell's soup. Depending on your look and type, you may want to make up more than one comp.

If the culture of your city requires commercial print models to have a portfolio (New York, for instance, does not), or if you are targeting fashion jobs, you may need to have a good portfolio done as well.

Finding People Who Hire Models

In a smallish city there aren't all that many potential clients - it's literally possible to contact all of them. In a city like New York or Los Angeles you can't do that, but you can make targeted submissions.

In larger markets advertising agencies usually do not do casting themselves (although a very small number still do). In smaller cities it's less likely that there will be intermediaries like casting directors, so the ad agencies may be the ones to approach for a job. Usually in commercial print work the ad agencies aren't interested in maintaining a list of models (that's what agencies are for) and don't want to see models except those that are suited for whatever ad they are working on at the time. Companies who do fashion-related advertising (such as large retail stores) may be interested in seeing fashion model independents, since they repeatedly use the same kinds of model in their ads.

So you have to find people who actually hire models (small clients) - or client-surrogates, like casting directors, who often keep models on file. Casting directors are listed in publications like *The Ross Reports*, or in *Backstage*, *Variety* and similar publications. In reading those listings you need to be careful to identify the type of casting director, since many of them specialize in a particular kind of production.

In major market cities, commercial and fashion photographers are very often the people who make the original casting choices (although the ad agency or client may make the ultimate decisions). Commercial photographers may not be in the "consumer" reference publications like the Yellow Pages. They often are found only in professional reference sources like *Le Book* or *The Workbook*, or in business-to-business yellow pages.

Some magazines also take direct submissions from models. Models can get into Maxim and Stuff, for instance, by direct submission. Find the magazines you are interested in, read the masthead of the magazine, and send pictures to whoever seems to be the one who hires models. Typically that would be a photo editor.

In smaller markets it often is a matter of personal relationships with the clients. Look on television and in the newspaper and local magazines, find out who actually hires models, and find a way to meet them.

Models looking to pose for artists may find them associated with university art departments, or local art galleries may have leads. Many photography schools also hire models for life drawing classes and student projects. It's common for college students to take these jobs, but they are usually open to non-students as well.

Models who want to do fashion work can get jobsd (although usually low- or unpaid) through their local malls. It's common for a mall to have a "teen board" or "fashion board" that will put on local fashion shows.

Finding Jobs

If you have gotten the attention of casting directors, commercial or fashion photographers or other people who cast for advertising, they may call you when a job comes up that you are suited for. Maintaining the relationships (without being a pest) makes that likely to happen. But a lot of jobs will come from people you have never heard of.

Some are advertised in normal consumer media like newspapers (classified ads), although that is uncommon these days. More often the jobs will be found on specialized Internet sites.

Some opportunities are listed in the professional press (such as *Backstage*) or their websites (such as www.backstage.com). Others are listed in "online Yellow-pages" sites like Craig's List (www.craigslist.com) – which also contains a high percentage of worthless "jobs". There are also subscription websites that list casting notices for actors and models, although these tend not to be reliable and often just republish castings found from other sources. Those jobs also tend to be very low- or un-paid. Use of search engines such as Google (www.google.com) can likely locate a source of casting notices near you, if there is one.

In some cities such as Los Angeles and New York there are services which specialize in taking casting breakdowns and publishing them to agencies. Normally these contain excellent jobs (often the best jobs), but they are heavily oriented towards acting, and have relatively little print modeling work in them. Since the early 1970s the predominant such company has been Breakdown Services, which used to fax breakdowns to agencies. Now distribution is done on the Internet. You can find them at www.breakdownservices.com.

A little after the turn of the 21st century a different company, Casting Networks, Inc., took on a similar role in Los Angeles, and it has since expanded to New York and San Francisco. You can find them at www.lacasting.com, www.nycasting.com. Like Breakdown Services, the castings are heavily oriented towards acting and other entertainment fields, although there sometimes are print modeling jobs listed in them.

Breakdown Services has strictly limited distribution of their data to talent agencies and other organizations qualified to receive them, and often have controls put in place to make sure others who get the information are found out if they use it. It has been commonplace for actors and models to get under-the-table access to this kind of information, but there are penalties for getting caught disseminating it without authorization.

Casting Networks follows a somewhat different business model. They recognize, as Breakdown Services long has, that many clients and casting directors do not want to deal with the huge number of questionable responses they get from unrepresented models and actors. They allowed casting directors to limit distribution only to qualified agencies, to agencies and represented talent, or to general distribution. Breakdown Services has now set up a similar service: Actor's Access, at www.actorsaccess.com.

Both companies also offer actors (and to a small extent, models) an online listing service. These have the advantage over other online listing sites that casting directors and agencies are familiar with them, know how to use them, and they add legitimacy to the talent shown there.

There is a final source of jobs on the Internet: professionally-oriented modeling sites like www.models.com, www.onemodelplace.com and www.modelmayhem.com have forums where jobs can be posted by members. www.models.com also has general discussion forums that are read by agents and clients. Models who make positive, constructive contributions on the forum can sometimes be given work as a result; models who behave badly can find they lose jobs and representation. It's a resource that must be used judiciously.

Pricing Your Services

One of the hardest things a new, unrepresented model has to deal with is price. Someone is interested in hiring her. How much should she charge?

Agencies deal with this question every day, and even they have trouble with it. There isn't a clear-cut answer to what a job should pay in many cases. Here are some considerations used in determining what to ask for:

"Market Rates"

The "standard" rate for commercial modeling varies by city, but it can be expected to be anywhere from $100-$250 an hour for commercial print and fashion print work. In cities with only one real modeling agency

rates are normally higher than when there are several good agencies for a client to choose from. There may be an additional "bonus" for usage rights, depending on how the pictures will be used. The "bonus" often can be larger than the hourly rate for widely distributed consumer advertising.

Promotional modeling may pay $10-$30 an hour for unrepresented models. Artists modeling rates are similar. Children generally get half the adult rate for modeling.

A self-marketing model should know "standard" rates, but also recognize that if the client is deliberately seeking only unrepresented models for the project, it's very likely they don't intend to pay agency-standard rates. The "standard" may have to be cut in half or even less. On the other hand, if you are competing with agency models for the job, normal market rates apply, and it's unlikely that a client will hire you simply because you are cheaper than other applicants.

The Client

The single most important factor in what a job pays is who is paying for it. An international pharmaceutical company or high-profile cosmetics company is likely to pay "market rates" (or more). Frank's T-Shirt Shop isn't. If Mandy's Bridal Boutique wants to use a picture in a local magazine she may want to pay you $100, where a major manufacturer may pay thousands of dollars for a more widely distributed shot of you in their dress.

The Budget

Experienced clients on most commercial jobs have a rate they expect to pay. If you ask, they will tell you. Normally there is little negotiating room in that budget, unless you have an unusually strong bargaining position for some reason.

Advertising or Editorial?

Advertising pays more than editorial. "Editorial rates" are typically $100-$250 per day for large publications, and may be less or even zero for smaller ones. High prestige fashion magazines pay less than general interest magazines, because they assume a tearsheet from them is of great value to the model. For non-fashion models appearing in their editorials that may not be true, but their rates still won't change.

Experienced or Not?

Generally commercial print jobs pay a new model on her first professional shoot the same rate as the veteran of a hundred paid jobs. Small, inexperienced clients will use a model's inexperience as a bargaining chip, but the larger clients will not. Inexperienced models are less likely to win the job, but if you win it, you don't suffer in your paycheck.

Fashion jobs are different. Clients are accustomed to paying a model a sliding scale depending on experience and market acceptance. When starting out you are at the bottom of the scale. Even so, if you get picked up for a national campaign by a household name designer, you ought to make a very hefty paycheck even if you've never modeled before.

Exclusivity Clause

(Note: This is NOT the same as an exclusivity agreement between a model and a model agency.)

Some jobs require an "exclusivity clause" which keeps you from working for a competitive product for the period stated. These may be specific to a narrow product type ("ophthalmic pharmaceuticals") or quite broad ("office products"). Because these clauses keep you from making money advertising for any of those things, they pay very well. It's not unusual for a narrowly written exclusivity agreement to pay over $1,000 for a year, and a broadly worded one ("no pharmaceuticals") can pay $20,000 a year or more.

Should You Take a Low Paid or Unpaid Job?

It's tempting for new models to take any offered job regardless of pay. Modeling jobs offer experience, networking opportunities and tearsheets that are valuable later in your career. But:

1. Not all networking (or "exposure") is equal. Working with marginal players and one-time clients on jobs that pay little or nothing may do no good at all to raise your value to other clients, and may only "expose"

you to more opportunities for similar low- to no-paying work. Make sure the people you are dealing with actually have professional experience and standing.

2. <u>Not all tearsheets are good</u>. Jobs for Internet advertising, except possibly for major corporations, have no value as tearsheets. Small, cheesy ads for small, cheesy companies aren't something you would want to put on your card or in your book either. "Will this present me well?" is a question you need to ask yourself before accepting unpaid or low paid jobs.

3. <u>Conflicts</u>. If you take a job for one client you may disqualify yourself from working for a later client. Doing an ad for the local Mary Kay distributor could cost you a high-paying job with Revlon – but it probably won't if you are in Topeka. Consider likely conflicts before accepting work.

Getting Paid

A model without an agency has to do his own billing, bookkeeping and collections; he may not get paid for weeks or months after he does a job. He may ask that he get paid at the end of the job. But that puts a burden on the client that many may find unacceptable, and it could cost a model jobs. The model needs to use the documents and procedures that agencies use to get models paid. To do that he has to create forms such as a voucher (a sample is in the Appendix) and invoices.

Sometimes it's worse than that. If a client refuses to pay, the model has to collect. He doesn't have the clout that an agency does, and may not get the respect from an accounts payable department that a lawyer or agent would. At worst, that may mean the model has to learn skills like filing and pursuing a case in Small Claims court.

Although an agency may send models to jobs based solely on telephone calls, a self-marketing model would be wise to have everything <u>in writing</u> before the job begins:

1. What is the nature of the job?
2. Who is the client?
3. Where and when is he to report?
4. How long will the job last, and what happens (overtime?) if it goes beyond that?
5. What is the session fee?
6. What is the usage and duration, and what fee is being paid for it?
7. When is payment due?

If all of those things are in writing before a job, the model stands a good chance of being able to collect if things start to go wrong.

One thing a self-marketing model needs that an agency model does not: a fax machine to send and receive those documents.

What Agencies and Managers Are

Mother Agencies

The job of the "mother agent" (who might be a man or a corporation, and might be called a *"Personal Manager"*) is to prepare you for the market and introduce you to people who can get you work. A good Mother Agent will know how to evaluate your look against the types used in modeling and advise you on changes you need to make. He will have a stable of photographers who can shoot in the style you need and a printer who can make composite cards for you.

It is common for mother agencies to have relationships with agencies in larger markets, either in the US or overseas. They act as filters for these larger markets, finding, preparing and sending models that they believe are suitable for those markets.

The positives

A good mother agency can save you from paying for bad pictures and the trouble of going to agencies in a bigger city if you are not suitable; can prepare an effective composite and portfolio and give you experience to help you be successful in the larger market; can open doors for you when you arrive, so you are not just one more pretty face at an open call, and can arrange for support when you arrive at another city. Through all of this they offer experienced advice to help you deal with the problems you face. In addition, many of them can get you local work until you are ready to go on to the larger market.

The negatives

A mother agency gets a cut (typically 5% to 10%) of your earnings from the larger agencies. In times gone by it used to be that the mother agency commission didn't come out of your pay, but from the booking agency commission. Now mother agencies often take their cut from the model (or from both the model _and_ the booking agency). So why pay that money? It's a lot cheaper to get some pictures done, send them to agencies or go to open calls on your own.

Should you have a Mother Agency?

Here's when it makes sense, and when it doesn't:

If you are in a moderate sized market city, working with a booking agency there can also get you prepared for "the big city". If you are living in an area with a good _local_ mother agency that you can see routinely, who can take the months to develop you for a major market, and who can open doors for you, it makes sense. They are your safety net at home for when the big, bad booking agency in the big, bad city doesn't seem to be doing what you need, or you don't understand what is happening. Your mother agent knows you, knows the culture you came from, and can help you and your family understand what is happening.

When it _doesn't_ seem to make sense is when you are already living in the major market city or when the "mother agent" is far from you. In the first case, you can go to the open calls on your own, seek advice from the agencies you see, and use it to find photographers or other services you need. You don't need a mother agency; you just need to know where the booking agencies are and how to approach them.

In the second case, if you are hundreds or thousands of miles from the "mother agent" they can't do much more than you can do for yourself. Unless you are willing to move to where they are all they can do is give you generalized advice and "development". A mother agency _must_ have a long term relationship with the model, and know the model and her family very well - or there is little use in having one.

There is an exception: where the model and the "mother agency" are both in remote areas but the mother agent has good contacts, such as overseas, where the model might want to work. In this case the mother agent can help with understanding the demands of working in a different culture, and can smooth the legal and cultural difficulties.

There is an alternative to the advice role of a mother agency. Books on modeling have long been available, but they were incomplete resources at best that didn't always answer a model's questions. In the last few years the appearance of Internet forums devoted to mainstream modeling has greatly improved things. Now models can find a wealth of knowledge that used to be known only to the few, and can ask questions about the industry from

models, parents, makeup artists and agents who are actually in the business, all for free or nearly so. Users of the best of those forums should not find that a mother agency is necessary.

All of the above discussion has assumed we were talking about real, good mother agencies. Certainly there are many of them, but there are a lot more that are scams or simply useless. The worst of them also find other ways to make money at your expense: setting up photo shoots with "their photographers", putting you in models apartments at inflated prices and fees for various services. It can be difficult to tell the bad from the good, since many good agencies do similar-appearing things. But a little common sense goes a long way. Ask yourself some questions:

1. Does the mother agency really have an opportunity to work with me for a long time and really get to know me and my problems?

2. Does the mother agent have years of work in the industry in a major market?

In this time of ready access to information it's smart to ask, "Why do I need to pay for this?" when so much information and so many support services are available free to models.

Managers

The term "manager" can mean many things. At the beginning of a model's career "managers" are the same thing as "mother agents". As the career develops a manager may have very different roles: managers may handle the business affairs of a model, including collecting his fees, managing his investments, advising him on the course of his career, and developing the model in different aspects of modeling and performing, recommending and scheduling classes, getting pictures done, and dealing with the press. Sometimes "manager" and "publicist" become close to the same thing.

For the most part managers do not book work for models – that's done by agencies. Agencies tend to think of managers as nuisances or necessary evils; models may feel they need the manager to protect them from the Big Bad Agency. The relationships can be cooperative or quite confrontational. To an agent, that manager is best which is heard from least. Some agencies refuse to deal with models who have intrusive managers. If you feel the need for a manager, bear in mind that it could affect getting and keeping an agency.

Managers normally take a percentage of the earnings of the model (10-15% is common) on top of whatever the agency commission on fees is.

Agencies

"Agency" vs. "Model Management Company"

Throughout these pages we use the term "agent" in the common sense meaning. In New York City (and some other places) many "agencies" really are not agencies at all – they are "model management companies." In fact, none of the famous "model agencies" in New York are really agencies; there may not be *any* real model agencies in New York City (although there are many "talent agencies" which deal with actors and other performers, and some model management companies with "talent agency" divisions.)

There is a difference in what agencies and model management companies do, and in the way they are treated by law and by union contracts. Talent agencies have a fairly simple job: to find work for their models. They may find it useful to invest some effort in advising models on what to put into their books and other things a model needs to know, but that is not their primary function. By law in New York, or if franchised by a performers union, they are limited to a 10% commission on their models work.

Model management companies, by contrast, are responsible for managing all aspects of a model's career, and to provide a much wider range of services. In New York they typically charge a 20% commission from their models. In cities where model management companies act as booking agencies, it is not unusual for a model to have a "personal manager" who then deals with her "management companies" who act as both managers and booking agents. It's enough to make the head hurt with all the overlapping functions.

In this book we will not be precise about the terminology unless we are specifically discussing the differences between true agencies and booking management companies. In common language they are both "agencies" and we shall treat them that way.

What Agencies Do For Models

Getting Work for Models

Agencies make their primary income from commissions on modeling work. If they fail at that they can't pay the rent. They advertise themselves and their models, make and maintain relationships with people who hire models, find job opportunities, match models to the opportunities and send the models off to see people who have modeling jobs. Then the model wins the job or doesn't.

Advice

An agency will advise a model on the work he is suited for and how he can prepare for it. The agency will suggest haircuts and coloring, styling, grooming when needed, and may suggest photographers, health spas, hair salons, print shops and other support companies as needed. A model ignores the advice of his agent at his peril.

Model Sharing

No model agency can satisfy every possible client request. The fertile minds at advertising agencies come up with far too many unusual types for any model agency to have them all. So agencies have sharing agreements with other agencies. Acme Model Agency and Awning Supply Company may find that they don't have enough Chinese basketball players on their roster, and call up Wong's Model Agency and Noodle House (hey, the modeling business is tough - agencies may have to do something else on the side to stay afloat) for the models they need. Which is why a model signed to Wong's may get a call from her booker asking him to go to a go-see at the gym, but to sign in as an Acme model. In situations like that the agencies negotiate how they will split commissions, and the model should get exactly the same net pay as if Wong's had gotten the original casting call.

Sometimes those shared jobs can be from an agency in a distant city. It's not unusual for a New York agency to supply models to a small-city agency to meet a difficult request.

Logistic Support

Some agencies go far beyond providing advice and job leads. They may provide housing in "model's apartments," advance money to the model for airfare, pictures and portfolios or visa applications for foreign models. They may store a model's portfolios at the agency office and courier (or FEDEX) them to clients. They may also give a model his net pay (less advanced expenses) immediately after a job is completed, instead of waiting for the client to pay them. Any of these services might come at a price; fashion agencies typically mark up the cost of each of these and charge the model for them. At some agencies the model's apartments are a significant source of revenue.

Many people are under the misimpression that agencies always do these kinds of things for their models. In fact, they are relatively rare. An agency which has a non-exclusive relationship with its models may do none of them. An agency with exclusive contracts is more likely to provide some or all of those services, but still may not, or may do it very selectively. Models should not assume any of this kind of support will be made available to them. If you need it, ask about it and don't be surprised if the answer is no.

Financial Services

Agencies will also provide a range of financial support services: invoicing clients for work done, following up to assure payment, and even bringing a lawsuit if necessary to force a client to pay. They will also provide you with end-of-year tax forms like 1099s to show how much money you made through them.

Training for Models

Although many of the "craft of modeling" skills are acquired through experience on the job and in tests, sometimes a model does need training in a specific skill. Agencies may produce training aids, have in-house seminars or put models in touch with private tutors for things like runway and photographic modeling. Such training usually is at modest or no cost to the model.

Fashion agencies may also send models abroad to places like Milan and Paris for experience and to build their portfolios. The major European modeling markets have many more fashion magazines than does America, and it's often possible to jump start a career by spending a few months in Europe.

What Agencies Do for Clients

The simplest version is: they get models to them. It sounds simple and helpful, but not extraordinary. Clients should be able to do it for themselves, if they wished. Yes they can, but True stories:

Job One

A major national news magazine calls an agency on Tuesday afternoon. They want a model for their cover, but she had to actually be the kind of person they to write their cover story about. It wasn't the kind of model data the agency keeps, so they ended up calling 75 models to find out who qualified, and then had extensive conversations with each of the four candidates who got through the first screening. The client needed comp cards in her office Tuesday evening, and she got them by special courier. Later the agency found two models who hadn't made the cut in time for the courier run, and the client looked at them on the agency Internet site, but it was harder for them to be considered. She needed paper to take to the production meeting Wednesday morning.

Final selection was done right from the comp cards, based on those pictures and the conversations the client had with the agency. Thursday morning two of agency's models went in for a paid shoot. The following Monday one of them was on the cover of the magazine at a news-stand near you.

It's customary for agencies to charge clients a 20% service charge for models. When it's not explicitly stated at the beginning of a casting conversation, the agency will confirm it with the client, just to avoid surprises.

That happened in this case, and the agency got a nice response: "I'm happy to pay that fee; it saved me making all those phone calls. I like being able to pick up the phone and make one call and get what I need instead of having to find it myself."

More than that, there were three qualified backup models who were available for the shoot if something happened to their first choices. They were ready to get to the shoot in very short order if necessary, and the client knew it. It's part of what the 20% fee is all about. The agency made nearly 200 phone calls for that one job. They got paid a "premium price" for that service, and everyone involved was happy about it.

Please note the timeline in the story above - it's pretty common in the commercial print business. Clients don't have time to wait for hours or days for someone to return an email. They want an answer NOW for a shoot in a day or two.

Sophisticated clients understand that they are buying more than "a model" from an agency. They are buying service, guarantees, backup models and assistance in making the shoot come together. That's what they pay for, and it's what they expect to get.

Job 2

The agency had a website that showed their models to prospective clients. Between half and a third of their business came from the site, either because a client found it on his own and chose models he wanted to hire, or because the agency referred a client to the site as a step in picking models. In that way it almost sounds like an "Internet Agency", but it's not.

An international airline with its ad agency in Los Angeles wanted to do a photo shoot at JFK airport in New York. They didn't want to fly in models from Los Angeles. They wanted good, professional models at the shoot. New York models. So they researched New York agency Websites, decided on one, and through email indicated an interest in several of the agency's people.

The agency called the people they were interested in, determined their availability on the proposed shoot dates, and after the client had settled on the four models they wanted to hire, handled the logistic and administrative details with the models. Part of the conversation with the client was through email (which is better for passing on lists of data) and part through telephone calls (which is more immediate and better for negotiations). In no case did the client contact the models directly; that's the agency's job. They tell the agency what they want, and the agents do whatever work it takes to make sure it happens.

Getting a shoot permit for JFK isn't easy in these days of Homeland Security alerts, and the shoot time was tightly constrained. One of the things the agency did was make sure that there were backup models of similar type available on call in case there were any last-minute glitches (which tend to happen in New York). An alternate model could have made it to the shoot within half an hour if need be. In addition, the model agency was able to provide a good, print-qualified makeup artist for the shoot.

The shoot went overtime. Rather than have the models try to negotiate a rate for the extra time, a model called the agency, which called the home office of the ad agency, and the issue was worked out. That saved any problems and possible disruption, bad feelings or delay on the set if the models had tried to handle it themselves.

If the agency had said "Please look over our site and contact any of our models, and we won't charge the 20%" they would have never gotten that job. Clients are less interested in saving money than in reliably, easily getting what they need. Clients want the agency to do the preliminary work so the client can concentrate on what *they* need to be doing.

Even at the rates models get paid their fee is a very small part of the cost of an advertising campaign. Production costs are much higher, and the cost of media placement (TV time and magazine pages) usually dwarfs any money that is paid to models. That's not to say that budgets are insensitive to price, but clients are much more interested in speed, convenience and reliability than in saving a percentage of the model's fee. That's why model agencies are still in business, despite all the model resources on the Internet.

There is a different class of client, of course, who is very concerned about the cost of models, and who is willing to do the work of finding his own, and also willing to take the risk of no responses, no shows and no-ability-models. There are lots of those clients, and they don't use the agency system all that much. They use friends, employees, or models they find on the Internet.

Types of Agencies

In a market as large and diverse as New York or Los Angeles agencies tend to specialize. Either they service niche markets or they have divisions that specialize in markets segments. Most "commercial print agencies" for instance, do not do much fashion work, don't staff music videos or national TV ads, at least to any large degree. Other agencies or divisions do that – and the model (or model/performer) may need to be represented by more than one agency for different market segments.

Editorial Fashion Agencies

For this discussion we will use the term "fashion agency" to mean "editorial fashion agency". More "commercial" fashion agencies are closer to a "hybrid" agency (see below).

Fashion agencies specialize in runway modeling, fashion magazine editorials and fashion (including high-end beauty product) advertising. Despite the name "editorial" agency, no agency survives on editorial work, since it pays very little. The money is in the advertising "campaigns" mounted by designers and cosmetic companies.

Kinds and Numbers of Models

Give or take ethnic diversity, editorial fashion models are all of a particular type. Men are tall (6' or so), attractive, slim, with long legs. Women are tall (5'10" or so), very slim, with long legs and beautiful faces. There are very few exceptions. A fashion agency may represent from a couple of dozen to a hundred or so models.

Kind of Contract

Virtually all fashion agencies use exclusive contracts with their models. They may allow a model to freelance for a little while, as they assess her potential and market appeal. But for anyone they are serious about, they will insist on the contract.

Model Services

A major part of the job of a fashion agency is model development. They are accustomed to recruiting models with no suitable pictures, no experience, and no modeling skills. The agency will guide the model through all he needs to learn and acquire, and sometimes will advance the money to get those things. Models may spend weeks or months under the tutelage of their agency before they graduate to the "main board".

In addition to training, experience, grooming and pictures, the agency may also have to assist models with housing (in their own models' apartments) and with the logistics of getting around in their city.

Model Marketing

A vital part of marketing an editorial model is development to establish her as a recognizable face. The agency will send models on "rounds" where they meet people who hire models. These aren't casting call go-sees

for specific jobs; they are simply an opportunity to meet and become known to clients. Then when a job comes up, the client knows who they are and is more likely to hire them.

Volume of Work

In a fashion agency clients are looking for (very roughly) the same kinds of people for every job. The only distinction is "look" within the broad category of "fashion model". Every model on an agency's books (within the special criteria of race and sex) is at least nominally qualified for every job. Given the small number of models (comparatively) in their agency, and the high probability that they will be qualified for consideration for any job, they can expect to have a reasonably large number of castings to go to, and book work relatively frequently.

Where They Get Their Models

Fashion agencies are looking for great rarities, especially among female models. No more than one in ten thousand girls qualify, and the number is probably much lower. Even in a city like New York there aren't nearly enough highly qualified girls to meet demand. Naturally recruiting is a major part of their function.

Fashion agencies recruit worldwide. They have networking agreements with mother agencies. They attend model searches and conventions, and in some cases even hold their own high-profile model searches. They send scouts to South America, Europe and wherever they think they may find more models. When they find them, they sponsor work visas for the models so they can work in the United States.

They also hold open calls (although very few fashion models are found through open calls), and the largest of these agencies receive hundreds of mail and email submissions from aspiring models each day. Even with all that, the continuing demand for new faces in the fashion business, and the rapid turnover of models, keeps the agencies looking hard for new faces.

Commercial Print Agencies

Kinds and Numbers of Models

Take a look at the kinds of people portrayed in commercial advertising. It's a very wide variety. Pharmaceutical companies may want primarily people in their 40s, 50s and older. Soft drink companies may want early 20s. An upscale car company might want to portray upscale drivers in their late 30s, or young couples just starting out, depending on the car they are advertising. They may target any ethnic group, and so need models from that group. Ads tell a story in pictures, and the story may involve business people, Harley Davidson bikers, soccer moms or debutantes from any major ethnic group.

Commercial print agencies need models who look like all of those. It's worse: they can't have just one of each type; they have to have a selection for the client to choose from. To the degree possible they do just that. They may have several hundred (or more) models on their books. That leads to all the other kinds of behavior you see discussed below.

Kind of Contract

In New York City commercial print agencies do not sign their models to "exclusive" contracts. Print work is much less intensive than editorial fashion work: they know they cannot keep you busy. They also know that commercial clients tend to call more than one agency; that they get some calls but not all of them, and that it is usually in the best interests of the model to "freelance" – to work with more than one commercial print agency if they can. This can lead to some potential conflicts, so procedures (discussed in "How Modeling Jobs Work") have been agreed on to deal with this. Generally the agency would prefer that you not be listed with several others, but they also understand that it is a reasonable thing for you to do.

Model Development

Because a commercial print agency has non-exclusive contracts with its models it tends not to invest in model development. They prefer models who are experienced, ready to work, and have the marketing materials they need before they are represented by the agency. In that way they are different from fashion agencies.

The commercial print agency will rarely front expenses for a model. If the model needs pictures, he pays for them himself. A portfolio? Same. A place to live? The agency doesn't have a model's apartment, so he will have to find an apartment or hotel.

Model Marketing

The process of presenting models to clients is very different from fashion also. Where a fashion agency may send models around to their clients just to get them known, that is rarely-to-never done by a commercial print agency. Models are not individually recognized; they are commodities: "types". Commercial clients use a very wide variety of models, and they focus on the next task at hand. They have no interest in seeing models except for the job they are currently working on. As a result, the commercial print agency becomes a warehouse which stocks models of various types and dispatches them to clients only as the need arises.

There is little "pushing" of a model. If there is preferential treatment by commercial print agencies it is based on the relationship the agent has with the model. If they like him, he comes to mind first when a job opens up. If they don't, he may be sent on jobs only when there aren't a lot of better choices.

Models who are used to the way fashion agencies operate find this disappointing. They expect the kind of individual marketing and presentation to clients that they have received (or heard about) at other kinds of agencies. It takes a period of adjustment to become comfortable with the role of their new agency.

Volume of Work

Even if a commercial print agency gets double or triple the number of jobs per day as a major fashion agency, any given model is very unlikely to be sent out on jobs as often as a fashion model might. "Construction worker" types aren't what gets sent on "Wall Street Businessman" jobs; 40s Business Women types don't get sent on beer ads looking for glamorous models. No model is qualified for more than about 5% of the work the commercial agency casts for. As a result, commercial print models usually treat modeling as an avocation or second job while doing something else to pay the rent. A small percentage in the heart of the market can make a full-time living at it.

Where They Get Their Models

The combination of non-exclusive contracts and intermittent nature of the work make it very inadvisable for anyone to relocate just to be a model with one commercial print agency. The agencies know it, and commercial print agencies recruit their models almost exclusively from their own city (or within an hour or so drive of it), hence the reason why they do not have models' apartments. Most do not hold open calls, and rely on mail-in submissions from applicants. When commercial print agencies go to model searches or conventions they are looking for a model who is already living in their city, or planning to move there for other reasons.

Hybrid Agencies

Editorial Fashion and Commercial Print agencies represent polar extremes of their type. Most agencies are a blend of the two types, and even within large markets the specialization isn't as rigid as has been presented.

In the smaller markets most real model agencies service the entire range of modeling. The market doesn't allow as much specialization; the overhead of an agency means they have to try to book every kind of modeling job they can. Even so, the heavy focus by most regional and local advertisers on clothing ads (or ads where people "look like models") means that the local agencies will likely focus more on "fashion model" types, albeit a more "mainstream" look than you might see in the New York fashion market.

Hybrid agencies may adopt some of the business practices of both editorial fashion and commercial print agencies, depending on their focus, the amount of work they have available, and how much competition they face in the area. In smaller cities most hybrid agencies also have ties to fashion agencies in larger markets or overseas, and act as mother agencies for their fashion-qualified models.

Promotional Agencies

Promotional agencies operate very differently. In other modeling the client hires and pays the model; the agency just serves an accounting and administrative function in passing on the money. Promotional agencies may be the employer of the models, and provide temporary staffing to events as needed from their group of models. Their relationship to the models tends to be more perfunctory than other model agencies, more like the way any other temporary employment service operates.

For such agencies models may not be on a commission basis. The hourly or daily rate the agency quotes the model is what he gets. The agency makes its money by contracting for a services at whatever rate they can negotiate for, and then sending the model on the job at whatever rate they can get her to take. It's not at all

uncommon for a job to be quoted to the model at half of the hourly rate the client is charged. Also because they are the employer, they may not be subject to regulation by state and local authorities as an "employment agency".

In-House Talent Agencies

In places like New York City, where "model agencies" aren't really agencies (they are management companies), there are some jobs that must be booked through a licensed and/or union franchised agency. Smaller booking management companies may "fee split" with a franchised talent agency, which actually books the work for the model. Some of the larger model management companies have their own "in house" agency. Formally it is separate, but it exists to service the booking needs of their host model management company. This practice is much less common in recent years, ever since the agent's associations broke the union contract requirements. Now non-franchised agencies in many areas can book talent into union jobs.

Almost-Agencies

A small agency needs to book tens of thousands of dollars in modeling work every month just to pay the rent and employees. In lots of cities that level of work simply doesn't exist. Remember Acme and Wong's, above? Those fictional model agencies were in small market cities where there isn't enough modeling work for a company to survive on commissions alone. So what to do?

A very common choice is to get income from some other source. Unlike Acme and Wong's, who chose side businesses unrelated to modeling, many agencies provide model-related services for a fee. They may offer classes, photo shoots, comp card printing, attendance at model conventions (they get a hefty commission on your attendance fee) or any of a wide variety of ways that entrepreneurs around the world have found to separate models from their money.

The very best of these will offer good quality services that actually benefit the models. Others will simply go through the motions and provide poor services at inflated prices. They are hoping the models (and their parents) can't tell the difference. Most of the time they are right.

In situations like that it's very unlikely that you will ever make enough money modeling to pay for all the services such an agency sells. The choices usually come down to: this is the only game in town (or all the other games are the same). If you want to be a model that badly, it's the game you play. But your chances of making money from it are remote.

There are hundreds of such "almost agencies" around the country. If you find one, go into it with your eyes open; recognize that you are being asked to pay for the privilege of being a model.

Getting Agency Representation

It is common sense to take a method and try it, if it fails, admit it frankly and try another. But above all, try something. -- Teddy Roosevelt

Selecting an Agency

The first thing you have to do is decide who to apply to. So how do you choose?

Location

This is one of the most critical factors, and yet it rarely given enough weight by models. If you are an *editorial fashion model* type, you need to be where editorial models are used: New York, or one of the major modeling cities overseas. The path to an agency in New York may pass through a "mother agency" local to you, but that's the ultimate destination. You are going to have to move.

If you are a *commercial fashion model*, it's best to be in one of the cities where a substantial amount of catalog-style work is done: New York, Chicago, Los Angeles, Miami, Dallas, Phoenix, Atlanta, Boston and a few other cities. Commercial fashion models also can get work, although at lower levels, in local agencies in a substantial city near where they live. It may not be advisable to relocate to be a commercial fashion model.

Commercial print, *glamour* and *promotional* models generally should not consider relocating to model. They should apply only to an agency near them. *Fitness models* may have to relocate, although the market for fitness is small enough that it is often not worth the investment in relocation.

Assess Yourself

Are you suitable as an editorial fashion model? Then that's the kind of agency you should seek. A "young mom" or "businessman" type? Then apply to commercial print agencies. If you are a perfect "businesswoman" type and apply to a fashion agency, they will not respond. If you are a perfect editorial fashion model, a commercial print agency will know (and you should) that they are not going to be able to do the best job of marketing you. A local "hybrid" agency may be able to deal with any kind of model, and if there is a good one near you, that's a good starting place, no matter what type of model you are.

SAG/AFTRA Affiliation

Often you hear that you should seek SAG- or AFTRA-franchised agencies. That's not always true.

A union-franchised agency is likely to be real agency, and not engage in some of the abusive practices that so many "agencies" do. The unions have strict rules about those kinds of things, and the agency franchise agreement prohibits them. Still, the unions don't enforce those rules on non-union jobs, and print modeling is always non-union. There are plenty of instances of SAG-franchised agencies which play by SAG rules for actors in SAG productions, but by a different set of rules entirely for models. There are SAG-franchised agencies which also run modeling schools and portfolio mills for models. You can't rely on SAG or AFTRA affiliation to protect you.

However, in major cities the best modeling agencies usually are not union franchised. They make their money from getting work for models, not actors, and living under the union rules would be a burden that they don't want. If you look for an agency based on union affiliation you may be passing up the best agency in your area. Also, in many states there are no union-franchised agencies.

References

Other Models

Do you know other models who have worked with the agency? What do they have to say about it? These references are a little unreliable, since any given person can have an experience that doesn't represent the norm. But still, seeking such advice is useful.

Reference Sources

There are a number of published reference sources that list good agencies. *The Black Book* and *Le Book* are two excellent ones. Other sources are more inclusive but do not quality-check the agencies they list. If you

find local affiliates of known modeling school franchises in a list, for instance, you should use the book to identify and locate agencies, but not as a guide to quality. There are also lists of agencies on the Internet, at a number of sites. An extensive one is at www.modelnetwork.com. Except for the list on www.models.com none of these lists make much of an attempt to validate agencies, but that list is quite incomplete.

Self Reporting

You can't rely on what an agency says about itself. Some are so good and well known that they don't have to brag or inflate their credentials. Some are relatively unknown but good nonetheless. (Commercial agencies are all virtually unknown outside the industry.) Usually the more an agency puffs up its own importance, the less good it is. Good ones let their reputations speak for themselves. Hype is a bad sign.

You should also pay little attention to famous name models that the agency claims to have discovered or represented. When those things happen it's largely a matter of luck, and it's likely that for every big name model there are a several agencies and managers who claim to have made her career.

The Yellow Pages

If you see an agency with a big ad in the yellow pages, or advertising its open calls or model searches in the newspaper or on websites like www.craigslist.com it's very likely to be a scam. Real agencies rarely do that.

Agency Web Sites

These days most model agencies have websites. Agencies which are focused on getting work for models will have a site which helps clients find and book models. It will list the physical address of the agency, telephone and fax numbers. It may show its models openly or require registration for qualified clients to see them. While it may discuss how a model can apply to be part of the agency, model searches and recruiting should be a very small part of the total presentation. A site which focuses on recruiting is a sign the agency likely makes its money from aspiring models, not from booking work.

Applying to a Modeling Agency

Go see them:

If the agency has open calls, or allows models to personally drop off pictures, or you can get an appointment, do that if possible. Pictures are good, but seeing you in person is better. There are lots of examples of people who would have been turned down from their pictures, but who were accepted when somebody actually laid eyes on them in person. When you go to see them, wear form-fitting clothes that let the agency get a sense of your body proportions. Dress "upscale casual" if possible. This is a job interview, and you don't want to make a bad impression. Wear normal daytime makeup or, for fashion agencies, less makeup than that.

Send them an application:

If the agency does not accept walk-ins, don't do it. It's annoying, and nobody wants to start off that way. If you must, send in an application.

Most agencies have a "Christmas File". That's a private file that they put the truly awful pictures into. Pictures that are sent by people who want to be accepted as models. Some are so bad that they are good for a chuckle, or even a hearty belly laugh, and what better time to break them out than the holidays.

Then there is the "round file": the trash can. The great majority of all submissions end up there. A lot of people would be consigned to the trash no matter what they did, but some of them don't have to be. It's possible to give yourself a fighting chance. If you don't want to end up in one of those files, pay attention. Here's what people do wrong, and what you should do right.

What Should Be in the Application:

1. *Keep it simple*. The agency wants to know what you look like, what your height and stats (for women, bust/waist/hips, for men, suit jacket, inseam and waist size) and location and age are. You should include eye color, hair color, dress and shoe size as well, since they may help. If you are currently represented by a real, booking agency somewhere, say so.

2. *If you have extensive professional modeling or acting experience, say so.* Very briefly. If the basics interest them, they may want to know a lot more about you. But they will ask. Don't force it on them at the beginning. It simply wastes their time and yours, and you may include things that will hurt you, not help. They do NOT want to know that you have dreamed of being a model your whole life, that you were third runner up in a local beauty pageant, or which high school plays you were in. They aren't interested in how many callbacks you received at some model convention. Do not tell them you are a graduate of modeling school. They also don't want to know about all the websites you appear on, and don't care that some "model exposure" site showcased a picture of you.

3. *Include contact information.* At a minimum, your telephone number. If you want to also include your address and email address you can.

4. *Don't ask them to contact someone else about you.* They want to talk to you (or, if you are a minor, your parents). The worst thing you can do is say "for further information please call my other agent at"

5. If you are not a citizen of the country you are applying to, explain what your visa status is. You must have the legal right to work, and the agency needs to know if you do, or if it's a problem that needs to be taken care of.

6. If you don't live near the agency, explain what your plan is, briefly. Sooner or later you are going to have to go see them. Tell them about that. *If you don't plan to move, don't bother sending an application.*

7. *Include the right kind of pictures.* Nobody wants to see pictures you happened to have lying around of your vacation, your prom, or snapshots of you and your friends at a bar. Make it look like you at least tried to send something specifically tailored for this purpose. If that means getting a disposable camera and taking a trip to the drug store, do it.

Pictures

The best possible pictures to send are tearsheets of you in prestigious, paid modeling work of the kind the agency does. Shots from Vogue or a national ad campaign beat snapshots every time. But most of you won't have those. If you don't, call and ask the agency what they prefer. Some (mostly fashion agencies) will want only simple Polaroid-style snapshots. Others (primarily commercial agencies) would prefer well-developed composite cards or similar professional pictures. Still, paying lots of money for those professional pictures may not be a good investment. It's wise to try an inexpensive approach first. *Only after that hasn't worked and you are still determined to pursue modeling should you invest in professional pictures.*

Many aspiring models know what an agency's stated preference for pictures is, but decide to go ahead and get a portfolio anyway. That can hurt a model's chances, not help. Here's why: "Pictures better than snapshots" have to be excellent professional images of the sort the agency uses. If they are the wrong style for his market, they fail may make you look like the wrong kind of model who cannot be what he needs models to be. The classic dichotomy is "fashion" vs. "commercial". If a model walks into an editorial agency with a bunch of excellent commercial style pictures, she will be immediately categorized as "too commercial" and rejected. If she walks into a commercial agency with excellent editorial fashion pictures she may well be told she is "too editorial" and rejected. The style of picture defines what you are, unless it is clearly a snapshot.

There is another problem. If you submit snapshots it will be evident that you are not an experienced model. That's not good, but it's not a fatal flaw. If you submit "professional pictures" and try to look experienced, and the pictures are bad, it says to them that you aren't a person who can attract real paying jobs. Most "professional portfolio pictures" are bad. Snapshots are better. No matter whether you use snapshots or professional pictures, keep them to a minimum (three is a good number) and be selective in what you sent. *You are only as good as your worst shot!*

How to Submit Your Application:

Send them a mail application:

The best thing to do is send a postal application. It should include pictures and the information described above. If you want the pictures back, include a stamped, self-addressed envelope. Make sure you write your name, contact information and stats on the back of every picture.

Email:

Before you send an agency email, check with them by phone, or on their website. Very few agencies prefer email, although these days many will accept it. Some will not. Most would rather get pictures and stats in regular postal mail. Here's why:

1. <u>Many models don't know how to send an effective email</u>. They send pictures in formats the agency can't read, they send pictures that are so large they clog the system and won't fit on the screen. They send pictures so small nobody could tell what the model looks like. They send pictures only, with no contact information except a return email address. (Yes, that's a problem. Agencies want to know where you are.) They send emails with no pictures and request the agency email for them if interested (fat chance!).

People with AOL send pictures as attachments. AOL won't let you send pictures to non-AOL subscribers as attachments, so the email arrives with text only.

Or they do things like say, "I've been hearing wonderful things about your agency and would love to work with you." Then the message header shows that it was sent to 47 agencies around the world, including four well-known scams.

Or they have the message enclosed in another message, sometimes three or four layers deep. After clicking on all those other emails to get to the message, the pictures had better be wonderful.

Or they ask the agency to go to some goofy site with six popup ads per page, and the agent has to wade through pages of pictures of the model's boyfriend, puppy and prom night, plus read all about her favorite foods, her best friends and the poetry she likes to write. Somewhere on the site there might actually be pictures of the model and her stats, but it takes time to find it. Long before that happens the agent is on to the next email.

2. <u>Agencies get lots of spam and viruses</u>. Agency email addresses are harvested by spammers and show up in lots of people's computers, so it's not unusual for an agency to get hundreds of spam messages, and several to hundreds of viruses every day in their email. They don't want to pay someone to go through all that, so they use automated virus and spam filters to get rid of most of their email. Lots of model submissions look like spam, and are deleted before they are ever read. Some of them with attachments are treated as viruses. Nobody wants to open attachments from someone they don't know.

3. <u>Email inboxes get clogged</u>. Agencies get so many submissions (and spam, and viruses) that their inbox can get full and they may never see your email.

4. <u>It's harder to file your submission and show it to other people</u>. No, it's not impossible. But pieces of paper are easier to deal with. They fit in file folders that can be passed around. Yellow stickies can be added to them. For all the talk of the "paperless office", paper is still easier to deal with. You don't want to make it harder.

Except when time is critical and somebody at the agency is expecting something from you, it is almost never the best idea to send email. Use the post office.

<u>If you absolutely have to use email, do it right</u>:

1. Include pictures embedded in the body of the message, or by hyperlink. The link should be to the pictures themselves, not to some website that the pictures are on.

2. Make sure the pictures are the right size and format. They should be 450-600 pixels high, and in JPEG format <u>only</u>. Do not ZIP or STUFF anything. Do not embed it in some other document like a word processing document or .pdf file. If you don't know what any of this means, or how to do it, find someone who does, or don't send email!

3. Send an email to each agency individually. It's not that hard. Nobody likes to get an email submission that is sent to everyone else he knows and some he doesn't want to know.

4. If you feel you absolutely have to send the agency a link to your website, make sure it is the same as what your submission should be: simple and to the point. Don't make anyone wade through extraneous information or click on lots of pages to find what they need. Put it on the first page. Put nothing else on that page.

<u>Telephone:</u>

For the most part, the telephone is for asking questions. You can use it to find out if the agency has open calls, how to send submissions, what they want to see, what their requirements are. You might be able to make an appointment to come in to see them, but at most agencies you won't be able to.

Call during business hours. Every agency gets calls from aspiring models who leave messages at odd times of the night, usually asking for a return call. They get ignored. If you can't call the agency when it is open for business, you can't be a model.

Call for yourself! (Or, if you are very young, have your parents call for you.) If you have your cousin, some "manager" nobody has ever heard of or, worse, your boyfriend call for you, you are already at a serious disadvantage. The agency wants to know why you aren't calling for yourself (are you not able to? Are you not interested enough?) and if they have to deal with some meddlesome intermediary in working with you. Don't give them that impression.

What Happens Next?

Nobody will contact you unless they are interested in you. Within minutes after they look at your application they will have forgotten it unless they are interested. Usually if you call and ask if they have gotten it, they won't know. Nobody logs and tracks those things. There are too many of them to remember or keep track of.

If you don't get a response within a couple of weeks you probably aren't going to. At that point you can think about trying again, but by doing something differently: get different pictures or go see them instead of just making a mail submission. If after all that you still aren't getting a response, it's probably time to forget that agency.

At the Agency

You're in the door. Now your visit needs to be treated like a job interview, but with some additional considerations.

Dress

You should wear something upscale and flattering that generally shows the shape of your body. You need to show the agency that you can present yourself well on go-sees. Women should wear a skirt (from knee length to a couple of inches above the knee) and high heeled shoes. Do what models do: wear flats to the door of the agency, take your heels out of your purse, put them on, and put the flats into the purse. Then walk in.

Personality

Agencies want to see outgoing, confident, engaging personalities. You need to portray reliability, commitment to modeling, and willingness to take direction as well. If a young model brings a parent, the parent should sit quietly and let the model speak. The agency wants to see how well *you* present yourself, not how well your mother can. Parents can respond when spoken to, or ask questions when necessary, but this is about the model, not the parent. Less is more.

Availability

One of the primary concerns of the agency will be, "Can you get to castings and jobs when you need to?" If you already live in their city and have a very flexible job (or night job) that may not be an issue. But be prepared to tell them how you will relocate, if necessary, and arrange your time so you can be available during the business day.

Things *Not* to Do

It's not hard to turn "yes" into "no" if you don't handle yourself well. Here are some common mistakes models make with their letter or visit to an agency:

1. Be late. That's the surest way to get on the agency's bad side. They sell reliability as much as they sell models, and you just told them you aren't reliable.

2. Come to the appointment looking very different from your photos. They asked you in for what you looked like when the shots were taken. If you've gained age or weight, or cut or colored your hair differently, you should have sent in different pictures.

3. <u>List all the things you *don't* want to be</u>. "I just want to be hired to be me. I don't want to lose weight, cut my hair, wear clothes I don't like" Models are hired to be what the client wants them to be. If you can't accept that, you should consider another line of work.

4. <u>Make an appointment to come to an agency, then reschedule</u> it three times because you are too busy. You have just made it look like you aren't available to be a model, or don't place modeling high in your priorities. Agencies don't like that.

5. <u>Take your boyfriend with you</u> and have him hang out in the agency. If you aren't a minor, you should come alone to the agency. If you need advice or support, you get it after the interview, somewhere else. If you are a minor, you should bring a parent along early in the conversation, if not the first interview.

6. Come to an agency door without an appointment, be told you need one, and insist on coming in anyway.

7. <u>Have inappropriate pictures in your portfolio</u>. Agents will look at the whole thing. If you have anything but excellent pictures, appropriate to that agency in your book, get it out.

8. <u>The "L word"</u>. If an agency offers you a contract, it's fine to take it home and have a lawyer look it over. If you aren't comfortable reading contract language, it's a good idea. But don't tell the agency you plan to involve your lawyer. That makes you sound like a problem. If they are wavering about you, that can turn the tide.

9. <u>Argue with the agent</u>. Make sure to tell him that the fashion industry is making a mistake and really needs people like you instead of what they typically hire. He's heard that one 7,000 times already, and it has never worked.

Non-Traditional Approaches

If traditional approaches don't work it may be time for a different tack. Here are three time-tested ways to make a favorable impression on an agency.

Bring Work

Have you been self-marketing? Had a job offer? If it's a reasonably good job, call up an agency you are interested in (and qualified for) and ask them to handle it for you. Many agencies are happy to do that. By showing you can bring them work, you become more valuable in their eyes. If you fit the profile of their models, they may well decide to regularly represent you, even if they rejected you in the past.

It can be a win-win. They make money on a job they otherwise wouldn't have and may build a relationship with a new client. You may have to pay a commission, but some agencies will waive commission on a job you bring them if they can charge the client an agency service charge. Even if you do have to pay a commission, the agency may be able to negotiate a higher rate for the job, and they will handle the billing and collection problem for you.

Intern

Model agencies love free labor. Many of them have formal internships available, and others will informally let people help out in the office for free. Call them up, offer to come in for an interview and donate your services. If you work with them and they like you, they may send you out on castings that you are qualified for and you are more likely to get representation. Or you may get an offer for a paid office job with the agency.

Become a Celebrity

Having trouble being noticed as a model? Get known as an actor, a singer or anything else that brings you into the public eye. Fame is saleable in commercial work, and it's common for advertisers and editors to use known faces rather than unknown models in ads and editorials.

Exclusive or Non-Exclusive?

If you get interest from a modeling agency you may have to deal with the question, "Should I sign an exclusive contract?" Some agencies (fashion agencies, mother agencies and others who think they can get away

with it) will ask you to sign an "exclusive" with them. That means you can only work with their agency (or one they send you to). Any work you get, no matter how you get it, they get a commission.

It's easy to see why they want it. They don't want to have to compete for your services, nor spend time and effort developing you as a model only to see you go to some other agency to get work. If they make a large investment in you, it's they want to have a chance to get a return on the investment. On the other hand, if they aren't offering anything you can't do for yourself, you may be signing away your rights and a portion of your income for not much of value.

Some agencies offer non-exclusive contracts: you are free to work with other agencies or on your own with no commission to them. That seems like a better deal for the model, and in many cases it is. Still, agencies are like anyone else: if you give them a bigger incentive to work for you, they are likely to do more work. Non-exclusive agencies are much less likely to devote a lot of resources to developing or supporting models.

An exclusive contract with an agency make sense:

- If you really are confused about how to enter the marketplace, and can't get what you need from reference sources like this book or advice from Internet modeling support sites, you may need a personal manager or mother agent.

- If you don't have the resources to fund your modeling career and an agency offers to front you the money, an exclusive with them may be your only realistic choice.

- If you are not authorized to work in the United States and an agency offers to sponsor your work visa, they probably will expect you to sign an exclusive.

- If you want to work overseas, you should have an exclusive contract with a domestic agency which has strong relationships with foreign agencies.

- If the agency has a strong and unique position in the market, you may consider signing an exclusive with them even when it's not customary in that market segment. An example would be the Commercial Print division of Ford, New York, which operates much differently than specialized commercial print agencies do.

- If it's the only good agency in town (or the only one willing to work with you after you have applied to many), they require an exclusive, and you want to be a model there. You don't have much choice.

- If they are widely known for the power of their marketing. This especially applies to the top fashion agencies. If IMG offers you an exclusive contract, you don't argue about whether or not you want to be with them on a non-exclusive basis.

- If it's the standard for agencies of that type in your city. But confirm that with other similar agencies before you make that choice.

Even when the agency prefers an exclusive contract, many of them will allow you to work with them on a non-exclusive basis (to "freelance"), at least at the beginning. That can be a wise choice; it allows you to get experience with the agency and its clients before you have to make a long-term commitment to them.

There are times when an exclusive contract will be offered when it is **not** a good idea:

- A "personal manager" with little real experience in the industry offers to "develop you" and present you to agencies. If they don't have years of experience actually working in agencies as bookers, they are likely not going to be effective. Even if they do have the experience, do you really need them?

- Any "agency" or "manager" that operates primarily on the Internet. They rarely have much mainstream value and can keep you from being signed by a good agency.

- A real agency that tries to get you to sign an exclusive even though the norms of his market segment are non-exclusive. An example would be a commercial print agency in New York. Some of them claim they will give preferential treatment to the models that are exclusively with them. The truth is, if you are right for a job, they'll send you on it no matter what kind of contract you have with them. If you sign an exclusive you are limiting your ability to get work from other agencies.

- When the "agency" is a modeling school.

- When the "agency" is in some city a long way from you, doesn't have an office where you live, and they aren't a nationally known fashion agency. You probably shouldn't sign any kind of contract with them, but certainly not an exclusive one.

When It Doesn't Work

It is possible to commit no mistakes and still lose. That is not a weakness; that is life.
-- Jean Luc Picard

You get the right kind of pictures, write a good letter, wangle yourself an invitation to the agency of your choice . . . and they turn you down. You build a portfolio and a comp card and they still turn you down. After six weeks of interning they still have never sent you out on a go-see. It's time to do something different. What to do?

Re-Evaluate What You Are

Yes, we know you want to be an editorial fashion model. Everybody does. But very, very few can do it, and thousands try every year. Maybe it's time to consider fashion print or commercial print modeling. Already tried commercial print? Maybe instead of the glamorous babe type you ought to consider a comp card portraying you as a soccer mom or business woman. If you don't have the finely chiseled features of a matinee idol, you might even consider the field of character modeling. It's far less crowded, pays just as well, and you get the most amazingly interesting kinds of work.

Change Your Appearance

Get a new hairstyle, new clothing styles, gain or lose weight, join a gym and tone up, buy a set of contacts and lose the glasses. In extreme cases, try minor cosmetic surgery to correct a nose or other small imperfection that may keep you from working.

Get New Pictures

This is the time to try the full portfolio and comp card approach, with your new look, in the market niche you really fit, and with the best photographers you can get. The shots have to be absolutely outstanding and perfectly crafted to the style agencies want to see for your type. You want to turn a "no" into a "yes". This is not the time for half way measures.

Try Different Agencies

It may be that your city contains several good, real agencies with different focuses. In New York there are well over a hundred model agencies with all kinds of specialties, from editorial fashion to fitness, commercial print, glamour, jewelry modeling, character types and pregnant models. It's just a matter of finding the one that specializes in people like you. Look at agency websites, read news articles about them, call up and ask if you can't find enough information. The best agency for you is one that already represents models like you.

Try a Different Market

You're the edgy, beautiful-but-not-pretty type? What are you doing in Omaha. Get to New York! Cheerleader type or surfer dude? Try Los Angeles. Move to a smaller market with less competition or a larger one with more diversity of opportunity.

Self Market

If you aren't already doing it, put yourself out there on your own. Get some experience and tearsheets, learn the ropes, and come back with a book that knocks a booker's socks off. Nothing is more attractive than a model with proven success.

Try Another Line of Work

You might try one of the fields related to modeling and use it to come to the attention of someone who hires models. Act, be a makeup artist or stylist, assist a commercial photographer or go to work in an advertising agency.

If none of this works for you after you've really given it your best, it might be time to listen to your mother's advice and become a dentist.

You Got an Agency! Now What?

Models often feel like the holy grail of their efforts is getting an agency. Not true! It's when you have an agency that the going gets tough. They will have you do all the things necessary to prepare you for the market, and then send you out to compete. *Actually getting jobs is up to you.* Here's some of what you can expect:

Location

You will probably have to go to where they are. At the beginning you may need to be there only for a few weeks for development, but ultimately you will have to move to where they are before you get very much work. They may also send you to other markets (such as Milan or Paris) to accelerate your development. They may or may not offer to advance the costs of your moves – be sure to ask.

Development

Fashion Agencies

The Life Cycle of an Editorial Fashion Model Career

Fashion clients respond to two primary cues in selecting models: (a) youth, freshness, newness, and (b) experience and market acceptance, as demonstrated by a model's appearance in fashion editorials and other high-end fashion advertising campaigns. These two cues are somewhat contradictory, but never mind that: it's fashion.

When "freshness" dominates the mind of the client, a model may be picked for a job right off Polaroids shot that very day by her agency. But more commonly fashion clients "follow the herd". If they see a portfolio full of tear sheets they draw two conclusions: she is a good, reliable model that can get the job done, and others have liked her look well enough to select her. Clients like to see their judgment validated by others. If a model has enough appearances she transitions to a "known face" or, better, a "known name" whose image is of special value.

The rates for fashion models (for "campaigns", but not for editorials or most "commercial fashion") depend on her market acceptance. More editorials equals not only a higher chance of being selected, but of being paid more when selected. Rates are set on an individual basis after the "new faces" period is over.

At the beginning of her career a fashion model spends her time building market acceptance. She does low-paying editorials for months, perhaps for years, until she becomes "known". Then one day a client calls up and instead of saying, "Send me some fashion models for a go-see," they say "I want Mabel for this job". She has begun to arrive, and the investment in her career up to that point may now reward her with big pay days.

But no matter how long she models, she will continue to do those low-paying editorials to keep her face in the public (and clients') eye. When the world forgets about you there is always another fresher face on her way up to take your place.

The Process

Unless you come to the agency as an experienced model with a lot of professional work behind you, a fashion agency will almost certainly ask you to get new pictures. They may also suggest a new hair color or cut, wardrobe that you need, or exercise and diet to slim and tone your body, and will have you visit a manicurist. They might even send you to another country for experience and to build your book. The agency may send you on "rounds" so clients can get to know you. Depending on the agency, the "development" process can take a small number of weeks to several months. Models should assume that during this period they will make little if any money and they may have substantial expenses. If a model gets a positive response from clients on go-sees, books some editorials or good commercial jobs, she may be at the beginning of a long career.

Commercial Agencies

For this purpose "commercial fashion" and "commercial print" models are somewhat similar.

Life Cycle of a Commercial Model's Career

For commercial models pay doesn't depend on experience or "market acceptance", but simply whatever the budget is for that job. (That is not true for "skilled" jobs like fit modeling, where experienced models can get

higher rates.) From the moment you become "fully qualified" (right after you print your first comp card) until the end of your career, you compete on a more-or-less even footing with your peers. Commercial models do not become household names; there is no value associated with the perceived "endorsement" by an unknown model. You remain someone playing a generic role, and new models can enter at any stage of their lives.

Certainly it is true that a better portfolio and a composite card full of excellent commercial tears make you more likely to get the job, but the effect is nowhere near as powerful as it is in the fashion world.

The Process

If a model comes to a commercial agency with well done commercial pictures and a composite card, the agency may decide to use what he already has, or simply get a new card printed with the agency's format and logo. That is particularly true for agencies that have non-exclusive contracts with their models.

The agency may decide to have the model modify his appearance (new haircut, gain or lose weight, tone his body) and get new pictures before deciding to place him on the market. This is a relatively quick process, and normally can be completed in a small number of weeks.

Once the new card (and portfolio, if the agency requires one) is ready, the model will be sent on go-sees. But this is a distinctly different process than for fashion models. Rather than being sent around to "commercial clients" for a response, models are just sent out when a client has a specific job that they may be right for.

An editorial fashion model may have a very close relationship with her agency, and visit them daily or weekly. A commercial model may make no more than a few trips to the agency over a career spanning several years. The agency is likely to be consulted only when a new card is needed, or changes in appearance are contemplated.

Self Marketing

It's the job of the agency to market you, but you shouldn't just leave it to them. You should network with photographers, clients, casting directors, makeup artists and stylists whenever the opportunity arises. At clubs, parties, trade shows and on modeling jobs, you need to take any opportunity presented to increase your circle of contacts.

Other Agencies

If you have a non-exclusive contract you should pursue representation from other agencies. No agency gets every modeling job, and the more eyes you have looking out for you the better. It is possible to overdo this; agencies can lose interest in you if you are almost always unavailable to them because other agencies have called you first. You need to find a balance of the right kind and number of agencies, and the right number usually isn't "one".

Sometimes a model may find that they can be exclusive for "fashion" with one agency and work with "commercial" with another. It's a very useful income supplement. Even models on an exclusive modeling contract may find that their agency allows them to pursue non-modeling work like TV commercials through other agencies. You should consider being listed with talent agencies.

Other Pursuits

The old joke is, "Oh, you're a model? Which restaurant?"

If you are an editorial fashion model you may not have time for another job, but most models find that they need to have some source of income just to keep afloat. Waiter, bartender, real estate agent, personal trainer, dog walker and similar jobs let a model put food on the table until their modeling career gets established. For many commercial print models, modeling is the *other* thing they do while they live otherwise normal lives.

How to Lose Representation and Jobs

Here's a list of things models have actually done (some of them quite often). ***These things can keep you from working if you have an agency, or can cause you to lose representation:***

1. Accept a booking from two different agencies at the same time, betting that one of them will be cancelled. Or accept a booking and then back out when something better comes along. If you aren't in Intensive Care, you do the jobs you booked.

2. File an unemployment claim listing your agency as your last employer. That raises his unemployment compensation rates he pays on his employees, and really lowers his mood.
3. **Be late.** For anything.
4. Have your own comp card printed after the agency accepts you, without letting them see the pictures first. Use pictures VERY different from what the agency wants.
5. Make harassing, embarrassing or obnoxious posts on Internet forums. It's not true that "it's just the Internet." The Internet is simply one more part of the real world, and people in that world pay attention to it.
6. Go to a casting from one agency and sign in for another agency. Sometimes they don't find out. Sometimes they do. You really don't want to be you when they do.
7. Share a casting an agency gave you with other models – including models from your agency. There may be a specific reason why your agency gives it to you and not someone else, and sharing it can cause embarrassment for everyone concerned.
8. Give a casting one agency gave you to another agency. If that is discovered, you are certain to be dropped.
9. Take your boyfriend, family or neighbor with you to the agency or a job. Have him hang out in the agency whenever you come to see them.
10. **Don't show up.** For anything, but especially a job.
11. Make a significant change to your look and not tell the agency.
12. Treat modeling as a form of entertainment. It's not. It's a job.
13. Be unpleasant to a client. If it has to be done, it's the agency's job, not yours.
14. Tell your agency you are available for a job when you aren't. That makes the agent look bad to the casting director, and may cause the agency to lose clients.
15. Tell the makeup artist or hair stylist how they should work on you; or after they are done, go into the bathroom and "fix it" to the way you want it. Nobody cares how you want it.
16. Act like the director on a shoot. Your job is to do as you are told. Unless asked, do not offer your opinions or give direction to anyone else.

Getting the Most From Your Agency

All too many models treat the agency simply as a source of casting calls, and passively wait to be told where to go to apply for jobs. That is only a part of what you got the agency for. A good agency provides a wide range of services, and the more you use them, the more value you get. That's what you are paying all that commission money for!

Things you should do from time to time with your agent:

1. Discuss grooming and styling options. Is your hair, makeup and wardrobe appropriate for your "type"? Do you need to be more stylish? Less? Buy a set of scrubs and a stethoscope? Get glasses even if you don't need them? Your agent will help with those kinds of decisions.

2. Review the way you present yourself. Do you need to appear to be a different type entirely? Gain weight? Lose weight? If the bookings aren't coming, what can you do about your approach and self-presentation to improve them?

3. A model's book and card should always be evolving, both because the model's looks change, or as better pictures become available. Can the agent suggest a photographer who might do a free test?

4. You have pictures. Which should go into your book and card? Models often make awful choices. Agents should make the choices for you.

5. Get help with the process and business aspects of the profession. Ask how the agency's policies work.

There is more than one reason to do all that. The obvious benefit is to get the advice and support you are asking for. But there is a subsidiary benefit as well. Agents have a limited amount they can hold in their attention at one time. If they have more than a few models (and almost all agents do) they will tend to remember some more than others. When calls come in, the model who is uppermost in their mind will be considered first. You want to be uppermost in their mind, in a good way. Asking for advice, without being a pest, is a way to have a positive experience with your agent.

That's not the only way to be kept in mind, though. Little things can be done to help. Some models send their agents postcards with their pictures on them at monthly intervals. I've never found that very effective, but it's better than doing nothing. Others bring in little gifts when they come to the office: a cup of coffee for the agent, a little box of cookies. Not enough that it's a bribe, but a thoughtful token that will leave a positive impression.

Professional Lifespan

Fashion Models

The average career span for an editorial fashion model *after* being signed by a New York agency is six weeks. A considerable majority of the models put into the "New Faces" or "Test" board will get their portfolios started, make some rounds and find that there isn't much positive response from clients. So they go home. Those that "click" may work for several years, up until their mid twenties or even later if they are very successful. But at some point they have to transition into other kinds of modeling: commercial fashion, commercial print or lifestyle work. Editorial fashion is about youth and freshness.

Commercial Print Models

Commercial models may have to reinvent themselves several times in the course of their careers, from "schoolgirl" to "glamour girl" to "young mom" to "business woman" to "grandmother". But it is something they can do, and many models stay with a commercial agency for decades. They are less likely to burn out in a hurry since getting started and remaining in commercial print is much less demanding than editorial fashion. While a model is supporting herself as a bartender she can wait a year or two for her modeling career to really catch on. Fashion models don't have that luxury.

Other Kinds of Models

The age for glamour models is roughly 18-25, although some particularly young-looking women can stretch that several additional years. Promotional models can start as early as 18, although mid-twenties seems preferred, and may be able to work into their 40s or later. Artists' and specialty models often can work into their 30s and 40s. Fitness models tend to be from 18 to 25 or so, sometimes into their 30s.

How Modeling Jobs Work

In the simplest cases the Client calls the Model Agent directly, tells them what they need, the agent selects someone who is right for the job, and the deal is done. In the most complex, the Casting Director calls every Model Agency in town, they end up with hundreds of comp cards and then hundreds of applicants in a complex recursive process, and everybody in the chain feels they get to make a decision. When that happens models will be looked at, photographed, discussed and sent home. They may be asked back for another look. Someone may decide to hire them and put them on hold, while someone else decides they aren't right, and substitutes other models. It can be frustrating when there are so many people in on the decision.

Most of these people (Model Agents, Clients, Photographers, Ad Agencies, Casting Directors, sometimes Stylists) have the power to keep a model from getting the job. The model needs to understand who these people are, how they affect her career, and learn how to make each of them part of her team.

If you haven't gathered it already, modeling is a team sport.

Your First Call from the Agency

The first time you will hear from your agency about a job is when you are sent out on a "go-see" or "casting." For you, this is the beginning of the process, even though the creative team is nearing the end of their efforts on an ad. Selecting models is one of the last things that happen before a shoot, and even a lot of the casting process may have taken place before they ever get to calling you.

When you get that call you need to call them back quickly. Jobs may arise and be cast in a matter of hours. Sometimes clients select several models for a single assignment, call them, and give it to the first model that calls back to confirm. If you don't have a way (beeper, cell phone, good answering service that will track you down) to find you quickly, you run the risk of losing a lot of jobs you otherwise could have. You might even lose your agency.

So, what do you need to do in that call? Make sure you get all the information you will need for the go-see. Your first problem is whether you even want to take the job (sometimes you may not). So you need to know:

1. What is the job for? Who is the client and what is the product?
2. When is the shoot?
3. Where is the shoot?
4. What does it pay?
5. What will you portray, and how will it be used?
6. Does it require wardrobe that you don't have?

If you get through all that, don't have any conflicts or objections, you need to know about the go-see itself. You should ask your agent:

1. Where is the go-see?
2. When is it?
3. How do I need to be dressed to play my role? (For commercial models.)
4. Who should I see at the go-see?

All of the questions above relate directly to that job and should be asked if the agent doesn't volunteer the information. But one of your obligations is to get off the phone quickly. A complex casting call may require your agent to call 50 or more models in a hurry. She doesn't have time to chat or deal with other issues; she would rather not have to give you detailed directions to the go-see. That's why you bought all those maps!

You have just been given privileged information. You should not share it with others and you should not take other people along with you to either the go-see or the shoot (unless you are a child and need an escort).

Before and At a Go-See

If you get a call from more than one agency for a go-see, the general rule is that you should tell the casting director (and each agency after the first) that you are going for the first agency to call. That is standard practice and should be accepted by all agents. There are some exceptions: if you are called by several agencies and one of them has a preference clause in your agreement with them, you should tell the casting director you are represented by that agency regardless of what order the calls were received in. You should also tell the other agencies who

call you that you, since they may know that they called you first. Another exception is if an agency gets a "name-request" from the client specifically for you. In that case you should accept the go-see for that agency, even if you got a call earlier (not a name request) from some other agency.

Bring your portfolio if you have a good one; leave it at home if you don't. If you have a wide selection of portfolio pictures, make sure to include some that show you in the role this job requires. Do not include pictures that may be inappropriate for the client (e.g. don't take a portfolio full of lingerie shots when "young mother" is being requested.)

You should arrive near the beginning of the go-see period. The mechanics of the selection process favor those who are first seen. Don't let an opportunity slip away because you chose to go at 5:45 for a go-see that runs from 4-6 PM. Yes, you were "on time", but as a practical matter you may be "too late".

When you are at a go-see you are being evaluated for a particular role that the client wants a model to play. Your agent should give you the details if he knows them, although all too often the casting director hasn't told the agent and you are on your own to figure out what they want. If it is for "young mother" or "executive", "sporty" or "active retired" or some other type you need to put yourself in that frame of mind and remember that you need to project that persona from the moment you open the door. The photographer or client needs to be able to visualize you as what they need to shoot – you should give them all the help you can. That means to dress in a way appropriate to the role, and take on the demeanor of a person in that role. You still need to be courteous, but always while acting as the person they are casting for.

What counts is what you look like, not how old you are, except in special circumstances. If there is a data sheet to fill out, do not list your exact age or birth year. Rather, list an age range appropriate to you in the role you are being asked to play (for instance: 27-32) and if birth year is required, select a year in the middle of that range. Some exceptions include people under 18 (who should indicate exact, true data) and ads for tobacco or alcoholic beverages, which require that the true age of the model be over 25.

Many times the sign-in sheet asks for your personal contact number in addition to your agency phone number. Many agencies have a policy that you should not give this out, both to protect you and to protect them. You should ask your booker about this before you get sent out on your first go-see. Normally if there is a reason for the photographer or stylist to have your direct contact information (sometimes there is, but later in the booking process) it will be given to them by your agent.

Sometimes a photographer will attempt to renegotiate the terms of the deal (different start/stop times, different pay rates, additional usage of the pictures) either at the go-see or later, when you have been booked. In all cases you should decline any such request and refer the question to your agent. Frequently these seemingly innocent questions have the effect of costing you a lot of money. It is your agent's job to recognize that and to protect your (and their) interests.

A photographer or client may ask to book you direct, not through the agency that sent you to them. That is unethical and they know it, but they might ask anyway. In all such cases you should politely decline and report the matter to your agency as soon as you can. Models who accept such offers may get that job, but agencies who find out about it will drop the models immediately.

Under no circumstances should you sign a release of any sort at a go-see. If asked to do so, politely say you have to call your agency for permission. It is best to allow the agent to take on the "bad guy" role when this kind of thing happens

After all those "don'ts", what should you do? Be outgoing, cooperative, friendly, expressive, but within the role you are trying out for. There will be lots of people at the go-see whose looks qualify them for the job. The one who gets it will be one whose personality shines through – that the team feels they will enjoy working with.

After the Go-See

What happens after the go-see? Most often, nothing. The number of models sent by agencies greatly exceeds the number who will be hired, so mostly the casting director will tell you they "will let you know," and then you will never hear from them again.

But sometimes something better happens. You may be called back (you made the short list) one or more times, you may be put on "hold" (or "option"), or you may be booked.

A call-back is just another go-see for the same job, but this time knowing that somebody liked you well enough that they want to see you again. It isn't time to break out the champagne, but it is time to start getting optimistic. Your agent will advise you of anything special you should do to prepare for the call-back.

If you are put on hold, you have a good chance of being booked. That means that the client has selected you for the job but the job itself still may not happen, or may be postponed. A client may also select more people than they really intend to use; you may be the first, second or third choice. Sometimes your agency will know that, sometimes they will not.

If you accept the "hold" you give that client a "first right of refusal" on your services for that time slot. If something else comes along, you can have your agent call them and ask if they want to book or release you. They are obliged to do one or the other. If the "hold" hasn't been released within 24 hours of the shoot it is customary for you to be paid for the job even if you don't do it.

Being "booked" is the brass ring you are in this business to grab. It involves an offer to your agent for your services, which is relayed to you. If you accept, you are obligated to do the job. The client is also obligated at that point, and once the time for the job nears you may become eligible for cancellation fees if the job doesn't happen.

The Shoot

You have been booked, the appointed time is near, and you are about to have a lot of fun. You should be relaxed and enjoy yourself – you are about to get to do what models all want to do. But some rules apply at the shoot that you should be aware of – both to protect the amount of money you are about to earn, and to make the client want to have you back again:

1. **Be prepared.** For men this means having a haircut, ideally about a week before the shoot. For women it means have your hair attractively styled in a manner consistent with the shoot. For everyone it means knowing before you get there what role you will play. Unlike fashion shoots, most commercial shoots require you to have appropriate wardrobe (a small selection of clothing and shoes that fits the role you will play). It should be clean, pressed and ready. Even if you have been told that there will be a makeup artist present, bring your own makeup. Get a good night's sleep!

2. **Show up on time!** This is the most important rule of all. If you are late, you are liable for all the overtime you just contributed to. At the huge hourly rates of other models, the photographer, stylist and others, you *really* don't want to have to pay that. "On time" doesn't mean the time scheduled – it means 10-15 minutes earlier, so you have a chance to get ready for the shoot. At the appointed time you need to be able to step out on the set, ready to shoot. If a makeup artist is provided you can be made up "on the clock" – but sometimes a scheduled makeup artist is cancelled, and you need to be prepared.

3. **Introduce yourself to everyone**. Or at least to everyone who seems to want to meet you. These are people who can make you look bad or good, who may or may not want to hire you for the follow-on TV commercial that goes with your print ad, for instance. Do what you can to help *them* look good and they will return the favor.

4. **Do not discuss rates or terms**. If someone on the set brings these things up, politely refer the question to your agency. Never change the terms of a shoot without your agent being involved.

5. **Shoot what was booked**. But no more than what was booked. If you are doing a TV commercial and someone asks to "just take a couple of still shots," call your agent immediately. Never put yourself in the position of having to be the one to say no, but don't allow any shooting beyond what was booked without your agent's approval. If you do, you may give up rights to thousands of dollars worth of usage fees, especially if the photographer asks you to sign his release.

6. **Sign the voucher.** *When the shoot is over* you should fill out the portion of the voucher that shows how much time you worked and the rights being purchased at the time of the shoot. Time is computed from the time the shoot is scheduled to start (if you were ready on time) until the last shot is taken. Lunch and other breaks are included in the time. When the shoot is shorter than what was booked, you get paid for the booked time. When it runs longer, you get paid for each 15 minutes extra that you worked. Use a little common sense in this – good relations suggest that a 62-minute shoot shouldn't be billed at an hour and a quarter. Sign the voucher, have the photographer or client's representative sign it, take one copy for yourself and one for the agency. Leave a copy with the photographer or client rep.

7. **Releases.** The voucher you just signed is a release, and no additional release is normally necessary. Nonetheless if you are given a separate release, *make sure that the usage and duration specified on the release is the same as on the voucher.* If it is not, cross out any portion that is different from what the voucher says, write in the voucher's usage restrictions and duration, and sign it. If the photographer objects to you making changes to the release, politely ask to call your agent. Never sign a release that has different usage or duration from what is on the voucher or you may be signing away thousands of dollars in future rights purchases. Even better, if the client or photographer presents you with any document to sign, make sure your agent sees and approves it before you sign it.

Getting Paid

That is what it's about, right? You've made all that investment, done the right things, finished a shoot, the client loved you. So you're rich!

Not so fast, Bucky! You may have just earned a very hefty paycheck, but this isn't quite the time to blow your money on a new car. There is this little, tiny problem. Your agency might pay you immediately after the shoot is completed, but most will not. Much more likely, your agency will collect the money for you, and will pay you after the client's check clears (after taking out his commission of course - he has to make car payments too). But we missed a few steps along the way.

You have to take the completed voucher back to your agent, who uses it to compile an invoice for the client. If we get the next-to-worst-of-all-possible worlds, the agency sends the bill to the photographer, who forwards it to the ad agency, who sends it to the client. They take their usual 30 days to pay the invoice from the ad agency, which then eventually pays the photographer, who waits until his rent is paid and sends a check on to the model agency, which waits for the check to clear before paying you. It isn't always that bad - sometimes the client can be billed directly, and sometimes they pay promptly on receipt of the bill. But don't count on it. It is much more likely to take 45-90 days from the shoot before anyone gets any money.

And there is the (fortunately rare) worst-of-all-possible-worlds: the client doesn't pay. He may go bankrupt, or simply be unable or unwilling to pay for any of a number of reasons. When this happens the agency will help you collect if that is possible, but that's all they will do. If they don't get paid, you don't get paid.

A wise model spends money only when she knows she has it. This business can be tremendously lucrative, but it can also be a feast-or-famine nightmare; even if you just did a huge job for a national corporation, it's best to remember:

No extravagance before its time!

Large Market Cities

The United States

New York City

The overwhelming fashion and advertising capital of the country, New York is the sole Major Market city in the United States. The largest American design houses are located there, as are most fashion magazines and major publishing houses. The great majority of editorial fashion modeling is done in New York, or by New York models on location somewhere else. There are numerous opportunities for showroom and fit models, specialized fashion trade shows several times per year, and New York Fashion Week in September and February are the largest and most prestigious opportunities for runway models in the country.

The headquarters of many of America's largest corporations are in New York, and most other large companies have a strong presence there. Not surprisingly, New York is also the center of the advertising industry. There are hundreds of top commercial and fashion photographers in the city, and a wide variety of production support companies. All that is supplemented by the most robust theatrical center in the world and a substantial amount of television production. Opportunities for models and actors of all types abound.

Finally, New York is a popular destination for conventions, trade shows and expositions, so promotional modeling opportunities are great as well.

As you would expect, competition abounds too. The most and best fashion models are in New York. There are thousands of professional commercial models as well. Many models who could have long, lucrative careers in smaller market cities languish in New York, simply because of the level of competition. It's the city you go to if you want to work at the top levels, but it's also the hardest city to succeed in.

Chicago

Long the second city of fashion in the United States, Chicago is a major market for catalog work, and a strong secondary market for advertising.

Numerous national retailers including Sears and Spiegel shoot their catalogs in Chicago. A number of large advertising agencies are also located in Chicago, and there is a substantial amount of commercial print work to be had. In addition, Chicago has a robust industrial video market, and live theater opportunities for actors that are second only to New York.

Editorial fashion opportunities are much smaller than in New York City; mostly they are for local newspapers and magazines.

Los Angeles

Los Angeles is driven by the movie industry in Hollywood, which has spawned episodic television and TV commercial production companies and the richest supply of actors in the world to work on them. There is substantial commercial work, although the competition among commercial print models is the stiffest in the country, since actors tend to take up commercial modeling as a supplement to their incomes.

Los Angeles also has its own garment district, and now hosts its own Fashion Week. It is not as large as Fashion Week in New York, but it does provide substantial opportunities for runway models (often flown in from New York and Europe).

Because of its warm weather and beaches, Los Angeles provides a good market for swimsuit models. It is also the largest market in the world for glamour models, in part because Los Angeles is the production center for the adult film and magazine industry.

Miami

People shoot in New York because of the concentration of creative and financial resources there. But New York isn't always congenial to shoot in, especially in the winter.

A couple of decades ago production companies discovered that Miami's South Beach, with its warm winter-time weather and art-deco architecture, was an excellent place to do location shoots. At the time prices were much lower than in New York, and governmental regulations less burdensome. The city became a winter-time haven for northern and European production companies, and a strong secondary market for editorial fashion

and swimsuit work. Models and photographers flock to Miami at the beginning of "season" (roughly November of each year) and stay until April or so, when nearly everybody packs up and goes home.

Time has moved on, and South Beach Miami has changed. Prices have risen dramatically, the city government has imposed both taxes and burdensome regulation, and South Beach is starting to feel less congenial than it once did. Many of the production companies are now going to Cape Town, South Africa during "season". Even so, Miami remains a very substantial fashion and commercial market during the winter months, and it appears that the initial flight of talent to other markets may be reversing.

Tertiary Markets

A number of cities in the US offer substantial catalog and commercial opportunities, although few of them do much editorial fashion work. Local ads (print and TV) are produced everywhere, and the larger the city, the greater then chances for getting some of that work.

The strongest tertiary market cities are Dallas, Atlanta, and Boston. Phoenix was at one time thought to be on the path to being a strong tertiary market, but its development has been slower than anticipated. Other substantial markets are in Seattle, San Francisco, Tampa and Greensboro, NC.

Canada

By far the dominant fashion market is Toronto, with Montreal in a distant second place. Vancouver has a thriving film/TV production business, and commercial modeling is available, but relatively little opportunity for fashion.

The Internet and Mainstream Modeling

The beginning of the 21st century brought the first major change in the way agencies had done business in nearly 30 years. The old ways remain, and are still relied upon for many purposes, but the Internet has fundamentally changed the way models, agencies and clients communicate with each other. It has also made information about modeling widely available to aspiring models, although that is sometimes a mixed blessing.

Locating Agencies and Models

Search engines and model industry reference sites on the Internet enable models and clients to find agencies suitable for them. Tools like that should be used by models to find out who to submit applications to and, just as important, who not to. Sites and URLs on the Internet change constantly. As of this writing some useful sources of information about agencies include: www.rasource.com, www.modelnetwork.com, www.workbook.com, www.lebook.com, www.models.com

Locating Support Personnel

Model agencies aren't the only things of interest to models. If you are trying to put together a photo shoot and need crew members (photographers, stylists, makeup artists, hair stylists) to work with you (paid or unpaid) you can advertise for them on sites devoted to modeling and the support specialties. Many "modeling sites" don't deal much with fashion and commercial modeling, but a few do: www.makeupartistchat.com and www.beautytech.com

Model Agency Communications

Clients want models; agencies need to get information to them. The traditional way is to send over a stack of portfolios or composite cards and let the client choose who they want to see. That's a burden on the models to have the cards printed, and on the agencies (or the models, if their agency passes on expenses) to pay for sending things to the client. For clients outside of the city, cards may have to be sent overnight, which can get expensive. For their part, clients may want to send reference pictures to an agency so the agent can see what an ad will look like, or what kind of person the casting director wants to see.

Most clients are now accepting the Internet as a means for getting initial screening information. They may get a package on Modelwire, an email with pictures or URLs to model's online comp cards, or simply look at models on the agency website to make their choices. For clients in remote cities it's not unusual for a job to be cast entirely off the Internet, and it's becoming more common even in the major market cities.

After the casting is done, clients can use email to send contracts, call sheets, releases and support information to the agency for review and signature if needed. The fax machine is still used, but email is easier and better quality.

Although few agencies prefer it, many will accept email submissions from aspiring models, which can greatly reduce the time and cost of a model bringing himself to the attention of the agency. Models can also get releases, contracts, call sheets, shoot instructions and scripts for upcoming jobs through email.

Model's Personal Sites

Many models have personal sites on the Internet, either on their own domains or as pages on a model exposure site. They can be very useful for communicating with agencies or other professionals. Rather than include information and pictures in an email, you can simply include the URL for your website and let the other person click on it.

There are pressures on models to produce the wrong kind of personal site. Model listing services want you to use their format, which may be cluttered or include lots of things inappropriate to professional communications. Models see (or are sent) ads from web site designers, all of whom want to produce something for a price, and most of whom want to make it look like something that either justifies their price or showcases their skills. Models can get self-indulgent in what they put on the site. All of that is bad. A model may choose to have a personal site with lots of bells and whistles, but that's not what she should use in professional communications. It's like a resume, or your application letter to an agency. Keep it simple!

The best choice is your own domain. It isn't all that expensive; some places will let you buy a domain and host a small site with email for less than $50 a year. They also often have simple website design tools to help you produce the pages. If you absolutely have to save money and go to one of the freebie site companies (such as Yahoo, MSN, or worst of all, myspace.com) make sure your correspondent does not have to become a member of the site, join anything or use passwords to see your page. If they do, most professional clients will just go away.

The first page of the site should contain your name, location, stats, contact information and a small number of pictures. You might choose to have one large (400-500 pixels high or so) headshot on the first page, but all other pictures should be thumbnails that a viewer can click on to bring up a larger image. That saves kilobytes; kilobytes equate to time, and professionals want a site that loads very quickly even in this broadband age.

Site layout should be simple, clean and attractive. Do not clutter it up with complex graphics or lots of different fonts. Keep animation to a minimum. Zero animation is best. If you want to have a more complex site and fancy animation, do it on another page that a viewer can choose or not, while still first seeing everything they need to make choices about you. Do not include music. No pop-ups or advertising on your page! Keep it clean. Professionals don't want to have to spend their time closing popup ads or looking for the mute button.

Do not include an excess of biographical data. Professional modeling experience, if you have it, should be briefly described. Nothing else.

Your contact information on the site should not include your telephone number or home address. Don't ask the viewer to contact an agent or manager unless you have a mainstream, brick and mortar agency that handles all your bookings. Experienced models with multiple agencies often have personal websites with additional pictures on them, *but no contact data.* That allows their agencies to refer clients to the site to the additional pictures without running the risk of the client doing something stupid with the contact information.

Model-Related Web Sites

In days gone by models had few good places to get advice from. The best choice was a good agency, but agents tend to be stingy with advice to models they don't represent. They have to be: so many models, so little time.

The next best source was the books on modeling. Many books don't deal much with the kinds of modeling a reader should be doing; they may not deal with the model's particular situation or, if they do, the model may not recognize it. Times change, and books get outdated. And not all of them are written by people who really understand the industry.

After that, the choices got pretty dismal. The next-to-worst source is the model's friends and family. Few of them understand the realities and complexities of the business. Even those who have been models have personal experiences which may have little relevance to an aspiring model's situation. If a person could arrange to talk to advertising and publishing industry professionals it would help, but even they have very limited insight into anything but their own experience with the business.

The worst possible source of information is people who have something to sell you. They may be honorable, knowledgeable people (although a too-high percentage is not). But they are motivated to tell you what you want to hear or what will get you to buy from them. These people include modeling schools, photographers, "model managers" and vendors of other modeling-related services.

Times change, and information sources have changed with them. The Internet has provided us with countless sources of information. These include advice sites by governmental and private watchdog agencies which tend to be concerned with telling you how to avoid scams. Neither of these gives in-depth advice and both over-simplify the problem and proposed solutions:

The Federal Trade Commisson: http://www.ftc.gov/bcp/conline/pubs/services/model.htm

Better Business Bureau: http://www.newyork.bbb.org/library/publications/tt1903.html

Reference sources to find out if an agency is licensed:

In California: http://www.dir.ca.gov/ftproot/talenta.txt

In Florida: https://www.myfloridalicense.com/Default.asp

In Texas: http://www.license.state.tx.us/LicenseSearch

General Modeling Advice and Resource Sites:

www.modelresource.com

www.americamodels.com

www.fashionbook.com/home.html

www.e-model.net/info/FAQ.html

www.models.com

Finally, there are modeling forums. Literally hundreds of these exist, but the vast majority have no value for mainstream professional models. Virtually all are nude/glamour oriented, and the participants mostly have neither knowledge of nor interest in how fashion and commercial modeling works. There are a few exceptions, including:

the Fashion Only Forum: www.duroi.com/fashionforum and

Models.com forums: http://forums.models.com/index.cfm.

These forums are oriented towards fashion or commercial modeling, and either have strong moderators or are self-policed by the core membership. A wealth of information is available on these forums. You can find answers to questions in FAQs on the sites, or ask whatever you like of the forum members. Each of these forums has members who post frequently, and who have real agency experience that they will share with you.

Even so, forum advice must be carefully evaluated. Forums are like any other community: the residents form friendships and cliques; many have been members for years. Some will support anything another of their friends say. Others will argue with anything said by someone they don't like. Some people on the forum say things they think you will want to hear; some pick fights just for sport. People give advice whether they know what they are talking about or not, and on most forums there is little control over who says what.

The best approach to a forum is study, respect and caution. Read the forum's rules and FAQs. Read the last hundred or so posts to see what kinds of questions are asked, who answers, and how credible their answers are. Then make your first post on the forum, introducing yourself and letting people know your areas of interest and experience. There is nothing wrong with being ignorant of the industry – the forum is there to fix that. Just don't pretend to knowledge and expertise you don't have. The long-time members of Internet forums have a well-developed BS sensors, and do not treat poseurs kindly.

Be prepared for evaluations of you or your work that seem harsh. Some people will never say anything bad to another, and nice posts are common (and usually meaningless). The posts which tell the truth are often not what you want to hear, and it's tempting to lash out at the person telling it. Forum participants are not always kind or politically correct in their phrasing. Try to get past the tone of the response and see what information of value may be in it.

If you participate on a forum with respect for its customs and members, and are careful to take advice with a grain of salt, you can learn a great deal about the modeling industry.

Model Safety

The new field of Internet modeling is rife with safety issues. Models who market themselves in part on the Internet ought to read the Internet Modeling Safety chapter in addition to this one. Still, there can be safety issues even in mainstream modeling. There is at least one well-documented case of a professional photographer hiring an agency model and murdering her on a location shoot. Lesser forms of assault and harassment also occur in the mainstream (particularly fashion) world, but they are not widespread. Models have support systems in place (primarily their agencies, but also the constraints placed on a professional community by its other members) that limit the dangers they will face on professional jobs and test shoots. This is not to say that mainstream agency models should blithely ignore safety concerns, but they are not the ones primarily at risk.

Models who are self-marketing to traditional types of clients have less of that support system to rely on. Even agency models will frequently find themselves approached with offers that may or may not be worthwhile, or safe.

Agency Models

The first rule of working as an agency model is this: *trust your agent,* and rely on him for guidance. A good agent has well developed BS filters that it may take a model years to develop. He is likely to know many of the legitimate clients and photographers, will have encountered virtually every kind of scam, and have seen the dangerous pitches before.

If you are approached on the street, in a mall or at a party by someone claiming to be a photographer or producer never, ever give them your personal contact data. You may give them a comp card or business card, but it should have your agent's telephone number on it. Let them know that all offers and inquiries should be directed to your agent, not to you, even though you may talk to them briefly about what they are offering. The great majority of the time your agent will never hear from them. That's fine; it's most likely not an opportunity lost, but a scam or dangerous situation avoided. It's very rare for someone who is not legitimate to contact a model's agency.

If a person claims to be another agent, you may or may not want to contact your existing agent about it. If you are under a non-exclusive contract, your current agent may be willing to tell you what he knows of this new person's agency, or he may not. Many agents do not like telling unpleasant truths about others, even their own models. This is a small business, and the word gets around if someone is bad-mouthing you. On the other hand, your agent may be motivated to say bad things about another agent just to keep you away from them. So in this one case you may want to seek other opinions, whether or not you talk to your agent about it. Ronald Reagan got it right: "Trust but verify."

All Models

Be on the lookout for the scams and predators described in this book. You cannot assume that people are who they say they are.

Never give anyone your home address or home telephone until you are comfortable in your business relationship with them. If you have to give a telephone number, it should be your cell phone. A postal box is a very useful safety tool.

SPECIAL MODELING TOPICS

When Things Aren't What They Seem

In other parts of this book we have presented modeling largely as a straightforward business. You need to understand what is expected of you, and what will happen on castings and shoots. Nothing fancy about it and nothing that you can't learn.

But if you take things too literally you may end up misunderstanding what is happening. Sometimes it helps you, and other times it can hurt you a lot. It's hard to tell if what just happened is normal and can be taken at face value, or if it's a game of some kind.

Some of the things discussed below take place mostly in large, complex markets like New York and Los Angeles. Others are practiced all over the country. Although some of these games are unethical and illegal (and others are neither), they are done by real organizations with legitimate places in the modeling industry, not by "scammers". So here is a tutorial on things people don't want you to know about.

Games Clients[1] Play

Bait and Switch

This is pretty common. A client has a favored candidate (relative, friend, whatever) for the featured model in a print job. They also want some "background" models for a lot less money – so much less that the model agency may not want to deal with it. So they put out a casting call for models at a high "principal" pay rate and, when they have seen all the models they want, offer to hire several of them as "background". By then the agency has already done the work, the models have been to the go-see, and so they will get the people they want.

This is What I'm Getting Paid For

Here's a dirty little secret: in a reasonable-sized market, lots of models are qualified for most jobs, and who gets chosen is a subjective decision that could be made very differently. That gets driven home during those rare shoots when a booked agency model doesn't show up, or for some reason turns out at the last moment to be unsuitable. What happens? There is a panic call to an agency, someone else gets chosen in a matter of minutes, and it all works fine. You get the feeling that it could have been done that way in the first place instead of the enormous casting process they went through.

Casting can be very simple, but more often it isn't. Usually the client is paying someone else to do it. They may be paying quite a lot, and whomever they are paying has to make it look like the client is getting his money's worth. So they play a game.

Part of the game is "Look how many choices I can get you so you will find just the right model!". Casting directors will put out blanket calls on the "breakdowns" which go to many agencies and individual models. They will call, fax or email lots of agencies with the specs for the job, with the specs fuzzy enough that lots and lots of models show up. They may also put the job out on Internet casting sites, even though the client has a strong preference for agency models.

Casting directors have been known to call agencies and say "I'm afraid I won't get 100 people to show up for this casting. Please send a lot more!" They know they will get a lot more models who aren't what the client is looking for – but it makes the numbers bigger, and so makes it look more like they are worth what they are getting paid for casting. They can always blame the agency for the inappropriate models who show up.

If you find yourself at a "cattle call" with hundreds of other models, remember that your time and trouble in getting there serves a purpose: it helps the casting director get paid.

[1] In this chapter we will use words a little differently: "client" means something specific (the person who is paying for the model), but we are going to broaden that meaning a lot. Clients hire others to act for them, and whether something is done by the client themselves or one of their surrogates (ad agencies, casting directors) can get so fuzzy sometimes that it doesn't much matter who plays the game. They even play games among themselves, and the models get affected by it. So for this chapter we are going to simply lump all those folks into the "client" bucket and not be too careful sorting it out.

The term "casting director" will be used pretty loosely too. Often the casting will be done by someone who is not a professional casting director: a photographer, the ad agency, or even the client themselves. We will ignore all of that too, and call whoever is casting the job "casting directors" regardless of whatever other role they have in the process.

I'll Know It When I See It

Sometimes it's not that the casting director wants to fill the hall with aspirants to prove his value to the client. It's that they simply don't know what they want, or that there is disagreement over what they want.

A real casting: *The client wanted a scenario involving well-known historical figures. The casting director called the agencies, and one role they were looking for was "Julius Caesar". OK, there are plenty of Julius Caesar pictures on coins and statuary, so it should be simple to find someone who looks like that. But there was a problem: the casting director included a note that the "reference type" they were looking for was Alec Guinness. Well, that's not as much of a surprise as it might be; Sir Alec played Marcus Aurelius in a movie once. But it illustrates a great difficulty in the casting process: different people have different ideas as to what a "type" looks like. The client may have thought Julius Caesar should look Italian; the casting director had seen The Fall of the Roman Empire and thought differently. Everybody else is confused by all this, so the agency has to use a very broad filter in deciding who to send on the casting.*

Sometimes it's worse: *A major telecommunications company sent around a big-money casting call for "men between 20 and 45". That's it. The whole description. So what are they going to hire? A "model" type? "Businessman"? Jock? Computer Nerd type? Nobody knows, so everyone in the agency gets sent, hoping someone will be what it finally turns out they want.*

You're on Hold!

The second most exciting part of the casting process comes when you get put "on hold". You have passed the first cut and are only one small step from booking the job! That's a good thing, of course, but like all good things, it isn't free. By accepting a hold you are limiting your right to take other jobs or do other things.

Some casting directors will put only one or two people on hold for each job. "Hold" is used instead of "booked" to avoid cancellation or rescheduling fees, and to give them some flexibility in case their primary choice for the job isn't available. But "hold" can be a game too. There are casting directors who put several (sometimes 10 or more) people on hold for each job. Their client can't make up their mind, so they put everyone on hold and sort it out later. That protects them, but it puts a great burden on the model. Imagine: a model goes on five castings in a day, and gets three "holds". On the next day, should she go to other castings for jobs that shoot on the same days as the ones she is on hold for? If she doesn't, she loses the opportunity to compete for work. If she does, she risks having to tell a client or her agency that she has created a conflict that they have to resolve. Sometimes that can get pretty messy.

If You'll Do Something For Me . . .

Modeling jobs are given to the most qualified candidates, right? Well, maybe not. "Most qualified" is very slippery, and it leads to all sorts of criteria. Among them is *quid pro quo*. The first thing that leaps to most people's minds is sex, and the "casting couch" is not unknown. It seems unusual in mainstream commercial print modeling, somewhat more common in fashion and glamour modeling. When that kind of "opportunity" arises, if you have an agency that you trust, the best thing to do is to take the problem to them for guidance.

But sex is hardly the only *quid pro quo*. It could be "if you do this low-paying job I'll make sure you get favorable consideration for the next big one that comes along." The promise is that by going along with the request you will get a later job that you want. That promise may be real or it may not: You may be one of several people that the promise is made to, and only one can actually get that good job. There may not ever be a future opportunity, or the person making the promise may not be in a position to deliver the job to you when the time comes.

Sorting all this out is not easy. You have to balance the probable reality of the future opportunity versus whatever it costs you to comply with the request. In any event, you or your agent need to find a way to get through the situation without alienating the client.

Rights

When a client calls in a job to an agency, they will normally say what rights they want to purchase with the shoot. It may be "one year domestic trade print plus Internet," for instance. The price negotiated for the model's time and usage will be based in large part on what those rights are. So far, so good.

Then comes the game. The client may present a release to the model at the shoot that has much more expansive rights on it than what were negotiated, or may even fax a release for the agent to sign for the model

with that same expansion on it. They are trying to get rights they didn't bargain for, but might be able to trick you into signing away.

One of America's largest advertising agencies does this routinely. They fax a release to the model agency with an "exclusivity clause" that limits the model from working for any competitors for a long time. Exclusivity clauses aren't unusual in print modeling, but they should be paid for – often paid very handsomely indeed. An exclusivity clause can be worth more than the value of the shoot and usage – and they are trying to get it for free.

When an agency or a model catches the additions, they line them out of the release and send it back. Every time, the person at the ad agency says, "Oh, that's fine, everybody does that." What that means is, they know they are playing a little game and usually will get caught, but once in a while they will get away with it. So they keep trying.

As a model it's up to you to know what rights are being bought for any job, and to make sure you don't sign anything other than what was negotiated. A good agency may be able to stop them, but you are the first line of defense. If you sign whatever is put in front of you, you may make it impossible for the agency to fix the problem, and you could lose thousands of dollars.

The Audition is the Photo Shoot

At most go-sees the casting people will take Polaroid or digital pictures of the models, and may shoot videotape. The shots may be very routine and boring ("Stand against that wall and smile,") or they may have the model doing something like what the job will require. All that is entirely normal.

Sometimes models show up for an audition or go-see and find a sign posted outside the room. Something like: "By entering here you content to be photographed or video taped." Or the sign-in sheet does more than ask for data about you – it says you will let the client publish the pictures they take at the audition.

At that point a big, flashing red light should go off in your head. What is happening is the client (often a media company of some kind) is trying to get free content for their website, TV show or other production. Reality TV shows do this routinely. At least one major men's magazine holds casting calls around the country, shoots nude pictures of the applicants, and then posts the shots on its pay website "so the members can choose who should be in the magazine." All this without giving the model any money at all. Maybe, after all that "exposure" she will get hired. Or maybe (probably) not.

When a model encounters a situation like this she should immediately notify her agency and let them deal with it. There may be a legitimate reason for what the client is doing, but often there is not. If the model has no agency, she should weigh the likely consequences of signing what they request, and decide for herself if giving a client free pictures of her to publish is worthwhile for her.

It's Great Exposure!

When a client doesn't want to pay market rates for a model he may invent reasons why she should do the job anyway. The most common is claiming that the job will generate "exposure". He's playing a little game, hoping the model will have visions of some Important Person seeing her who will launch her modeling career. Most of the time that's hogwash.

For "exposure" to work, at least one of three things has to happen:

1. Your picture is so widely seen that you become well known to the public, and your image has value because of that public awareness.

2. Some potential client sees the picture, likes you so well that they track down your contact information and hire you for a project they are producing.

3. The shoot produces a tearsheet that would enhance your comp card or portfolio.

There are some such assignments. The cover of Vogue (or Playboy, or Sports Illustrated Swimsuit issue) comes to mind, as do layouts in many mainstream, respected publications. Those are the kinds of places that fashion, commercial and glamour clients may look for models. That's why "editorial rates" are as low as they are. Prestigious clients know that appearing in their publication can enhance the career of a model. Still, the great majority of jobs which promise "exposure" are of no value for a model's career. They may be in little-known publications of no prestige, or of a type of work that would not be useful to a fashion or commercial model's book. "Cheesy" is often associated with such jobs.

The situation is a little different for Internet models, since their target market is not commercial or fashion clients. Appearance on one of the well-known websites or virtually any print publication is used by lots of Internet models to enhance their perceived experience, and in all honesty a lot of the people who hire them don't know the difference.

The general rule about "exposure" is that if the job is something that a model much higher in the food chain than you would compete for, it's probably worth doing. If it's not, you probably should pass.

Just This Once

This game requires collusion between the agency and the client.

For the most part the agency's interests are aligned with the model's. They make money by getting you work. The more work, the better. The higher the pay, the better for both of you. You win, they win. But "aligned with" isn't the same as "identical to". There can be conflicts of interest that the client can use to get agreements from an agency that aren't in the best interest of the model.

A classic instance is where there has been an error: a model has been booked at one rate, but the budget calls for a lower one. If they pay the model what they said they would, they lose money on the project. The model should get the full booked rate and let the client or suffer the consequences of his error.

The model may never work for that client again, so going to the mat for the booked amount isn't a long-term problem for her. But the agent may very well not want to lose the client. The agent would rather compromise (or capitulate) for the sake of a long-term relationship that benefits the agency. Often the agency arranges things so the client gets what he wants, and the model gets less than she bargained for.

It may not be quite as complete a loss to the model as it seems at the time. The agency had the ability to get her that job in the first place because of that cooperative relationship with clients. If the agency loses their clients, the models don't work, and everybody loses. Even so, the loss of income on that job feels bad, no matter how much long term benefit it may have to the agency and its models.

Games Photographers Play

Photographers often get to act for the client, so they can play a lot of the same games clients do. In addition they have some of their own.

Stock

OK, the job is cast and booked; you show up for the shoot, everything goes fine. The time comes for the paperwork at the end. And the photographer gives you a release to sign. Maybe it's exactly what it is supposed to be, and maybe it is not.

This is a variation of the "rights" game played by clients. In this case, the photographer wants to be able to sell your images for more than just the job you were booked for. He might think that the client will want to expand the usage for the pictures, and he can sell to them without ever having to go back to you or your agency and asking for more rights from you. That way he gets to pocket your additional model's fee.

He may have another thought: some photographers supplement their income by selling "stock" photos. If he can get you to sign an unrestricted release, he might be able to put a lot more money in his pocket.

Sometimes the photographer will offer the model some small part of any such future sales for this right. Other times they will go so far as to claim this is what was negotiated as part of the deal, and trick the models into signing their release. Once the model has signed, it's very hard to get the deal undone. She may lose a later, high-paying job because the image was sold to a competitor of the new client.

The best defense against this kind of game is to have your agency review every piece of paper presented to you before you sign it. That's what fax machines are for. If you don't have an agency, at least make sure whatever you sign is what you originally agreed to, and something else hasn't been snuck in.

Stock, Part Deaux

The way stock photography is supposed to work: a photographer shoots pictures without having a definite client in mind, puts them on the market and hopes to sell them. Stock doesn't pay well, because the photographer has no assurance of every making a sale from the shoot.

Some stock companies have now decided to play the game differently. They get clients who want specialized photography but don't want to have to pay full commercial rates for it. So the stock company calls

agencies and models, claiming they are casting a stock shoot so they can pay much lower stock rates. This is unethical, but it is happening more and more.

The Bait

Most photographers would rather go from one high-paying commercial job to the next, with a little personal work and editorial thrown in just to keep fresh. But not everybody is successful at that. In fact, some professional photographers rarely or never shoot real commercial jobs. Their income comes from doing paid "test" photos for models. In a well-ordered world they would advertise, network, get put on agency approved lists, and generate the income they need. The world is not so orderly.

If the photographer's marketing efforts aren't working (often because his pictures aren't competitive) he may be tempted offer the promise of future modeling work so more models will hire him. Sometimes this offer is entirely legitimate, if the photographer really does do a lot of assignment shooting. But often it is not. The photographer who can't sell photo sessions on their own merits will try whatever he can to convince models he will be able to do things for them: upcoming jobs; people he will introduce them to; agencies he can get them into.

One photographer/model agent in New York is famous for using the Internet to advertise his need for models for high-paying commercial print jobs. The jobs are real, but usually have expired before the model ever gets a chance to apply for them. The photographer doesn't care. The point of the ad was to bring in models, tell them all the wonderful things he was going to do for them, and get them to buy a photo session (or just join his agency).

A test photographer in Miami is well-known for using the Internet to solicit models to come to shoot with him. Since he doesn't do much commercial work that involves models he offers the possibility of being in an editorial that he is working on for some third-rate magazine, or says he will do his best to use his contacts at the agencies to get the model seen and signed. No promises, of course, just a bill for photography. And models have been known to fly in from all over the country to take him up on his offer, including many who had no realistic chance at agency representation, or were obviously wrong for the agencies he works with..

Sometimes these offers are even real, but they should be looked upon with great skepticism by models. It's almost always better to shoot with a photographer who is approved by agencies *in your area* than to fall prey to some hype.

You Need a Portfolio!

There is an old maxim, "Never ask a barber if you need a haircut." It applies to photographers also.

Many test photographers will happily tell you that you need a portfolio and composite card before you apply to agencies. And of course they will make those things for you, for a fee. The trouble is, most of the time for a fashion model no professional pictures are needed before she gets an agency.

A new commercial model may need professional pictures, but what is needed usually isn't what the photographer produces. Far too often the photographer does his rendition of what he thinks "fashion" photography, or "model photography" looks like, without regard to (often without knowing) that his style is completely wrong for that model in that market.

"Internet photographers" on model listing sites are particularly bad about this. Over 90% of all photographers on such sites list "model portfolios" as a specialty, despite the fact that a large majority of them have never set foot inside an agency or seen a working model's portfolio.

Agencies see this all the time, and it is one of the primary reasons that many agencies tell models they don't need more than snapshots to apply.

You Look Like a Model To Me

Remember the question to the barber?

For many models, the first person they encounter who is really involved with professional modeling is a photographer. So they ask him questions, but that leads to lots of questions that the photographer may not be qualified to answer. Still, many answer anyway, either out of ignorance or for their own purposes.

The most basic of these questions is "Do I have what it takes to be a model?" The photographer may know, or he may not. Fashion photographers don't really know what it takes to be a commercial print model;

commercial guys usually don't have the educated eye to tell a high-fashion model from any other tall, skinny girl. But many of them don't know it; when they do it usually isn't in their best interests to tell the truth.

Imagine the conversation with an honest, knowledgeable photographer: *"Do I have what it takes to be a model?" "No, it doesn't look like it to me."* He may be absolutely right and, if he is believed, save the aspiring model a lot of time, effort and money. But two bad things can happen if he tells the truth: she gets very unhappy, and he loses a sale. The more ethical of the game-playing photographers will not directly answer the question. If that happens to you, there probably is a reason, and you need to seek a qualified second opinion.

If You'll Do Something For Me . . .

Just like with casting directors, this isn't necessarily a bad thing, and can even benefit a model. Still, the model should be careful to fully understand what is being before rushing into any deal a photographer presents.

Models need professional pictures. Professional photographers need to be paid for pictures. The simplest deal is that the model hires the photographer, gets her shots, pays him, and is done: the classic "paid test". But there are many variations on the theme. Photographers need more than just money. They need to have pictures for their own portfolios, comp cards and websites. Often commercial jobs don't provide opportunities to produce the kinds of shots they want to use to market themselves, or for creative outlets. So they need a model to work with to produce them.

They may need practice to master new equipment or techniques. They may be shooting for a "spec" editorial or a book on photography or modeling. Again, they need models. In these kinds of situations deals can be made. If the model is what the photographer needs for his other purposes, it's not at all unusual for shots for her own book to be produced as part of a shoot where the photographer also gets what he wants. This is referred to as a "free test" (even though it may not turn out to be completely free) or, in Internet-speak, a "TFP/TFCD".

Such arrangements can involve negotiation. What will the photographer give the model from the shoot? Negatives or raw digital images? Finished pictures? How many? How much do additional prints cost? Who pays for support staff like stylists and makeup artists? Is a release needed? What kind? Generally in mainstream modeling, a "test" does not involve a release; in the Internet culture a "TFP/TFCD" customarily does require the model to sign a release for the photographer.

These and other questions need to be asked up front, or there is a great danger of ill will arising even between a model and photographer who both mean well. Each side has its own expectations and needs, and they should be clearly communicated prior to the shoot.

Games Agencies Play

Agent-Speak

Agents are people too. They know how emotionally charged modeling is, and how personally people take rejection. They also know that they have to reject almost everybody. So they devise games to keep from being too hurtful (and to protect their own feelings).

Oddly, one of those games is the hard-nosed insult. If they are brutal enough in rejecting you, you can blame the agent and not have to look too deeply into your own shortcomings. "You won't believe how he treated me. He was such an ass!" may be easier to bear than "He said I have a pug nose, a short neck, and a lazy eye!"

Another game is to say that you are whatever kind of model that agency doesn't do. An editorial agency will tell you "You're too commercial." The commercial agent will say they see you as "an editorial type". Neither means what the words say. All they really mean is, "we don't want to represent you "You are too young", "I have another model who looks just like you," and other stock responses that may just mean "no".

You need to understand this and not take the words too literally. Some models have left an editorial agency and gone out and spent a thousand dollars on a "commercial" portfolio because an agent told them they were "too commercial". What the agent really meant was "no way in hell you are ever going to be a model." Take these kinds of comments with a large grain of salt.

Do Difficult Things

Agencies don't just supply models. What the agency supplies is reliability. When a client books an agency model, he expects the model will look like her pictures, will be roughly the height, stats and age claimed, will show up, won't be stoned on set, and won't bring a jealous boyfriend along who insists on watching and

commenting on the shoot. To have those kinds of assurances, agencies tell models to do difficult things: Get new pictures done. Cut your hair. Lose ten pounds. Get a manicure. Tone up your body. Show up on time for every one of the things the agency told you to do, ready to do it.

Partly you may be told to do those things because you really need to do them. But another important reason is that the agent wants to know that when you are told to do something, you do it. After a few of those, the agent has a lot more confidence sending you out on jobs. Even if they like your look, they may make you do one or more difficult things, just to see if you will.

Parking

Agencies can effectively represent a limited number of models at one time. The problem is much more acute for fashion agencies than commercial. Fashion models are on an exclusive contract, and to keep them the agency has to get them a substantial amount of work. If they have too many models, or too many of the same type, the money available gets diluted to the point that none of the models are happy, and the agency loses them.

Still, there are lots of models that an agency may have an interest in, but aren't going to do much for, at least for a long while. The model may be only 13 years old and living in a remote city. The agency will sign her for "development" and then "park" her where she lives. If she still looks like a fashion model two years later, they have her on contract so nobody else can get her. If she doesn't, well, that's just too bad for the model. It doesn't cost an agency much to park her and find out. Or the agency may already have eight blue-eyed blondes at a time when the market is trending towards Eurasians. The next stunning blue-eyed blonde that walks through the door may be signed, but then "parked" until the market preferences change, or the agency loses some of her type. Again, during that time the model is off the market.

How to deal with this game? Get a commitment from the agency on exactly what they are going to do with you. Will they market you quickly, or "develop you" for an extended time? If the latter, you might consider that it is in the agency's best interest to sign and park you, but it may not be in yours, no matter how good the agency is. That's the time to see if you can get other, more immediate offers.

Sign Everyone in Sight

A slight variation of the "parking game" is the shotgun approach used by some "mother agencies". They recruit models from wherever they can find them: malls, print ads, on the Internet, at model searches and conventions. The pitch is always the same: they will "develop" the model, make her ready to market, and get her seen by the major agencies in New York, Los Angeles, Milan or other major city. They might actually do something for the model, but at the model's expense. They can sign up a large number of models. Why not? It doesn't cost a lot.

With luck some of the people they find and sign will end up with real booking agencies, and the "personal manager" can take a cut of her earnings for a while. Never mind that she could have been signed by that same booking agency without all that "development" and delay, and without having to give up part of her earnings. The "development agent" is happy if he only gets one success every once in a while.

There are good, ethical personal managers. They devote substantial time, skill and expertise to finding highly qualified models and preparing them for the market. These "shotgun" managers give them a bad name.

Sending Wrong People

Agencies have to keep their models happy. In large markets this is less of a problem because non-exclusive models may have many agencies and many outlets. But for smaller markets and some commercial agencies, they have to struggle to give the appearance they are "doing something" for their models. One of the things they do is send people out on castings who are manifestly not what the client wants. All it costs the agency is a phone call; and if they do it from time to time, the model feels they are trying to get him work. What it costs the model is the time and money it takes to get to a casting.

If you find yourself showing up at castings where everyone there looks very different from you, and the casting director looks a little confused about why you are there, that might be what is going on.

Selling Rights

From time to time agencies get calls from prior clients who want to extend the usage rights on a job shot a long time ago. It may be several years after the original shoot. This extra money can be anywhere from hundreds to thousands of dollars.

Normally the agency has a contract from the model allowing the agent to negotiate and execute these rights extension contracts in the name of the model. So they do it, the client accepts it, and the model is bound by it. What is supposed to happen next is that that agent receives the money for the extra rights, takes his commission out of it, and sends the model the rest of the money.

But the model doesn't know anything about this request, will likely never find out about the extra use, and doesn't expect to get any extra money. If the agent simply says nothing, the model will probably never know. That's unethical and illegal, of course, but it happens. Even respected agencies have been known to do it. It's not clear how a model can protect himself against this, except to deal only with agents with a reputation for honesty, and to pay attention to the usage rights for each job they do.

Secondary Income

The gold standard: a real agency makes its money by taking commissions from work they get models, not from selling products and services to models. But often that is not strictly true, even for the largest, most prestigious agencies. They may have secondary sources of income that are taken out of the pockets of the models.

Some real, respected booking agencies take a kickback for photoshoots or composite card printing. Some have "models apartments" where they charge the models for lodging considerably above local market rates and their costs. Often they charge for administrative and courier fees, and do it in a way that the model pays for more than the cost of the services.

Some agencies also offer to pay a model for work even before the client has paid the agency. For that the agency may charge an extra 5% or so in commission, which goes directly to their bottom line.

Another common profit center for the agencies is the "headsheet book" or, in the 21st century, the agency website. They may charge several hundred dollars for inclusion in the book or site. Such charges are traditional among agencies, and most make a profit at them.

In smaller markets some of these "secondary income sources" dwarf what the agency makes from modeling commissions. That means the agency borders on being a scam, but if it's the closest thing to a real agency in the area, it's as "real, mainstream" as many models have access to.

Not all of these practices are unethical or even to the disadvantage of the model. Sometimes the services provided do pay for themselves in increased bookings, flexibility of movement or convenience. But the model does need to be aware of the possibility of each of them, and understand what exactly is being offered and charged.

Then there is the "reserve." Some agencies, primarily large market fashion agencies, charge models an additional percentage as a "reserve" against future expenses advanced by the agency to the model. The theory is that when the model finally leaves the agency, the excess in the reserve will be returned to him. The most amazing number of agencies seem forgetful about this, however. A model should always ask for an accounting if he has a "reserve" arrangement with his agency.

What the Job Pays

Sometimes an apparent scam can be perfectly legitimate. For instance, in New York a model's fee is quoted, and then "plus 20%" added as an agency service fee. A job may pay a $1,250 fee to the model, plus $250 in agency service fee, for a total of $1,500 that the agency bills. When the bill is paid the agent puts the money in the bank, takes his 20% ($250) commission from the model's $1,250 fee, and forwards the model a check for $1,000. All that is perfectly normal.

Increasingly, clients are quoting jobs as "inclusive" rather than "plus 20%", in this case "$1,500 inclusive of agency fee". The same calculations still apply: the agency service fee is backed out and the model quoted a fee of $1,250 for the job. It all works out the same, even though it can get contentious from time to time. Clients and casting directors aren't very sensitive to this problem, so the confusion will probably continue.

But that's not the game this section is all about.

The real game is the one where the agency doesn't tell the model the whole amount of the model's fee, and the agency pockets the difference. It's not often a problem for fashion and commercial print jobs, where the voucher signed at the shoot by the client and model says what the model is being paid. But it is very common on

promotional modeling jobs, where the model may be paid in cash by the agency rep, or where there is no agency voucher signed.

When the Job Pays

We've already described the process of a model getting paid: the client sends a check to the agency, which subtracts its commission and sends the balance on to the model when the client's check clears. The ethical agencies have an escrow account for models' fees. Money goes into this account and is only used to pay models their fees and the agency commission into a separate account. Such escrow accounts, if properly administered, are a helpful guarantee that models will get paid when and what they are due.

But all too often agencies decide that times are tough, they need to "float" the money to stay in business, and they don't pass on model's fees when they should. Some of these agencies delay a model's payment for months or longer so they can use the money to pay rent and salaries instead of sending it to the model as they should.

Even some famous modeling agencies engage in this unethical practice. Some are notorious in the industry for it. Sometimes the agency recovers financially and models get paid what they are due. Other times the agency declares bankruptcy and the models lose the money they worked for.

A model should ask around the industry to find out if their agency (or one they are considering) does this. Usually it is fairly well known. Other models have probably heard of it, and clients likely have as well. They get tired of fielding calls from models asking why they haven't sent a check to an agency for work done six months earlier.

Model's CD-ROMs

If nobody uses it, there's a reason.

This discussion wouldn't be necessary except for a group of people who are trying to sell models CDs to market themselves. As the pitch goes, technology marches on and the wise model stays ahead of the tech curve.

The notion sounds good on the surface. Instead of a bulky and expensive portfolio to send around to agencies or clients, you send a CD. Instead of the five or so pictures you can put on a composite card, you could put 500 on a CD. You could give a casting director everything he needs to know about you in one small, compact, cheap package. Sounds good, as far as it goes. But there are problems with the pitch:

1. You don't have 500 pictures of yourself you want a casting director to see.

2. He doesn't want a CD, he wants pictures. And he wants them in a way that works for his workflow. It has to be convenient for him.

When jobs are cast, the "casting director" (which may actually be several people in a production meeting) gets a couple of hundred comp cards per role from agencies. On a complex job with roles of different types, they may have a thousand or more cards to go through. Their first problem is to do a rough sort: down-selecting from 200 cards to 10 or so for each role. For comps it takes no more than two or three seconds to screen each person. That's long enough to say "no" (mostly) or "maybe" and put the two groups in different piles. For 200 cards that's about ten minutes. For a thousand, it's close to an hour.

Now what happens if they get CDs instead? Each CD has to be loaded in their computer and reviewed. If we are lucky casting director has a computer on the production desk and the CD-ROM designer has been smart enough so they simply put the CD in the drive, let it spin up, and the computer will immediately present pictures for review whether they are using a PC or a Mac. (Those are big assumptions, by the way. These CD-ROM producers usually aren't that smart.) It takes, oh, a minute or so, maybe longer, to review each person.

Now your 200 person stack becomes a 3 ½ hour process just to get through the first cut, and the 1,000 person casting takes a couple of full work days. Nobody has time for that. If they get a CD, they'll likely toss it and move on.

For the final ten people the process becomes to compare them side by side for discussion. If they sent comp cards, no problem. You can simply lay them all out on a table, and choices are easy to make. With CD-ROMs it's a lot harder. Each one has to be loaded and unloaded before the next one can be viewed. Side-by-side comparisons are tough. There are technological solutions to all of this, of course, but those solutions put the burden on the Casting Director and the client, and they aren't looking for additional burdens. They just want to get the selection made, notify the agencies, and go home.

The problem is similar when a model sends a CD-ROM to an agency.

It sounds like a great idea, but it's a solution in search of a problem. Don't waste your money.

Rejection

The cat, having sat upon a hot stove lid, will not sit upon a hot stove lid again. But he won't sit upon a cold stove lid, either. -- Mark Twain

Harrison's Postulate: For every action, there is an equal and opposite criticism.

Here's the great conundrum of the model's existence: She has to think of herself as attractive, and to be confident, outgoing and engaging in interviews. More than that, she needs to *believe* in that confidence. But most of the time she gets rejected. Most agencies turn her down and when one finally shows interest, it almost feels like it was an act of mercy. She goes on castings and the great majority of the time doesn't get the job. Even when she finally gets chosen, nobody is fussing over her or showing her any special deference; she's just the person they chose to hang the clothes on this time. Then the next ten casting calls come, and she doesn't get the job in any of them.

It's worse. At the same time her agent is telling her to have confidence, he's also telling her all about her flaws, and trying to get her to minimize them. Things that wouldn't cause a moment's notice in the "real world" can create an obsession in a model. And if that's bad, being told by a casting director that your neck is too short or hips too wide can ruin a model's day, if not her week.

That's extraordinarily hard to take. Keeping her morale up in the face of all that rejection is very hard to do. It doesn't take long before the model questions if she belongs in the business; if she is even as pretty as she thought she was. Those who survive learn not to take it personally. They finally get it: they just don't look like Bob's daughter.

What a minute! Who's Bob, and what has his daughter got to do with it?

Marlene at the ad agency decides to do a print ad where a father and daughter are together at the gym. She hires Patty the Casting Director to find her models. Patty puts out a casting call to the agencies, looking for Caucasian men in their 40s ("dad types") with brown hair, and brunette Caucasian girls in their teens. The model agencies don't have much to go on, but they send some cards over to Patty. Patty does her first sort and makes a by-name request for ten "Bobs" and ten "daughters". The agencies send the people requested to see Patty and Marlene.

Of all the men, one in particularly stands out. He's exactly what Marlene envisions as "Bob". He's perfect. So then, with Bob chosen, the search becomes to find the girl who looks the most like him. It isn't about who is the prettiest, or the best prepared, or the most confident (although all of those things may count). It's about who looks the most like Bob. And when the model was sent to the go-see, nobody even knew what Bob looked like.

A client has a vision of what they want for this particular ad: a picture in their head that matches the story the ad is telling. If you don't happen to match that story in their heads, you don't get the job. It may be because you don't have a gap in your front teeth and a goofy smile. It might be because Marlene's daughter has brown eyes, and yours are blue. It could be any of a thousand reasons that will be different the next time, and that don't have anything much to do with you, your attractiveness, or your worth as a person or a model.

If you can't learn not to take these things to heart, you will have very tough sledding as a model.

Nudity In Portfolios and Comp Cards

Whether a nude (generally, topless for women, implied nude for men) is appropriate for a model's portfolio depends on the type of model, the city the model is in, and even the specific job a model is applying for.

Fashion Models

Nudes are quite common in portfolios and, to a lesser degree, composite cards for editorial fashion models in major markets like New York, and even more so in Europe. They are used often enough that it is a rare client indeed who would be put off by them. They are much less common for "fashion print" (commercial fashion) models.

Whenever a nude appears in a book or card, it needs to be elegant, sophisticated and fashionable. "Glamour" nudes are not acceptable in a fashion model's book unless specifically suggested by her agency.

Fashion models in smaller cities may find that nudity is not considered acceptable on a card or in a book. Models without an agency should seek the advice of a good agency, casting director or sophisticated client who has seen many models' books.

Commercial Print Models

Generally nudity is not acceptable on a model's composite card even in New York. There can be exceptions for specialty models or extraordinary, glamour-oriented commercial models, but they are quite rare. Implied nudes and sheer garments generally are acceptable in New York, however. They may not be in less sophisticated markets.

A model who is willing and qualified to do nude work may wish to have an elegant nude or two to put into her portfolio, but it should be there only for go-sees for jobs for which it would be appropriate. Nudes should not be in the book when going out for a job for a conservative client, product or role.

Other Kinds of Models

Models specializing in the fitness, glamour and art markets may well find that nudes are a requirement for their books and cards. Promotional models very rarely to never would use nudes.

Child Modeling

In many ways child modeling is similar to adult modeling, but there are some special considerations that apply only to children.

1. The children most likely to be successful have to have <u>all</u> of the following qualifications:

 a. They should be small for their age. That lets them play younger roles in advertising, and have more life experience and maturity than a child of the age they are playing.

 b. They need to be comfortable around adults, and have outgoing, pleasant personalities.

 c. The need to be well-behaved and take direction well.

 d. They should have acting ability, not only to get commercial acting jobs, but because print work also requires acting. Your child had better take acting, singing and dancing classes (NOT modeling classes).

 e. The child has to want it. They have to want it so badly that they pester the parent to get them into modeling, and they have to have the kind of personality that lets them focus on a single task and meet its demands. If modeling is the parents' idea, it's almost certainly a bad idea.

 f. They need a parent who is supportive without being pushy or critical, who is available on short notice to take them to castings, classes or jobs. One parent has to be unemployed, or have a night job.

 g. They need to have the freedom to take off from school from time to time to pursue modeling. That means good grades and a cooperative school administration. In some states, child models also have to get a work permit for each job, which may require the permission of the school.

2. There is a market for kids, but outside the major market cities it is quite small. Top models in Ford's Children's Division can make a very nice income indeed, but the probability of that happening is about the same as growing up to be a Supermodel. Most children get modeling work rarely. Babies get work even more rarely.

3. Child modeling pays roughly half what adult modeling does.

4. Location is <u>much</u> more important to child models than to adults. Parents located more than 50 miles or so from a significant media market city cannot have more than a tiny chance of any significant work for their child. Unlike some adults, children <u>should not</u> relocate to pursue modeling. The risk-to-reward ratio is much too poor. It isn't economically feasible to pursue it unless you are already in a substantial media market city.

5. Relatively few agencies will represent children. Of those that do, most represent them as "talent" (typically, actors, sometimes singers or dancers) rather than models. The reason is simple: there isn't much modeling work for kids, and to have any shot at all you have to be able to do more than "look pretty". Then there is the other reason: most agencies don't want to have to deal with "stage mothers" – so many agencies leave child models to agencies which specialize in children.

6. You don't need a "portfolio" but you do need one or two professional quality pictures. They should NOT be "glamour", "portrait" or "fashion" style - which means 92% of all the photographers within 100 miles of you aren't qualified to shoot them, and 99% of the "Internet photographers" near you aren't qualified to shoot them. You will probably have to pay a good professional to take those one or two shots. The chances of getting what you need from an Internet "TFP" session is near zero.

7. When you have an agency, keep them updated on the children. Kids change rapidly. If they lose a tooth or gain braces, tell the agency. If their sizes change, tell the agency. It's embarrassing for everyone if the child shows up for a job and isn't the size the client needs.

8. Children must always have a parent at any shoot, but the parent should be away from the set if possible. Parents should <u>never</u> give direction to a child during a shoot, unless specifically asked to by the photographer. "Seen but not heard" applies to parents.

9. There is a robust industry designed to take advantage of the parents by providing classes, pictures, access to conventions and lots of other things that will do them no good whatsoever. Very little of what they have to sell, and nothing of what they have to say, should be used by parents in deciding on their child's modeling career. Seek and accept only the counsel of agencies which make their money by booking children.

10. There isn't much mainstream modeling work available on the Internet for anyone. There is virtually none for child models. No Internet agency, "website promising exposure", no magazine with your child's picture in it "to send to casting directors", no "model search" or "modeling convention", and no photographer claiming to be a "manager" will do you a bit of good. The only hope you have is to get representation from a good, brick-and-mortar agency that doesn't sell modeling classes. To do that, you have to do all the things above - and even then it isn't likely to work.

Commercial vs. Editorial Photography

"What is the difference between "commercial" and "editorial" pictures?" This is one of the more confusing questions models face, and a full answer comes in at least two forms.

The first is the formal definition of "commercial" and "editorial". "Editorial" is a picture used to illustrate a point by a writer. It may be a picture of a boy with a fishing pole for a story on fly fishing in Upstate New York; a pole vaulter setting a new Olympic record, in a story on the games, or a bean-pole fashion model in a story about designer clothes. Or any of thousands of other things magazines or newspapers write about. "Commercial" on the other hand, is a photo used by a "commercial client" for their own purposes. It might be a boy with a fishing pole for a rod and reel manufacturer; a pole vaulter in an ad for the upcoming Olympic Games, or a beanpole model in a campaign by a clothing designer. Or any of a thousand other things that people sell. In addition to advertising, it may also be a picture in an annual report (boy with fishing pole to illustrate the improvements in quality of life for corporate clients after the move of the headquarters building.) Or it might be a public service announcement (an anti-smoking ad featuring a pole vaulter who credits his success to quitting). Or a package/box cover for sweaters: a picture of a bean-pole model wearing a cardigan.

As you can see from the description above, the photo itself doesn't determine if it's "editorial" or "commercial", the use of the photo does.

That's the formal definition, and it defines the difference between what a "commercial print" agency does and what an "editorial" agency does (although an "editorial agency" wouldn't stay in business if they didn't do some "commercial" also - editorial doesn't pay well.)

Then there is the "artistic" or "style" definition. "Commercial" pictures for corporate clients tend to be more "mainstream" photography, reflecting the corporate values of the client. Editorial pictures (editorial fashion, at least) tends to be more "edgy" or "avant garde" or "different" or even "weird". Certainly there are no hard and fast rules in that - we see some pretty weird commercial shots, and some very "mainstream" editorial shots. But as a "type" (which is sometimes actually followed in real life) that seems to be the distinction.

Here's an example: two head shots of Shirley Xu, one "commercial" and one more "editorial".

Age, Sex and Race in Modeling

The issue of race comes up a lot in discussions of modeling, and a lot of misinformation gets written about it. Age and sex (gender, to misuse the term as it is commonly misused) don't get discussed much at all, but they should.

Fashion

If jobs were given to models on the basis of their distribution in the population, we wouldn't be having this conversation. But advertisers are less interested in population numbers than in the portion of the market for their product that each ethnic group represents, and in how to reach that portion with their message. The fashion world has struggled with these issues.

Fashion advertising through the 1970s and beyond mostly used Caucasian models. There are many reasons. One undoubtedly was racial stereotyping. Fashion ads are designed to create an association between the brand and whatever people aspire to. Designers viewed white women as "higher class," setting the pattern for emulation by others, so it was natural, if not desirable, that they should choose white models almost exclusively. They reasoned that if their labels could achieve prestige, the ethnic minorities would be brought along with everyone else.

Another reason was the perception that African-Americans were not a significant market for high-end apparel, despite their numbers in the population. It remains true that the median household income of African Americans is substantially less than Caucasians, a fact not lost on the fashion houses. Only in relatively recent times have two additional demographic facts become understood: African Americans spend nearly a third more than Caucasians on apparel as a percentage of their income; and African Americans tend to form brand loyalties much earlier and more strongly than Caucasians. As the advertising industry came to appreciate those facts, the African-American market segment seemed suddenly more important.

There remains the problem of how to reach it. African-Americans are hardly a unitary bloc when it comes to purchasing power. Urban/Hip Hop lines like Baby Phat and Sean John may appeal to a part of it, but that portion of African-American consumers who might purchase Calvin Klein, Donna Karan or Tracy Reese is little impressed by the hip-hop approach. There remains a debate as to whether it is best to advertise through African-American oriented magazines and media, or through more general-interest media.

In the last decade there has been an increasing trend to use African Americans in magazine editorials and covers and as runway models. High-profile models like Imam and Tyra Banks have shown that black models can be attractive to white audiences, and models like Alek Wek have changed the perception that black models have to have light skin and European features to be seen as beautiful. Even so, although there are no authoritative numbers available, the perception remains that African-Americans are under-used by fashion designers.

Designers are not the only important source of fashion advertising, though. If the designer sets the "national" tone for use of models, retailers set the regional and local pattern. In recent decades they have become much more willing to use minority models in their advertising, although that depends on the local demographic. A mall store in Bangor, Maine is more likely than one in Atlanta to use Caucasians in its advertising. But overall, from about the middle of the 1990s on the number of African Americans used in retailer fashion ads has approached their distribution in the population.

The situation is different in the other "major minorities". Hispanics are more fragmented than African Americans. They may share a common home country language, but they come from many countries and different cultures. Hispanic is also not a "race" and many Hispanics are cross-identified (or see themselves) as Caucasian. Finally, even though they are numerically about the same as African Americans, they spend a smaller percentage of their household income on apparel, and their brand identification is weaker. It has been easy for advertisers to treat them as simply another kind of Caucasian, perhaps advertise in Spanish-language media, and leave it at that. As their percentage of the populations rises, however, that seems to be changing.

Asians present a different problem. As a group they represent only a small portion of the US population (roughly 3%). But there really is no such thing as an "Asian group". They are primarily Chinese, Japanese and Koreans, and each of those differs markedly from the others. What you do to target one with advertising doesn't work well for the others, and using a Korean model may not improve your label's desirability with Japanese.

There are other issues as well. Asians tend to be shorter than Caucasians, and to have relatively long torsos and short arms and legs. That is precisely the opposite of the "fashion model" mold. If Caucasian and African

fashion models are something of a rarity, recruiting slim, 5'10" long-legged Asian girls as models has proved a challenge for the agencies. It's hard to have a large number of them on the roster – and when they are there to chase 1-3% of the market, it's hard to justify the effort. Needless to say, fashion advertising tends not to overachieve in using Asian models.

Commercial Print

As late as the early 1990s, studies of print advertising found no more than 3-4% of models in ads were African-American. That changed greatly in the decade that followed.

In the USA, national print ads are largely produced in New York. Not surprisingly, they are targeted at people advertisers think will spend money on their products. Requests to model agencies are usually very specific about the sex, age, ethnic group and type of person the client wants. When they aren't specific, agents ask.

The Census Bureau figures for year 2000 show that non-Hispanic Caucasians make up about 62.6% of the population of the United States. African Americans are about 12.3%, Hispanics 12.5%, Asians 3.0%, Asian Indians (which are asked for separately by casting directors, even though the Census Bureau considers them "Asians") are about 0.6% of the American population. About 2.4% of Americans are of "mixed" race (which, for casting purposes, tends to get lumped into groups like "Ethnically Ambiguous") and another 5.5% are of other races.

We put together a statistical study of 3,419 actual commercial print casting requests to characterize ethnic requests as best we could. The data is from a classic New York City "commercial print" agency that doesn't get very far afield with "fashion" or "fitness" or "promotional" modeling that would skew the numbers.

Here are the results presented as statistical tables. Each number represents the percentage of modeling jobs in that age category for a particular ethnic group:

Adult Female Models, Ethnic Percentages by Age Group:

Age:	Total	17-23	24-29	30-39	40-49	50-59	60+
Caucasian	49	45	43	45	44	54	55
African-American	20	24	23	21	22	17	15
Hispanic/Latino	16	18	18	16	16	15	14
Asian	10	8	9	11	12	9	10
Ambiguous	4	4	4	5	4	5	6
Asian Indian	2	2	2	2	2	0	0

Adult Male Models, Ethnic Percentages by Age Group:

Age:	Total	17-23	24-29	30-39	40-49	50-59	60+
Caucasian	51	44	44	51	53	53	56
African-American	18	22	21	16	15	14	18
Hispanic/Latino	15	16	19	16	13	13	12
Asian	9	11	9	8	9	8	9
Ambiguous	6	6	5	8	8	9	6
Asian Indian	2	2	2	2	2	2	0

OK, I know that people's eyes glaze over when they are presented with columns of statistics, especially when it isn't exactly clear what the data mean. So let's give some examples. Here are conclusions we can draw from the tables.

1. Among women, overall 49% of commercial modeling jobs go to Caucasians. The percentage is a little smaller for younger women through their 40s, but rises to about 55% for women in their 50s and 60s.

2. The pattern is the reverse for the major ethnic subgroups. About 20% and 16% of all female modeling jobs are for African American and Hispanics respectively, but the percentages are higher for younger models than older ones.

3. Among Asians and other minorities, the percentages remain reasonably constant at all ages.

4. The patterns are very similar for male models. About half of all modeling jobs are for Caucasians, but the African American and Hispanic models take a bigger share of the market in their younger years, and then a smaller share as they get over 40.

5. **The only ethnic group systematically underrepresented is Caucasian.** Hispanics, African Americans and Asians are all asked for substantially more often than their distribution in the general American population.

6. The exceptions are the "other races" category which collectively is less than 6% of the population, and American Indians. None of these groups makes up enough of a market that national advertisers target ads at them, so the demand for models in those categories is virtually non-existent. The way models and agencies handle this is to disregard what a model really is, and present him as what he can appear to be. There are a lot of Persian "Hispanic" or "Generic Ethnic" models, for instance, because advertisers never ask for "Persians."

Now let's take a look at the same raw data, but presented in a different way. This time we want to ask ourselves the question, "What percent of all commercial print jobs goes to any particular age and ethnic category?" Here are the results:

Adult Female Models, Percent of Total Modeling Jobs by Age and Ethnic Group:

	All Ages	17-23	24-29	30-39	40-49	50-59	60+
Caucasian	**24.1**	5.1	6.4	5.4	3.2	2.5	1.5
African-American	**11.4**	2.7	3.4	2.5	1.6	0.8	0.4
Hispanic/Latino	**8.9**	2.0	2.7	1.9	1.2	0.7	0.4
Asian	**5.1**	0.9	1.3	1.3	0.9	0.4	0.3
Ambiguous	**2.3**	0.4	0.6	0.5	0.3	0.2	0.2
Asian Indian	**1.0**	0.2	0.3	0.3	0.2	0.0	0.0
Total	**52.8**	**11.3**	**14.8**	**11.9**	**7.4**	**4.6**	**2.8**

Adult Male Models, Percent of Total Modeling Jobs by Age and Ethnic Group:

	All Ages	17-23	24-29	30-39	40-49	50-59	60+
Caucasian	**23.5**	2.5	4.2	6.7	5.0	3.4	1.8
African-American	**8.1**	1.2	2.0	2.1	1.4	0.9	0.6
Hispanic/Latino	**7.2**	0.9	1.8	2.0	1.2	0.9	0.4
Asian	**4.1**	0.6	0.9	1.0	0.8	0.5	0.3
Ambiguous	**3.3**	0.3	0.4	1.0	0.8	0.6	0.2
Asian Indian	**1.0**	0.1	0.2	0.2	0.2	0.1	0.0
Total	**47.2**	**5.7**	**9.4**	**13.0**	**9.4**	**6.5**	**3.2**

What conclusions can we get from these tables? Here are a few:

1. Only 11.3% of all commercial print jobs are for young girls in the 17-23 year old category. The highest percentage of these is Caucasian, but that still means that **95% of all commercial print work is NOT for "pretty young white girls".** Obviously it's very different in fashion, glamour, art, fitness and some other specialties. But these are numbers that people ought to be aware of when deciding that "I'm too short to be a fashion model so I'll be commercial".

2. "Prime time" is the late 20s and 30s for women, 30s and 40s for men, and in fact **the average age asked for is 37** (35 for women, 39 for men).

3. Not shown in the numbers are further important attributes that qualify a model for a job. No matter who or what you are, **93+% of all commercial castings are not for you.** Even disregarding other things as

hair color and "type", a commercial print agent has to get 15 or more castings in for every one that he can give to even his most popular model. With those other considerations thrown in, even the most popular model may only be qualified for one job in 30 or so.

The figures and conclusions above are for New York national commercial print ads. It's a lot harder to find statistics on local ads, which could be more expected to follow local demographics rather then national. It would be reasonable to believe (even though we do not have data to demonstrate) that local commercial print advertising in Seattle would be different from Detroit. But assuming that, in aggregate, local ads are similar in racial, age and sex distribution to national ads, the overall opportunities should be similar throughout the country, even though there will be areas which vary substantially from that average.

Height and Professional Modeling

We hear this all the time: *"I've always wanted to be a model. Everyone tells me I ought to be a model. I'm 5'2" tall. Can I be a model?"* The answer is "yes". But for professional fashion models it is about the as probable as being struck by lightning on the way to cash in your winning lottery ticket. Even for commercial models, the market for short younger models is small. The realistic answer is "no."

"That's not fair." No, it's not, but that's the way it is. This is a business, it isn't about what you want or what's fair, it's about what the marketplace wants. The mainstream market doesn't want short models.

Fashion

Women

Height requirements in fashion are driven by two factors: sample size and preference. Designers and fashion photographers prefer taller models. Dresses for runway shows and editorial and advertising photography are cut to a "sample size" that reflects that preference. Once the clothes are put together it's a lot easier to hire a model to fit than to redo the clothes for a shorter model.

The requirements for being a major market fashion model are not absolute – they are just (very strong) preferences. Everyone in the industry knows that Kate Moss and Laetitia Casta, among others, don't fit the "standards," and yet they have been very successful. So why shouldn't you say to yourself "Hey, what about them? I'm only 5'7" tall, but so are some other fashion models I could name. That means I have a chance to make it, right?" Yes, it does. But we have to distinguish between "possible" and "reasonably likely."

Let's look at some numbers. A study done in 2002 showed that among top editorial fashion agencies in Los Angeles and New York, 81% of their "editorial fashion" models were 5'9" and above; 15% were between 5'8" and 5'9", and only 4% were below 5'8" tall. According to the US Center for Health Statistics, only about 3 ½% of all young women are within an inch of 5'10". The average weight for those women is about 145-150 pounds – some 30 pounds more than the "normal" fashion model. If you add in factors like facial beauty, body proportions and all the other things that qualify a girl to apply as a "fashion model" the competition is a very small part of the population.

By comparison, almost 20% of all young women are within an inch of 5'6". So couple the strong desire of the fashion industry for tall women with the fact that a short girl has 5-6 times the number of competitors, and the chances look very small indeed.

When a model below 5'8" tall is successful it is almost always because someone, typically a photographer, agent or editor, took a special interest in a girl and "made" her career. It doesn't happen through the normal route, but by having a special person with influence in the industry decide, for whatever reason, to push you to the front of the line. Things like that can't be worked for, planned for, or reasonably hoped for. They simply happen, very, very rarely. The "modeling schools" and the scammers seek out girls who want to believe they can be the exception. They assure girls that they can, but they never say what it really takes to be that exception – because it's almost certain most victims don't have it, and the schools and scammers aren't going to give it to you.

A girl who does not meet the "standards" for a fashion model almost certainly should not spend a lot of time, effort and money pursuing that goal when the probabilities of success are so very low. She is better off pursuing some other kind of modeling that uses different standards.

Men

For men the situation is very different. It's still hard to make it if you aren't the preferred six-footer, but the numbers tell a different story. Over 25% of all young men are within an inch of being six feet tall. The average weight for young men of that height is 175-180 pounds – not very different from what the fashion community wants. If it's true that a short girl can get taken by an agency simply from the difficulty of finding enough tall girls, the opposite is true for men. There is an abundant supply of men who meet the height criteria, so there is little need for an agency to look outside their preferences.

Commercial Print

The typical reaction when counseling short aspiring models is that, since they can't be a fashion model, they ought to be a commercial model. It's pretty common to hear that "height doesn't matter" in commercial

print. The motivation is understandable, and there is some (limited) sense behind the advice. But it's every bit as wrong as it is right. Here's the truth: The criteria are different than they are for fashion, and not as firm. But **height <u>does</u> matter in commercial print.**

For the most part, very tall and very short models (for women, 5'11" and above, 5'4" and below, for men 6'3" and above, 5'8" and below) are not what the print industry is looking for. Yes, there are exceptions, and commercial agencies tend to have some models who will work in those exceptional cases. But for the most part, commercial work goes to those who are of "middle height". (Yes, 5'4" is close to the median in the "real world", and 5'4" girls really are not "short". But the terms and criteria used here are based on the norms of the modeling industry, not "real life".) **The average female commercial print model is 5'6 ½" tall, the average male 5'11 ½" tall.** We did an analysis of who was actually requested for commercial print work, based on thousands of castings. A great majority of the time, height was not specified, but when it was, **96% of requests were for women over 5'6" tall.**

Since height is not often an explicit part of the casting request, we took a look at who actually gets hired. The sample size was a lot smaller than for requests, but based on what we have observed, we can draw some tentative conclusions:

1. Short minorities are more likely to get hired than short Caucasians. That is especially true of Asians, less so of Hispanics.

2. Short older models (over 40) are much more likely to be hired than short younger ones. There is too much competition among the 5'6" and above group for a young, shorter girl to compete.

Again, this is for classic "commercial print" work, not specialties like glamour, promotional or fitness modeling, where height doesn't seem to matter as much.

The bottom line is this: Except for Asians, **the market for young female models under 5'5" is vanishingly small,** much less than 1% of the market. With rare exception, a taller girl can do pretty much any print job; a shorter girl is limited to a very small subset.

Agencies know that. And that is why it is so difficult for a short model to attract the attention of a commercial print agency.

Promotional

There is a preference for taller models in promotional modeling (taller people are easier to see in a crowd, and attract more attention), but it's far from a requirement. Many promotional models who are well under "modeling" height have had excellent careers.

Glamour and Art

There is no height requirement for glamour and art models.

Getting an Agency if You are Short

Fashion agencies want tall models. Commercial print agencies in major markets may have a variety of heights, and so accept shorter models. But agencies in medium and smaller market cities generally are "hybrid" agencies which book a lot of commercial fashion work, and that sets the baseline for their needs.

Many non-fashion clients don't much care about the height of their models. If models were all 5'4" tall that could be just fine for them. But there are three reasons why print agencies don't carry many short models on the books:

1. Even though "short" may be OK, a large height disparity between models used in a multi-person shoot is not OK. Since most models are on the tall side, it's more likely that another tall model will fit in.
2. Very few clients will object to a 5'9" inch model – but many will not want to hire one at 5'3". So the taller girls can do virtually all the commercial jobs that the short ones can, but the reverse is not true. Shorter models can only do a fraction of the work available.
3. In smaller markets, clients tend not to want to spend a lot of money on models. If they need taller models, they probably need to use an agency to find them. But if short models will work for them, as likely as not

they will use family, friends and company employees, who are readily available in heights less than 5'8" (women) and 5'11" (men). Agencies know that too, and they don't try to compete with the client's niece.

Agencies don't want a lot of models that aren't getting much (or any) work – they would much rather have all of their models working as much as possible. So they want to sign models that can work in as much of the market for their type as possible. And that means taller models.

A Primer on Modeling Law

Most models simply go about their business, doing shoots or shows and cashing checks and never worrying much about laws. If they are lucky they never will have to. Sadly, many models are not so lucky. Things go wrong, they lose money or worse, and often it is too late to recover from a bad situation that could have been prevented. Just as bad, you could pass up a wonderful opportunity because you don't understand that it is presented as such things always are: in scary language. So here's what you need to know.

<u>Copyright Law for Models</u>

The obvious question: "Who Cares?" Maybe you don't, but how about a little fable:

Mabel goes to a photo shoot, has some wonderful pictures done, and pays Ralph the photographer for the shoot and prints. So far, so good.

She takes the pictures to a print shop and has a few hundred comp cards made up.

Mabel also joins a "model listing" website that put her pictures, stats and contact information on a web page. She starts getting offers of work from her web page.

She submits her pictures to modeling contests, too. She's even a finalist in one of them, and the contest sponsor uses her pictures in advertising their contest on the web.

A local artist sees Mabel's pictures and wants to use one of them as the basis for a fantasy painting he is working on. Mabel agrees, and the picture is so good the local newspaper publishes it as part of a story on the artist's gallery and show.

A local restaurant sees her pictures on the web and wants to know if she would accept a $200 model's fee so they can use the shots to advertise their restaurant. Mabel happily agrees, and the restaurant puts her picture in their ad in a local entertainment and arts magazine. Mabel even gets a tearsheet out of it. She's a very happy Mabel.

Then she gets a telephone call from a very unhappy Ralph. Enter the Dragon (Ralph's lawyer), stage right.

Mabel is convinced she did nothing wrong. After all, she paid Ralph for his time and the pictures, so they are hers to use, right? Wrong!

Since buying her pictures from Ralph, Mabel has violated copyright law in at least five different ways. Ralph may choose not to make a fuss about it, but he could. A print shop, contest promoter and sponsor, a restaurant owner, an artist and Mabel all could get sued if Ralph chooses to take a hard legal line. He could win, and the bad publicity and ill will Mabel gets from all those people could badly hurt her modeling career.

Have we gotten your attention yet?

What Copyright Is:

As the name suggests, **copyright is the right to make copies**. The person who owns the copyright can keep others from making copies of his picture, or can license others (perhaps for a fee) to make copies. He can sell the copyright if he wishes, to one person or many. Under some circumstances (for some art photos) can also keep people from making changes to his picture that might show it in what he feels is a bad light (what is called "moral rights", also part of the copyright law).

Unless something explicit, <u>in writing</u>, changes it, the photographer is the "author" of a picture and owns the copyright. There are exceptions, but mostly they don't apply to the kinds of situations a model might find herself in.

Copyright is established in Federal law, so it's the same all over the United States (and similar in most other countries). Mabel would have the same issues almost anywhere.

The Legal Effect of Copyright:

So what does that mean to Mabel? She has a print she paid for. She can show it to anyone she wishes – she just can't make a copy of it, or let anyone else make a copy of it. She also might not be able to let anyone make substantial "improvements" to it without violating Ralph's "moral rights" or copyright.

So when she had composite cards printed, she violated Ralph's copyright. When she put pictures on the Internet, those were copies of her print, and she violated Ralph's copyright. When the restaurant used the shots of

her in their ad, she and they violated Ralph's copyright. When the artist changed Ralph's work, he may have violated Ralph's copyright.

And even though Mabel signed a piece of paper authorizing the contest promoters to use or even to own the rights to the pictures she submitted to them, she and they violated Ralph's copyright. Her authorization isn't valid; she was trying to sign away something she didn't own.

Is That the Way Things Really Work?

Some Gentle Reader may notice that at least some of what Mabel did is done by models all the time without creating a problem. And sure enough, the Gentle Reader would be right. Most of the time models who get pictures from photographers can use them on comp cards or self-promotional websites without objection from the photographer. That's an industry-standard practice, even though it doesn't strictly speaking follow the law. There are photographers who insist on getting paid extra for the rights to do those kinds of things, but they tend to be on the fringes of polite photographic society.

When Mabel entered the contest she was asking for more trouble. Contests frequently put clauses in their entry forms saying the contest promoters or sponsors own rights to the pictures submitted. So what happens when a photographer notices the shot used to advertise the contest and he objects? The contest promoter throws up his hands in mock surprise and says, "Hey, she signed a contract saying she owned the rights and assigned them to me. If you have a problem, go sue her!" And he could.

Allowing someone else to modify her pictures also is dangerous. If the photographer delivered shots that weren't retouched and she has someone else do it he probably won't object. But when some artist takes Ralph's art work and turns it into a Dungeon scene, Ralph could get a mite peeved. That is creating a "derivative work", which requires Ralph's permission.

What the restaurant did is the clearest and worst kind of copyright violation. They took a picture and used it to advertise themselves. That's certain grounds for a lawsuit if Ralph is in a bad mood.

Dealing with the Issue

Another Gentle Reader who has heard a little bit about copyright law might object, "Wait a minute. She hired Ralph to take her picture. The law provides for a 'work for hire' exception, so Mabel owns the copyright."

This time Gentle Reader is wrong. The copyright and moral rights could be hers if she had the photographer sign a "work for hire" agreement <u>before the shoot</u> – but she didn't. So the exception doesn't apply.

"Hold it!" our Gentle Reader cries out. "He was working for her, and the employer owns the copyright to pictures made by an employee." Once again, our Gentle Reader hasn't understood the important fine points. Mabel did pay the photographer to take her picture, but he was an independent contractor, not an employee. She didn't put him on her staff, didn't withhold Social Security and Medicare payments from his fee, and didn't have unemployment or worker's compensation insurance for him. In short, she didn't treat him like an employee – she just bought some of his services and pictures. So the "employment" doctrine doesn't apply to her. Ralph owns the copyright, and she has to live with it. (Canada and South Africa are exceptions, where the person who commissions a paid shoot owns the copyright).

Does that mean Mabel really can't use her pictures? She probably can at least for some limited uses, but to be legally safe, there are some things she ought to do:

1. Before you hire the photographer, find out his policies for how use the pictures. Can you have a copy shop make extra prints, or does he insist that he do it and sell them to you? Can you use them on comp cards? Websites to promote yourself? Most photographers will allow these kinds of uses, but some may not, and you need to know it <u>before</u> you hire a photographer.

2. If he will agree to it, have him sign a "work for hire" agreement <u>before the shoot</u>. Then you will own the copyright and moral rights to the pictures. Now the photographer has to come to you for permission to use them himself, and can't object to uses or changes you make in them. But many photographers won't sign such an agreement, at least not without a very large increase in their fee. From their perspective they are signing away their rights to make additional income from future copies or uses of the photographs.

3. Ask him for a license (or "waiver of copyright") for you to use the pictures for self-promotion. Most photographers will sign such a release willingly, unless the shots are being made as part of a commercial shoot for a client. Even then the photographer may sign the release if it takes effect after the client's ad is published.

4. If you want to use the pictures for something other than self-promotion, ask the photographer about it. He may grant permission (get it in writing!) and he may ask for a fee. Note that a contest is not just for "self promotion" for the model. The contest sponsors have their own ideas about how those pictures will be used, and it is to benefit them, not the model. Photographers can take a dim view of that.

5. By law, a model can't make copies of the ads she appears in (by, for instance, putting them on her composite card.) Even so, it is extremely unusual for an advertiser to object to this, even though formally it is a violation of copyright law.

Most models don't take the trouble to do these simple things, and usually they get away with it. But smart models will ask before problems arise, and that will keep them from the truly awful messes that can arise if a photographer decides to get ugly about something a model did with his pictures.

Use of a Model's Images

Let's spend a little more time Mabel and her favorite photographer, Ralph. This time things work out a little differently.

Mabel goes to a photo shoot, has some wonderful pictures done, and pays Ralph the photographer for the shoot and prints. So far, so good.

Very, very good, in fact. Mabel is a real beauty, and Ralph has some pictures of her that he really wants to show as examples of his work. He makes some extra prints and puts them in his portfolio, and hangs pictures of Mabel on his studio office walls.

Ralph does a lot of his marketing through a personal website. He puts some of Mabel's shots on that, too, and refers potential clients to them by email.

Mabel's pictures get a very positive response from his clients, so he has his own comp card printed up with a picture of Mabel on it, and sends out a mass mailing.

One of the people to get that comp card in the mail is the Arts and Leisure Editor of the local newspaper. He's calls Ralph. Would Ralph consent to an interview for the Sunday Supplement? Could they use a picture of Mabel in it? "Of course!"

A local artist sees Mabel's pictures in the paper and wants to use one of them as the basis for a fantasy painting he is working on. Ralph agrees, and the picture is so good the local newspaper publishes it as part of a story on the artist's gallery and show.

A local restaurant sees Mabel's pictures on the web and wants to know if Ralph would accept a $200 fee so they can use the shots to advertise their restaurant. Ralph happily agrees, and the restaurant puts Mabel's picture in their ad in a local entertainment and arts magazine. Ralph gets a tearsheet out of it. It's even better: the restaurant is part of a franchise chain, and the national headquarters pays Ralph a $5,000 fee and publishes Mabel's picture in their nationwide advertising. We have a very happy Ralph.

Then he gets a telephone call from a very <u>unhappy</u> Mabel. Enter the Dragon (Mabel's lawyer), stage left.

So what went wrong here? There's no copyright issue. Ralph owns the copyright, and if he wants to, he can license anyone else to make as many copies of his pictures as he likes. Mabel has no right to control that.

A Model's Rights

There is more to the use of a photograph than copyright. Mabel has control of how her image is used. Ralph can make all the copies he wants of her pictures, but he may have to put them in his safe and never show them to anyone. Or maybe not. It depends.

The reason it depends is that Mabel's rights are based on State law, not Federal, and there is a huge difference in the way the various States treat these things. Depending on the State, she may have a Right to Privacy that Ralph violated when he let her pictures be published. In about half the States she has a Right of Publicity, which prohibits people from using her pictures in advertising without her consent. In California and some other States she also has a right against Misappropriation of Likeness, which adds an additional layer of civil and criminal penalties to all the things Ralph did. If Ralph lives in San Francisco, he's in a heap of trouble.

On the other hand, there are States in which Mabel's rights are very limited. New York explicitly permits Ralph to show pictures of Mabel in his studio unless she objects in writing. Only commercial use requires the model's permission. There is no separate "right of privacy".

Then there are States like North Dakota, in which it's not clear that anything Ralph did creates a problem for him. There seems not to be any statutory or common law that applies. Ralph may move to Bismarck before Mabel's pet Dragon files court papers.

The newspaper's use of her picture in their article is not a violation of her rights. "Editorial" use usually is allowed without permission of the subject.

The restaurant chain has a bigger problem. They used her pictures in advertising nationwide. There certainly are States in which Mabel can bring suit for hefty sums for that use, even if she can't sue Ralph.

We haven't even discussed some more sensitive uses. Suppose the picture is used in a condom ad? Suppose the picture is manipulated, or text added to the publication, which makes Mabel look disreputable? Suppose the printer makes a huge error, all Mabel's pictures get badly distorted, and people in town start laughing at her? Mabel might have a legal cause of action for "portraying her in a false light."

All of the above shows what a mess these issues can be, and how difficult it is to know exactly what the law requires to use an image. Sophisticated advertisers usually assume the worst, and try to protect themselves against it.

Is That the Way Things Really Work?

As a practical matter, as long as there is nothing particularly sensitive about the pictures themselves, Ralph may not have a problem if he just uses them in his portfolio, on his website, and in his composite cards. In many places such uses are assumed to be part of the deal when a photographer shoots a model, and the model risks making a bad name for herself if she objects. In most places the newspaper can make editorial use those pictures without problems also.

But use in advertising is another matter. In virtually all cases an advertiser has to have the permission of the model, and in many States that permission has to be in writing. If the use is for something sensitive (such as an HIV ad) context may have to be authorized in writing.

Keeping Problems from Happening

The more professional photographers and advertisers know these things, and they are usually very careful to keep themselves out of trouble. They have the model sign a "Model's Release" that gives them the right to publish the model's picture as they want to.

In a commercial or editorial job the model (or her agency for her) will be asked to sign a release. It can be very broad (a "buyout" release with broadly worded permissions) or very narrow to cover only a specific use at a specific place and time. That release has value, and it's one of the things the advertiser is buying with the fee he pays the model.

In more informal arrangements like a simple shoot between a model and a photographer, the issues are a bit cloudier. The photographer may want some kind of right to use the pictures. If he doesn't get it, his price for the shoot may go up, or he may refuse to shoot the model at all. He may insist on a "full release" that essentially gives him unlimited rights to use the shots, or he may settle for something more limited.

Rights have value, and the model can negotiate as many or few of them as she wishes and the photographer will let her keep. A release is part of the compensation (or "consideration") that a photographer gets for doing the shoot; the more rights he gets, the more interested he will be in shooting. Photographers doing "test shoots" for agency models almost never require a release, and by tacit agreement with the agencies have limited usage rights to the pictures. Internet photographers doing TFP/TFCD shoots almost always do require a release.

Depending on the model's situation, personality and values, and the nature of the shoot, she may have little problem with the pictures being widely published. Or she may want to severely (or completely) restrict their use. All of those things have to be thought through by the model and the photographer, and some agreement should be come to <u>before</u> the shoot to avoid bad feelings and possible legal problems later.

Modeling and Taxes

Income:

Modeling income is taxable. It must be declared on your tax return.

Most of the time a model will be considered an "independent contractor," which means she is responsible for paying her own taxes, including the employer's part of Social Security and Medicare. Those taxes alone can take 15% from a model's pay, even before income taxes take their bite.

For models working without an agency, any single client that pays her more than $600 in a calendar year is required to report the income to the Federal government on a form 1099, which is also sent to the model not later than January 31st of the following year. Clients who pay less than $600 are not required to send a 1099. Agency models may find if the aggregate of all work they do with one agency exceeds $600 in a calendar year they will receive a 1099 from the agency, rather than directly from the clients they worked for.

Sometimes a client will use a "payroll company" which will, for tax purposes, act as the employer for that job. When that happens the model will be treated as an employee rather than an independent contractor. The payroll company will withhold taxes and pay the employer's part of Social Security and Medicare taxes. They will send a W-2 to the model at the end of the year, either directly or through her agency.

The bad news in jobs where a payroll company is used is that the model doesn't get her full fee (or full fee less agency commission) right away, since some will be taken out for taxes. The good news is that the tax burden on the model is about 7 ½ percent smaller, since she doesn't have to pay the "self employed" Social Security and Medicare contributions. Using a payroll company also greatly reduces the possibility of a big lump of taxes due on April 15th.

Expenses:

Modeling is a business, and business expenses are tax deductible. Because of the unusual nature of the business, models may be able to deduct things that mere mortals would not be able to. Depending on circumstances, a model might be able to deduct the costs of some:

1. Clothing
2. Makeup
3. Grooming (haircuts, manicures . . .)
4. Cosmetics and hair products
5. Health Club memberships
6. Travel to and from go-sees, jobs and the model's agency
7. Photo shoots and pictures
8. Portfolios
9. Composite Cards and postage to send them to potential clients
10. Office expenses
11. Agency and/or manager commissions
12. Training
13. Accounting and legal fees
14. Professional education and seminars
15. Postage and courier expenses
16. Professional association/union dues
17. Professional publication subscriptions
18. Taxi fares
19. Telephone
20. Travel expenses (air fares, hotel, meals, car rental . . .)

That by no means exhausts the list of possible deductions, and not all such expenses can be deducted. There may be limitations based on how much income you make from modeling. The variables are far too complicated to try to explain in a single chapter of this book. The most important thing for a model to remember is to save receipts for everything related to modeling, and let a good tax accountant figure out what is deductible at the end of the year. It might save you a lot of money.

Should a Model Incorporate?

On the face of it the question seems a little silly. The last thing a model gets into the business for is to have all the problems that come with setting up and maintaining a corporation. She wants to walk runways, get her picture taken, and cash checks.

Incorporating and having the model's services be billed by the corporation rather than the model herself can have two advantages: limits on liability and tax advantages. Although many corporations exist primarily to shield their owners from personal liability if things go wrong (a plaintiff may be able to bankrupt the corporation, but not the shareholders), that's not a powerful issue for models. Taxes may be.

Corporations can make tax-deductible investments and take deductions that may not be available to individuals. For many models who do not make a great deal of money from the business it may not make sense to incorporate themselves. But some more successful models have found incorporation to be a useful and profitable step to take.

If your modeling career takes off it might be worthwhile to talk to an accountant or attorney about the possible benefits that forming a corporation might bring you.

Contracts with a Model's Agency

One of the first legal issues a new model may encounter is a contract presented by an agency. If she signs it, she's one of their models. If she doesn't, she might not be. Such contracts tend to be full of big words and scary language. Often they are so long that a model is implicitly encouraged to sign the thing just to get out of the drudgery of trying to figure out what it all means. They are <u>always</u> worded in ways that work to the agency's advantage.

Although the contract will often be presented as a "take it or leave it" deal, with no negotiation encouraged, if there is something in it that you find bothersome it can pay to ask about it, and perhaps get it changed. Here is what you may see in a contract from a <u>good</u> fashion agency:

What Will The Agency Promise?

Not much. They won't promise to get you work. They can't – only clients can do that, and you have to compete for the jobs. If it's a management company in a State like New York where management companies act as agencies, they may not even promise to try to find you work – that could be a violation of law. That's how they make their living – but they still won't promise to do it for you. They won't promise to manage or control the conditions of any assignment. That's between you and the client too. At best the agency will try to help get a good deal for you. They may promise to do things to "develop" you and provide you advice, but how much they do is pretty much left to their discretion.

All of that is normal. Agencies are protecting themselves with that kind of language. It's much better for them if you believe you will get lots of jobs and lots of support from the agency, without them actually promising it. You have very little chance of finding an agency that won't have that kind of language in their contract. And who knows, what you want to believe may turn out to be true, if it's a good agency.

Exclusive or Not?

Contracts should explicitly say if they are exclusive or not. The "exclusive" nature of the contract may be worldwide or limited to only one kind of modeling in one city. Often a model can negotiate limitations on exclusivity with the agency, but some agencies require an exclusive relationship of some sort as a condition of working with the model. Generally the more investment of time and money the agency is going to make in the model, the greater the probability that they will want an exclusive (and the greater the justification for it).

How Long?

Representation contracts can be from as short as one year to as much as five years. In some cases the contract will be "at will" on both sides, meaning either you or the agency can cancel it any time you want to.

The agency would prefer to have you for as long as possible, especially if they are going to be investing a lot of effort or money in developing you. If you really like them, you might want to be locked into them for a long time too, although generally a model's interests are better served if she has some flexibility now and then.

Length of contract usually can be negotiated, depending on how much they want you.

It's Over When It's Over

There may be an automatic renewal clause in the contract that says when the term is up; it starts all over again without anybody doing anything. Somewhere it will say what you have to do to keep that from happening. Make careful note of that part in case you need it.

The hope is that you and the agency will be so deliriously happy with each whenever it expires that it wouldn't occur to either of you to change things – so they just keep on going, unchanged. Still, it isn't that hard to come into the office (or send a fax) once every few years to renew a good relationship, and it may be best to ask that this clause be taken out of the contract. They may or may not agree.

What Do They Get Paid?

A manager or agency will have a standard commission rate that they charge their models. The rate may be established by law (in some jurisdictions, limited to 10%) or by custom, or may simply be what they think they can get away with. New models have very little chance of changing the commission. What they charge is what they charge, and if you want to be with them, you have to pay it. It is smart to check with other agencies in the area and see if they are consistent, and if not, to ask questions about why this agency charges more than others.

Most contracts will also contain language that says when an agency gets work for you with a client, any further money you make from that job (or even perhaps later from that same client) will result in a commission to them even if you leave the agency. Again, that is normal. If the agency has made the contacts for you to get the job, you owe them for whatever fees you get from it.

What Happens To Your Checks?

Clients pay the agency for work done by the model. (They may also pay the agency a separate fee for work done for them in finding the model.) The agency deposits the check, takes out their cut, and then forwards the balance on to you. They can do that because the contract you signed allows them to.

Except for union acting jobs, that is almost always the way the agencies work. If you insist on having your fees sent directly to you by the client, the agency will likely insist on not working with you. They are protecting their own interests, making sure they get their commission from your work.

But they protect your interests too. The agency will act as a collection service, calling, writing or even suing a client to get money from them. That's work you don't have to do, and may not be effective at, since you don't have the clout or experience that an agency does. Still, it does lead to an opportunity for mischief with an unethical agency, or with one that goes bankrupt.

Who Works for Whom?

Except for some promotional agencies, which don't have contracts like this anyway, agencies will want to make it very clear that you aren't their employee. If anything, they are working for you, not the other way around. It's not negotiable.

The Model's Release

The contract will give the agency the right to publish your pictures in their own marketing materials. This is normal, and something you really want them to do. It's possible for something like this to be misused, but not likely at a reputable agency, and if you are bothered by this clause, you probably are pursuing the wrong line of work.

They Have Your Power of Attorney

The contract will allow them to legally act for you in many ways. They can negotiate and sign contracts in your name, sign model's releases and checks for you, and even bring suit in your behalf to collect your money. If you aren't old enough to sign for yourself, they will have your parents sign the contract. Once that is done, the agency doesn't need to ask for the parents' signatures anymore.

Again, this is normal. Jobs get booked in a hurry, and they don't have time for you come in and sign something every time a client needs it. You might be able to negotiate to limit or eliminate this provision (or you might not – it's key to what agencies do). You would eliminate the risk that the agency will bind you to a contract you don't want, or sign away something you have a right to. But you get that safety only at the price of a lot of time delay and bother for both you and the agent, and the possibility of lost jobs.

You Screw Up, You Pay

There is likely to be an "Indemnity" clause which says if you accept a modeling job and make a hash of it, you will have to pay your manager and the client for the damages. You're an hour late for the shoot and the

whole team has to wait for you? That's expensive. You don't show up? That's a lot more expensive. You show up stoned and can't do the job? You've got a big problem, and the agency doesn't want it to be their problem. You may have to pay the client for the cost of the shoot, the other models the money they were supposed to make, and the agency for the commissions it should have gotten.

There are two reasons for a clause like this: the agency wants to protect itself from something stupid you might do, and they want to make it very clear to you that there is a severe penalty for not being responsible. Both of those messages are near and dear to the agency's heart, and if that clause is in the contract you may not be able to get it out.

The Reserve Fund

Remember the part about the agency wanting to protect their own butts? Here it comes again. The agency may advance you money for pictures, lodging or other services. They will want it back. To ensure it they keep a part of your money in a "Reserve Fund" that they hold onto until all your debts to them are paid. Then, when your relationship with them is over, they give you the remainder of the reserve, if they or you remember. Agencies can be forgetful about this kind of thing.

Non-exclusive contracts usually won't have this kind of provision in it, because the agency doesn't plan on investing much of its money in you. With exclusive contracts you might be able to negotiate it away – but you might not.

The Boilerplate

Somewhere towards the end of the contract there is likely to be a lot of verbiage that only a lawyer could love. It may talk about things that happen when the relationship between you and the agency starts to come unglued. Things like limitations on liability, arbitration, separability clauses, which State's laws apply and a host of other clauses that lawyers stay up at night trying to think up. These sorts of provisions can go on for pages.

It's not that these things aren't important - they are. But they are yet another way that the agency is protecting itself, and they probably aren't going to give on any of it for a new model. Read it, think about it, take it to your own lawyer for review. But it is what it is, and it won't affect your relationship with your agency as long as everybody is still trying to get along. Eventually you will agree to that stuff or find another agency that doesn't insist on as much of it.

When Are You Old Enough?

From a legal standpoint there are two primary issues of age. One is "are you old enough to do the job?" and the other is "Are you old enough to sign contracts?"

Age Requirements for Modeling Work

Some types of products require that a model advertising them be over a specific age. Alcohol and Tobacco ads in the US, for instance, require the model to be at least 25. Some pharmaceuticals that have only been tested and approved for a certain age range may require the model to be legally within that range. The issue isn't "looks that old" but rather "really is that old". Usually the advertiser in such cases will want people who look younger than their real ages.

Other times a news magazine doing an article on a particular age group (30s, for instance) may want to be sure that the person they use to illustrate the article really is in that group. They may feel that their credibility as a news organization demands that they be accurate in all aspects of the reporting.

This why a model agency has to know your real age, not how old you think you look.

Finally, there is the matter of nudity and photos which may be perceived as sexually oriented. In the US anyone over 18 is likely to be old enough for any otherwise-legal shots a client wants to do. Under 18 gets murkier.

There is no Federal law against topless or simple nude photos of minors. The law is very strict about "sexually explicit" photos (which may not even involve nudity) of minors, but if they are just nudes, and not "lascivious" they probably pass legal muster. That's why fashion magazines sometimes run shots of topless models who are under 18, but a "men's magazine" cannot.

State laws vary widely on the issue. Some States mirror the Federal law. New York law, for instance, reads like the Federal statutes except the age is 17, not 18. In other States the law is much more stringent, and the age 18.

But the law is not the only factor. There is a heavy social prohibition in the US against nudity or sexuality in photos of minors. There is also the common phenomenon of the local prosecutor who would rather arrest first and ask questions later – particularly before an election. For all of those reasons, there are many clients and agencies which will not send minors on jobs which might come close to those lines.

In addition to the above, many states have requirements that minors (typically those under 18, although the age varies) get work permits, and may have special tutoring or health requirements for young models.

Ability To Sign Contracts

Modeling is full of contracts. When you sign with your agency, that's a contract. When you accept a modeling job, that's a contract (even if it isn't written down). When you go on a job that requires a model's release or a voucher, that's another contract. The people you are contracting with need to know that they can rely on your promises in that contract.

If you are a minor, they can't. You may do what you contracted to do, but if you don't, they may not be able to force you to in court. Your model release is invalid. Clients don't like those kinds of things.

There are two ways that a minor gains the ability to contract in their own name. One is to reach the "age of majority" so that they are legally considered an adult. In most States that age is 18, but there are a few in which it is up to 21.

There is another way: become an "emancipated minor." Basically, that is a legal status of adult (for contracting and some other purposes, and usually allows you to live alone without parental supervision or control) even though you are still "underage" in your State. There are two primary ways of becoming emancipated: by going to court and having a judge issue an emancipation order or, in many States, by getting married. Both of those, obviously, are solutions to the contracting problem that shouldn't be undertaken lightly, but it is not uncommon for an agency to assist a minor in becoming emancipated.

There is another solution used much more often by agencies: the agent has the minor's parents sign a limited Power of Attorney so the agent can contract in the name of the model. That way the agency can deal with contracts, vouchers and releases as the need arises, without having to involve the parents, who may be far away.

The Right to Work in the United States

Model agencies protect their corporate clients by assuring that the models they represent are legally able to work in the US. US citizens and aliens admitted for permanent residence ("green card" holders) have that right, but others must have a visa or work permit from the State Department. There are lots of ways of getting that: win the green card lottery, marry an American, come to the US on a cultural exchange, get a modification to a student visa (after the first year) and many more. Even though all of those are intended for other purposes, they can be used for modeling as well. But for someone who wants to come to the US specifically to be a model, there is provision in the law for that: an H-1B3 visa. Here is the State Department description of what it takes to qualify for one:

"The H-1B3 category applies to a fashion model who is nationally or internationally recognized for achievements, to be employed in a position requiring someone of distinguished merit and ability.

Petition Document Requirements:

"The petition (Form I-129) should be filed by the U.S. employer with:

"A certified labor condition application from the Department of Labor;

Copies of evidence establishing that the alien is nationally or internationally recognized in the field of fashion modeling. The evidence must include at least two of the following types of documentation which show that the person:

"Has achieved national or international recognition in his or her field as evidenced by major newspaper, trade journals, magazines or other published material;

"Has performed and will perform services as fashion model for employers with a distinguished reputation;

90

"Has received recognition for significant achievements from organizations, critics, fashion houses, modeling agencies or other recognized experts in the field; and

"Commands a high salary or other substantial remuneration for services, as shown by contracts or other reliable evidence.

"Copies of evidence establishing that the services to be performed require a fashion model of distinguished merit and ability and either:

"Involve an event or production which has a distinguished reputation; or

"The services are as participant for an organization or establishment that has a distinguished reputation or record of employing persons of distinguished merit and ability."

To show "recognition" in the field of modeling you need to show several (from 12 to 20 or so) significant fashion tearsheets. Frequently models will work in Europe or Asia to get fashion jobs which qualify them for a visa.

You need to have a sponsoring fashion agency in the US which, in effect, holds your visa. For this purpose the fashion agency is considered the "employer" even though that is not generally true for other purposes under US law.

You need to pay a filing fee (in addition to legal costs) which can be in the thousands of dollars.

The H-1B (of which the H-1B3 is a part) is used by corporations to bring in experts to assist in the US economy. In FY2001 through 2003 there was a cap of 195,000 H-1B Visas granted. In reaction to Homeland Security concerns, that number was cut to about a third of that in FY2007 and beyond. The effect is that there is a long waiting line for H1B visas – normally more than a year. Even so, press reports indicate that the actually number of H1B visas granted is much greater than the law authorizes.

It is also possible for models to qualify for Permanent Resident status, if they have a sufficient prominence in the industry. That again requires agency sponsorship and a good deal of money.

At this writing there is an ongoing attempt in Congress to make a radical change to immigration law. It is likely that the outcome, if the bills are ever signed into law, will provide more avenues to legally work as a model in the US. But in any event, there will be a legal application process that will require a lawyer, and probably a US agency as sponsor.

What To Do When Things Go Wrong

No matter how much we wish it were not so, things do go wrong. Clients don't pay. Pictures get used without permission. Other kinds of damages happen. What to do?

1. Try to resolve the issue without a lot of conflict. Talk to the other party, on the phone or in person. Try to work it out. That can save a lot of headaches later.

Nope, you've been wronged, they won't make it right, and you want it fixed! First, seriously consider whether the hassle and possible expense of taking it further is worth whatever you will lose by just letting the matter drop and chalking it up to experience. Often that is the wisest course, even if it isn't the most satisfying.

Time to take stronger action? Depending on the problem and who it is with, here are some things to try:

2. Get an intermediary to try to work out a solution. Often an agent, a lawyer, a mediator, a parent, the Better Business Bureau or simply a gruff-sounding (or conciliatory-sounding) adult can make things happen that you can't do for yourself.

3. Document the problem. Write up a description of what is wrong, how it got that way, what you have tried to do to fix it, and what you need to be done. Make the document as straight-forward and non-confrontational as possible, while stating your case firmly. Send it via certified mail, return receipt requested. When the offender has received the mail, try going back to step one. You have just put the offender on notice that you're serious, and preparing a case against him. Sometimes that's all it takes to get cooperation.

4. Contact regulatory agencies that have jurisdiction over the issue. Got a problem with a company? A serious one? If they are licensed, someone licenses them. Are they members of a trade organization with a code of ethics? A well-placed complaint to the licensing authority or trade group can do wonders.

5. If all else fails, go to court. For small problems (those involving damages of only a few thousand dollars) almost all States have Small Claims courts that you can use cheaply and without a lawyer. Look it up in the phone book, go see the clerk of the court, and they will tell you how to file and pursue your case against the offender. For larger issues you need a lawyer and a higher court – but if the issue is that big, you probably ought to have a lawyer involved early in the process.

Things NOT to do:

1. Do not raise your voice, use bad words, or make personal accusations. Just deal with the issue and keep discussions on a calm, professional level. The more heat you put in the conversation, the less the chance of reaching an agreed solution.

2. Don't use your boyfriend to be an intermediary or negotiator. Find someone who is less emotionally involved with the issue.

3. Don't threaten. At least don't threaten until you have to, and never make a threat you can't back up with action. Once you have made a threat, you have to be prepared to go forward with it, or you lose credibility.

4. Don't file a lawsuit until it's obvious you have no other choice. Once you have filed suit, the legal process takes on a life of its own.

Truth in Advertising

Age and Stats

Mabel was sitting at the booker's desk chatting. She had been referred by a Ralph the photographer. A beautiful 5'9" redhead, with the proverbial 36-24-26 hourglass figure and stunning face, she was the classic beer commercial girl. While she was there the agency got a call from a casting director looking for a "Bud Girl" type for a beer ad. Did they happen to have any redheads? The client especially was looking for redheads.

What a coincidence! There was Mabel, and she was perfect!

There was a tiny problem: to do alcohol ads you have to be 25, and Mabel insisted she was 22. But that really was a tiny problem: when Ralph called the agency to recommend her, he said she was 25. She had lied about her age when she filled out the forms. It happens all the time.

So it's an easy fix, right? All the agent has to do is say, "Mabel, we know you are really 25, so go tell the casting director you are 25 and you're practically a lock on a $7,000 job." The trouble is, she wouldn't do it. She was so firm about it that she lost her chance at that $7,000 and she was dropped by the agency.

The above is a true story. Years before "Mabel" had been signed with a Top Ten fashion agency. Her booker had told her to always lie about her age – and she took it to heart. In fashion modeling that's sensible. Fashion is driven by new, young faces. You look in your rear view mirror for competition at 18 and are over the hill at 20. Many fashion agencies won't even see girls over 19 at open calls. So if you can pull it off, you lie. You do it so often that you never, ever tell anyone how old you really are.

There is another reason, too. Vanity. It's common for actors and models to have an "age range" that they play, and they give that instead of their real age. Inevitably their real age is at or above the top of the range. Everyone wants to think they look younger than they are, and they even pass up good castings because they won't admit their age. There are some people who really do look much younger than they are – but nothing like the number of models who claim it.

If it makes sense to claim you are younger in fashion modeling, it makes a lot less sense to make the claim in commercial print. The commercial market typically is looking for models in their 30s and 40s, and yet people in their mid 30s inevitably want to be thought of as 27. They actually hurt their chances that way, taking themselves out of the heart of the market.

If age is a problem, stats are worse. Everyone is thinner than they really are. Women don't measure themselves properly, and it's routine to lie about the waist and hips measurements. For fashion models the "ideal" is thought to be 34-24-34, and everyone shades their stats an inch or so in that direction. The ideal fashion height is 5'10", so again many heights are moved an inch, sometimes two, in that direction. It's rare indeed for a woman over six feet tall to say so. They are all 5'11 ½". If there is anything certain, it's that you can't trust the height and stats listed on a model's card or listing on an agency web site.

The problem is so endemic that designers will sometimes call and specify that they want "real, no kidding" 5'10" girls, simply because they have seen too many 5'7" models who claim to b 5'9" show up for castings that specify 5'10".

For commercial print modeling the issue is less acute, although it still exists. Models usually are preferred to be over 5'6" and under 5'10" (for women) and 5'9" to 6'2" for men. Again, height tends to be moved toward that range by an inch or more. Other stats usually are either stated accurately (since the range of acceptable stats is much greater in commercial work) or stated an inch or two less than reality, since most people are a little "optimistic" about their weight.

Such "white lies" are understandable, and sometimes they actually help models get jobs. But excessive (more than one inch) lies are counter-productive. Models ought to have the agent measure them, and then offset the stats for whatever the agent thinks will work best in his market. It's his job to know whether his clients expect the truth, or will assume a lie and discount stats.

Retouching

People who know the advertising and fashion industries know that the pictures in magazines are heavily retouched. In real life models don't look like that. In pictures, skin imperfections are removed, pounds melted away, perhaps even eye color changed. The point of the shot isn't to show the model, but to create a desired

effect. If that means doing radical surgery to the model, so be it. However, that does not mean that a model's comp card or portfolio should contain highly manipulated pictures. What's fair in advertising a product is not fair in advertising a model.

In the digital age test photographers are doing their own retouching. Some are excellent at it; others heavy-handed. A common problem is the photographer who retouches skin to the point that it looks like plastic. Nobody in real life looks like that, and a model's pictures shouldn't either.

The bane of a casting director's life is the model who doesn't look like her composite card when she shows up to a go-see – or worse, to a direct-booked job. The card has to make the model look attractive but it also has to fairly represent the model's real appearance. It's understood that the photograph will use artful posing, makeup, lighting and costuming to create the best possible impression. If the model can actually look like that even with the help of all those techniques, she can use the shot in her book.

Some limited retouching is also acceptable. If the model happens to have an acne breakout the day of the photo shoot, it's OK to retouch it out of the pictures – in fact, she should. Minor problems that could have been hidden with makeup, but weren't, can also be fixed. But the picture has to be a reasonably fair representation of what the model will look like on the job.

The careful reader will notice a conflict here. Tearsheets are highly desirable in a model's book and card. They are also likely to be heavily retouched. So how is that resolved? At least some pictures in the card have to be only lightly retouched; casting directors understand that the tearsheets will not be, and accept it.

THE PERIPHERY OF MODELING

Should You Go to a Modeling School?

Why not?

Modeling schools are fun. You meet lots of new people, make friends, do fun things. They say nice things to you and make you feel better about yourself. They teach you to look better, walk better, eat better. You get some pictures taken that are different from anything you've had before. You see yourself looking "like a model".

These are all good things. They may also be expensive things, but for a lot of people the cost is affordable, and isn't all that much more than they might put into dance classes, piano lessons, summer school tutoring in Algebra 2 or any of lots of other things people spend money on. If it can be paid for out of the family entertainment budget, why not do it?

But wait a minute! You didn't say anything about learning to be a model. Isn't that what modeling schools are for?"

Ummm, no. Not for the vast majority of their students. The school knows that very few of their students will ever be models in any significant way. The "training" really isn't about that. We've already told you what it's really about.

From here on in this chapter we will concern ourselves only with people who really are trying to be professional models. If you are considering a school only for the fun or the personal life skills, read no further.

There are some medium sized cities in which the dominant modeling agency, the one that really gets the jobs, is also a franchise of one of the well-known modeling schools. It happens, and if it has happened in your city you need to read this chapter a little differently. There are also many cases where a real agency has a marketing agreement with a school (which may even be in the same building, and which may have the same owners). They agree to take graduates of the school into the agency. If you encounter that, you have to wonder whether it's worth the money to get represented, since what they want is your tuition money, not the opportunity to get you jobs.

Things you need to know:

1. **You don't need to go to modeling school to be a model**. Most real model agencies would prefer you hadn't. You will get the training you need through test shoots, experience on the job, through conversations with your agent and, if necessary, from brief classes arranged, usually for free, by your agent.

2. **A lot of what modeling schools teach is wrong!** It's a pretty good bet that the instructors are models from years gone by, from places you will never model in, and are types of models you will never be. That's if you are lucky. A lot of instructors aren't models at all, and never were. They are just graduates of the schools, imperfectly passing on what they learned. They probably don't have the skills a professional model like you needs, and they don't know what skills you need.

3. **Pictures from modeling schools aren't what you really need**. That's not always true, of course. Once in a while a school gets lucky, or the manager is really good, and they get professional quality pictures for their models. But the majority of the time they get junk. The school counts on the students parents not knowing any better, and they're usually right. So the money you spend on pictures is wasted. You could get selected by a real agency with simple snapshots just as easily.

4. **They don't tell you what you really need to know.** At least, not if it keeps them from selling you classes, or pictures, or expensive conventions that they say you should attend. They are a business. They make their money by taking it from you, not making it for you. So you can count on them not to tell you things that would keep them from making money. What are some of those things?

 a. There isn't much modeling work where you live.

 b. You can't be a model in a big city unless you live in the big city.

c. Unless you are a skinny, long-legged 5'10" 16 year old girl, you are going to have to pay all the expenses of relocating to where there really is modeling work - with no guarantees of ever actually getting any work.

d. Unless you are that 5'10" girl, no model agency is going to make you an offer to front expenses to work with them. Even if you are, they still might not.

e. People who hire models don't care that you've been to modeling school.

f. You don't need to know how to walk on a runway. OK, maybe if you are that tall skinny 16-year old you do, but an agency will teach you that in an hour. Nobody else needs to learn the runway walk.

g. A photographer can't take good portfolio pictures of ten people in a day.

"So all that means I shouldn't go to modeling school, right?"

Yeah, probably. If you want to be a model, that's not the right way. Go see real agencies or people who hire models. Read this book, do what it says, and you'll be better off.

Still, there are some (few) cases where the modeling school can be a good thing, and some (all too many) where they can keep a good model from ever reaching her goal.

"How good can it get?"

Pretty good. Here's the ideal case:

You've already met our hypothetical model, Mabel. Let's look at an alternate history for her: Mabel is 16 years old, 5'10", wears a size 2, has a 35 inch inseam and a face that people stare at as she walks down the street. She's bright, does well in school (and can be home schooled or tutored), has parents that completely back her and have the resources to provide whatever support she needs. She has a burning in her belly that demands she be a model. Nothing else will do.

Mabel's parents take her to the local modeling school. They get lucky. Maureen, the owner[2], has years of experience in New York, maintains close contact with the Top Ten agencies, and recognizes a real fashion model when she sees one. Rather than try to bleed Mabel's parents' wallets immediately, she decides to become a Mother Agent for Mabel. She signs her up, spends a month teaching her the things she will need to know to deal with an agency in New York, gets her some free test shots from a good photographer in town, and sets her up with appointments with the right agencies. Mabel goes to New York, is offered a contract by a Big Agency, and goes on to be a working model. Maureen makes her money by taking a percentage of Mabel's earnings.

Or, instead, Maureen contacts one of the major modeling conventions, tells them she has a winner, and convinces them to give Mabel a free "scholarship" to the convention. They go to New York, Mabel is seen by dozens of fashion agencies from around the world, and is offered contracts in New York, Los Angeles, Tokyo, Paris and Milan.

When a model seriously has potential it can work that way. Mostly it doesn't.

It can be absolutely awful:

Now let's meet Rachel. Rachel is 5'4" tall, 125 pounds. Her parents and friends all think she is pretty, so they decide she ought to be a model. Maybe Rachel even thinks so too. There are problems: Rachel's folks don't have much money, she is in school and can't leave town, and there is very, very little modeling work in her city for anyone, let alone for a girl like Rachel.

Still, Rachel's parents have heard for so long that "she ought to be a model" that they have come to believe it. They take her to see Hank, who owns the local modeling school. Hank used to be an aluminum siding salesman, but he hired a graduate of one of the other modeling schools (Patty, who was very, very tired of working at Burger King) and bought himself a franchise school with a well-known name. He's now in the modeling school business.

"Sure," Patty tells Rachel's mother. "She can be a model." All she has to do is take classes for $1,500 to become qualified. So Rachel's dad takes the money out of her college fund, planning to replace it with her

[2] In case there is a modeling school owner out there somewhere named Maureen or Hank, this isn't about you. All names are made up.

modeling earnings, and she takes the classes. She goes to the fund again to pay for "professional pictures" that she and her whole class have done one day by some visiting photographer. She gets "qualified". She even gets to work in a runway show at the local mall, and one weekend gets a job at $10 an hour passing out promotional materials at Patty's old Burger King. She's a real model.

So Hank tells Rachel that the time has come to take her to a modeling convention to see agents from all around the world. Maybe one of them will offer her a contract!

Or maybe not.

So again Rachel's college fund gets raided, this time for the $5,000 it takes to go to the convention, and the extra $2,000 for her mother to go along with her. She goes, has a lot of fun for a week, no agents want her, and she comes back home a lot poorer.

Sadly, not a lot wiser. Hank tells her she needs Advanced Modeling classes, which are only another thousand dollars, new pictures (several hundred dollars more) and in another six months she can go to another convention. Now the college fund is depleted, and her folks are looking at a second mortgage on the house.

Rachel is never going to be offered a modeling contract in a major market city, no matter what Hank says. And it only took them $18,000 to find out. Hank, on the other hand, has pocketed $2,500 in modeling class fees, a kickback of $800 for the pictures he had her get, and $4,000 in "commissions" from the modeling conventions. He's a very happy Hank.

It can be worse:

What if Mabel had gone to Hank instead of Maureen? (There are a lot more Hanks out there than there are Maureens.)

Mabel and her folks walk in to see Hank. Hank doesn't know what a real fashion model looks like, but Patty does. Now they *really* see dollar signs lighting up their eyes!

For a while it's the same as Rachel. Money for classes and bad pictures. Money for the Big Convention. By now Rachel is a 17-year old aspiring fashion model.

But this time it's different. Mabel is the *Real Deal*. Every fashion agency at the convention is clamoring for her. She gets 42 callbacks, three clandestine meetings with scouts, and offers to fly to exotic places to do wonderful things. She's on her way!

No, she's not. There's still Hank.

Hank has convinced her that he is the best person to manage her career. He has had her parents sign an exclusive contract with him that lets him choose which agency she goes with, and he keeps 10% of whatever she makes. Hank is seeing Big Bucks in his future.

He'd really rather she went with an internationally Famous Top Ten Agency (FTTA) that might be able to turn her into a supermodel. More bucks for her, more for him. What could be wrong with that?

Lots of things.

FTTA sees Mabel's potential. They should, they have a superstar in their stable who looks just like her. So they want to keep her on ice, not competing with their star. But Hank doesn't know that. They tell Hank that they want Mabel to be developed a little more, that in a few months they will want to sign her. They might even sign her right then, but send her back home. They tell Hank he can have a 10% scout's commission on all the money she makes. Hank is in heaven. This is the agency for her!

Only it isn't. There are other agencies that could do as well or better than FTTA. But they won't pay Hank the extra 10%. Nope, they are the wrong choice for Mabel! So Mabel sits at home, waiting for her chance to be a model. Time goes by, she gets older, less desirable. And she sure isn't working as a model. But Hank has a plan: let's take her to the next Big Convention and try again!

Well, what's a few thousand dollars more, after all this? So off they go again, to see the same agencies that wanted her before.

Mabel could have walked into any of them a year and a half and $12,000 ago, been accepted and been working as a model. But instead she has Hank, claiming to be looking out for her, and really trying to cut the best deal for himself. She is getting older, wasting prime time, becoming less desirable with each passing month. And Hank still has visions of making a big strike with FTTA, so he tells her not to go with any other agency. Meantime the latest fad is Malaysian models; blondes are out, and new models who look like Mabel aren't in demand. Mabel's career, so full of promise, is over before it ever begins.

Hank doesn't get the really big money he had been hoping for, but he at least got all those bucks for pictures, classes, conventions and anything else he could make up to take money from Mabel. He's not a thrilled Hank, but he's a happy Hank.

Modeling School as Mother Agency:

It's not all that often that a mother agency (or personal manager) is a good idea for a new model. But when they are, good Mother Agencies develop models without taking a fee (or a kickback on pictures), and make their money taking a percentage of the model's future earnings. They have an interest in her success: if she doesn't make money, they don't make money.

The modeling school often tries a perversion of this concept. First they take thousands of dollars from the model for classes, conventions and photos. Then they want more money from the model if she actually gets work somewhere. That sounds like the school is incentivized to find success for the models – but the great majority of their money is taken from the model for all those unnecessary services. Getting a percentage of earnings is only a small part of their income, and one they can afford to pass up. That leads to lots of opportunities for abuse.

The worst thing that can happen to a real model is for her school to stand in the way of her success with an agency that won't pay the school a commission. And yet it happens all the time, even though the school won't admit that is what they are doing. They find all sorts of other reasons for keeping a model from signing with that agency, or from even being seen by that agency. It's particularly a problem for commercial models, since most commercial agencies won't pay a "finder's fee" or mother agency commission. Modeling school students can find a good commercial print agency won't take them because they are locked into an exclusive contract with their school.

Fortunately, some schools don't follow this predatory practice. They make their money on the classes and services, and then do what they can to help their models find work or a real agency without taking a further fee. When a model finds an agency, the school is pleased simply to congratulate her and pass on the good news to their other students. It makes them look good, and helps them sell other students on their classes.

So, should you go to a modeling school? Maybe, but now you know reasons why not.

Model Searches and Conventions

Why Use a Model Search?

If you are a fashion model type who lives in New York, Los Angeles or Chicago, open calls at agencies are by far the most cost effective way of getting yourself in front of the people who could recognize your potential. But for people who live in Iowa or Oregon, just popping in to open calls isn't easy or cheap. It means staying a week or so in each of the market cities that might be "their" market, spending time and money on travel just for the opportunity to see a dozen or so agencies.

It is for those people that model searches exist.

What Model Searches Are

Some "model searches" are nearly complete scams: they claim they will get you "exposure" or even modeling work. But it turns out that, at best the "modeling work" is for one or two low-paying promotional jobs. The "search" makes its money by selling high-priced "portfolios" or by charging exorbitant fees for putting you on their web site. Only rarely is interest shown in a model by good agencies or clients. But it doesn't matter; the search company has left town and the model's check cleared.

Legitimate model searches come in many types, from major national events attended by thousands of competitors and scores (even hundreds) of agents, to local shopping mall "searches". A few are directly sponsored by a major modeling agency (the Elite and Ford Model Searches, for instance); but most searches are put on by independent companies who invite representatives of dozens of different agencies from across the country and even around the world to attend. If you are what they are looking for, there is no more effective way to be seen by all those people.

Much smaller, local searches sometimes have legitimate opportunities to present hopeful models to the major markets, but that is much less common. Sometimes they are "aggregators", designed to find models for a larger, later search. For the most part they are recruiting vehicles for modeling schools, photographers or others whose intent is to take the model's money, and who may have little or no ability to actually put her in touch with the right agencies for her.

Research is a very good idea before attending one of these events. Some of them are expensive: from a few hundred to a few thousand dollars. Others are inexpensive up front, but are designed to get lots more money once you get there. You need to understand which is which.

How they Work

Recruiting:

Here is how a typical legitimate model search works. The search will send an advance team to small- and medium-sized cities months before a search event. They may advertise on the radio, on television, in the newspapers or on job-placement sites on the Internet. People are invited to a free "screening session" at which they are told about an upcoming search event, and some of the attendees are invited to go to it – for a price. The more scrupulous search companies make an effort to screen out people who obviously have no hope of being selected by a model or talent agency, but not all are very scrupulous, and a wide net is cast. Sometimes anyone who is willing to pay is allowed to attend.

The search firm invites both model and talent agencies to their events, so the competitors are not all "models". They may be singers or actors looking for a chance to be seen by an agency. At most events, the "talent" applicants outnumber the "model" applicants. The total number of attendees needs to be several hundred just for the company to make their expenses, so typically a model search will have 800-1,200 model and talent contestants.

At the Event:

The model agencies are predominantly "editorial fashion" agencies, although there may be a few commercial print and promotions agencies in attendance as well. Most will be from major market cities: New York, Los Angeles, Miami and perhaps Chicago. There may also be a small number of local or regional agencies.

Usually a search is a two or three day affair. The first day may be taken up by various types of training and seminars (sometimes offered at additional cost) conducted by industry professionals. They will usually have a photo booth set up too, so attendees can purchase shots at the event. The second day may involve more seminars and some competitions.

For "talent" the competitions may be as simple as giving each of the hundreds of contestants a short (15-30 second) opportunity to perform at a microphone (a short a capella solo or monologue) for the talent agents. Then everyone (model and talent alike) take part in the "runway" competition. All the model and talent agencies assemble around a runway, and the contestants walk down it at 15 second intervals or so. There may also be another opportunity for contestants to parade by the tables of the agents, holding pictures of themselves.

Each attendee is given a number on a badge that they wear. At both the runway and talent competitions agents have "callback sheets" on which they write down the badge numbers of people they are interested in interviewing. At the end of competitions these sheets are turned in to the search firm staff.

Following the competitions, and after a break for the staff to compile the requests, "callbacks" will be announced, by agency and the contestant numbers each agent wants to see. The agents will be at tables in large rooms, and contestants with callbacks are let into the rooms. They may have to stand in line for a while, depending on the number of people an agency has called back, but they will get a brief personal interview at the callback.

The agent may take measurements, ask about their personal interests and situation, or inquire about their ability to relocate. If the agent is interested he will ask for the model's telephone number. In exceptional cases a model may be offered a contract on the spot, but most often the agent will follow up with later with some of his "callbacks". Some searches also have "open calls" at which agents agree to briefly see anyone who comes to their table.

The important part of the search occurs after it is over, when agents go home, sort through their notes and decide who to contact and invite into the agency. Almost always the trip to the agency will be at the expense of the model, who will be told he has relocate (at least for a while) if he wants to work with them.

What Modeling Conventions Are

Conventions are similar to the searches, but they differ in important respects. Searches are "retail" events – they market directly to individuals who want to be models, actors and singers. Conventions are "wholesale" events. Contestants are brought by modeling schools from around the country. The school receives part of the contestant's entry fee, and for many schools taking people to model conventions is a large part of their income.

The largest of the conventions typically gets 2,000-2,500 contestants; smaller ones may be in the range of 800-1,000. Where a good search event may attract 30-50 agencies, a large convention may have 200 or more different agents scouting at the event, including a number of international agencies. There is roughly an even split between model and talent agencies. The great majority of the model agencies at a convention will be editorial fashion agencies from major market cities.

The convention itself is usually longer than a search event, although the same basic things happen. There will be seminars, contests, group events where schools compete against each other, photographers taking pictures to sell, and runway or other opportunities for models and talent to briefly come to the attention of the agents. And there will be callbacks as well, handled in much the same way as at search events.

Reasons to Go to a Model Search or Convention:

These things aren't cheap, and before you go you should have a good idea why you are spending all that time and money. You might go:

1. *To have fun*. If you don't mind spending that much money on entertainment, the better searches are fun. They have events, tours, competitions, and a chance to travel to another city – which many young models have never done. Just the chance to meet people from other parts of the country is enjoyable. Still, it's a lot more expensive than renting a video, so you need to decide if the entertainment is really worth it.

2. *To learn about the industry*. You can do that, too. Some of what you learn will even be true. Some may not be. The better search sponsors have seminars given by industry professionals who tell you what the modeling industry is all about – although usually from a rather optimistic perspective. They can explain the different types of modeling, how agencies work, how you need to prepare to be in the industry and

what to expect when you get in it. You might get that from a local school/agency as well, but usually from a very different viewpoint. Hearing someone actually in the "real world" can be an eye-opener. But at conventions these industry pros are there as guests of the convention, which makes its money from modeling schools, so they won't say anything that the schools wouldn't like said. Model searches aren't dependent on schools, to the discussion can be a little freer.

3. *To "get exposure."* A lot of models come to "get exposure" in the industry. Maybe that's of value if it results in honest feedback. But for the most part, "exposure" is not of much professional value. A week after returning home (if that long) every agent present will have forgotten everyone he saw except those he actually made an offer to. "Exposure" of that type has extremely limited value.

4. *To "be discovered."* If it's going to have a lot of value to your modeling career, a model search needs to result in an offer being made by an agency. That should be the purpose of a search for any model serious about her career. Certainly she can have fun, learn something useful and "get exposure" – but none of that is what serious models really need. They should approach the search as a business decision, with a goal: to get representation by someone who can actually do them some good in a major modeling market.

Should You Go to a Model Search or Convention?

If you aren't a "fashion model" type – directly in the heart of what the market is looking for – and you aren't already planning on moving to a major market city, it is very unlikely that agencies from Los Angeles, New York or abroad will be interested in you. You should check on who the attending agencies will be. If they are all from far, far away, your chances of getting an agency at the search are very small. The better searches include some local and regional agencies as well, and they are much more likely to be interested in models who aren't "fashion models".

If you do have the fashion model look, maybe the model search is a good way to find a national or international agency. But before you decide to go, ask the next question: suppose you really do get the attention of an agency and they want to sign you. That means moving to where they are and devoting yourself to modeling, at least for a few weeks, and at your expense – they aren't interested in you where you live. Are you ready for that? If you aren't, why are you going to the modeling model search?

How to Succeed at a Model Search

You've weighed the pros and cons, understood the risks, and finally decided this was a good choice for you. If that's true, it may be the only chance you get to be seen by people who can give you a shot at major market modeling. It would be a shame to blow it over things you can control. So here's what you should do:

Preparing for the Event

If you are going to a modeling convention you will receive instructions from your school. It's their job to prepare you, and you should listen to them.

If you are going to a search with no Director, you still have to do the same things any prospective agency model needs to do: fine tune your appearance (hair, teeth, weight). If you are female, make sure you can walk smoothly in high heeled shoes – everyone walks the runway.

At the competition men should wear upscale slacks and shirt with dress or business shoes, for women a short skirt and simple, body-hugging top and high heeled shoes.

Many of the searches require you to bring pictures, but you don't need a portfolio. Good, clear smiling shots (8x10 or 9x12) are best. The shots don't have to be professional, but whatever you do, make it look like you actually brought pictures intended for the event. Bringing your old graduation pictures or snapshots from your vacation is not a good idea.

At the Event:

The Agents:

The people attending from agencies are there for several reasons, only some of which have to do with you. The same group of agency people tends to go to these events all over the country. They know each other,

socialize together, and treat the events as a sort of rolling party in different cities. For many of the events they are being paid to be there.

For all those reasons, some agents may not want to deal with aspiring models except when they have to. Others are quite willing to spend time with models away from the competitions: reviewing pictures, giving advice. The culture of some events encourages aspiring models to approach agents and ask for their advice or to give them pictures. Such contacts can result in the agents paying more attention to them during competitions, and may result in a callback.

Other events discourage this kind of contact, as do some of the agents. The only sure rule for a model is to try to judge the mood of the agent and not make a pest of themselves.

The Competitions

In some events there is a photo competition which may or may not be attended by the models (and usually isn't attended by most of the agents either). The "parade" is your best chance to get their attention.

Dress to grab that attention with the clothes you prepared for the event. Carry yourself with dignity (don't do anything goofy to draw attention to yourself) but don't be afraid to show some of your personality either. Agents want models, not robots, and they will be looking for models who give off positive energy.

Some searches give agents lists of model names/numbers with height, age and location information, others do not. It may be that the agent couldn't tell if you were qualified to be with them, and just needs to find out if you are 5'6" or 5'9" tall. The "parade" is your chance to at least get them to ask that question.

When You Aren't On Stage

At a large search or convention you may find a hundred or more agency people wandering around the venue, just like you are. They will be in the hallways, the restaurants, the conference rooms and may observe events and seminars they aren't judging.

Agents are people too – they want to work with people they like, and they make evaluations on more than just objective criteria. A smart model will assume that anyone she doesn't know is an agent and treat them appropriately. There are all too many stories of models who would have been given a callback by an agency, but who didn't get it because of some stupid thing they did or said to a person who turned out to be an agent.

The Callbacks

Every agency will have at least some callbacks – if they don't, they won't be invited to the next event. When you go into the room where callbacks are being held you will see some amazing differences. Some agent tables will have 20 or 30 people in front of it at all times. Others will have one or two, or sometimes no people waiting to see the agent. Some will have a clear focus of type they are looking for; others will call back quite a variety of people.

If you have several callbacks, you need to prioritize who to see first. The best strategy is to go to the agencies which have the smallest lines. Partly that's because you can see more agencies in a hurry. But it's also because the agencies with small lines have been more selective. Usually that means they have more to offer, and are more desirable to work with. It also means they may be willing to give you advice instead of rushing through an interview to get onto the next person, or that they may be willing to talk to you even if they didn't give you a callback..

When you have done what you can with the short-line agencies, stand in the longer lines. But be prepared to hear a pitch for you to be managed by them, rather than booked by them, or for you to buy their classes or other services. Frequently that's why the lines are so long: the "agency" is talking to a lot of people because they make their money by signing people.

Callback Interviews

You got a callback (or several). That's what you came here for, right? No, it's not! It's just a milestone along the way. The important thing is to get an invitation from the agent after the callback interview. Failing that, it's to get solid information during your interview with the agent.

When you sit down at that agent's table, you really don't know why you are there. He may really want to sign you for his agency; he may want to encourage you to change some things and get in touch later. He may have given you the callback simply because he had to give some, and you seemed as good a person as any to give

one to. So you need to treat this conversation as the beginning of a long process, either of becoming associated with that agency, or learning more about the industry so you can succeed somewhere else.

You need to be friendly, confident without overdoing it, respectful and attentive - all the things you would do in any job interview. You have to tell the agent how you would like to work with him, and when you can do it. If he's interested he wants to know your level of interest, knowledge and availability. You shouldn't be making any assumptions about what he or his agency might be willing to do for you.

If the conversation proceeds well, you may be on your way. If it seems the agent isn't planning on recommending you for representation, you should use the opportunity to learn. Ask questions: about his agency and how it works. Ask about the industry. Ask for a brutally honest evaluation of yourself and your prospects. Ask what kinds of modeling he sees you doing, and where. Ask what you can do to improve. If you're lucky you'll get all those things, and if you are really lucky you won't like some of the answers. Those are the ones that do you the most good.

Be prepared to leave pictures with the agent. He needs something to remind him who he talked to.

Post-Search Follow-up

The agents tend to go to a lot of these things. They may have a genuine interest in you when you are standing in front of them, but some of them see 20,000 (or even a lot more) aspiring models a year. You need to help them remember. A week or two after the search is over, send a comp card or other picture to the agent who showed an interest in you, with a brief reminder note and contact information. If they are really interested, that will help them remember you and take some action to bring you into the agency.

No matter what your school director (if you have one) says, every model agency would prefer that follow-up notes be sent by the model, and personal contact information be given in the note (as well as at the search). They are less likely to contact your director about you than they are to call you direct. Help them out. The school has already made lots of money off you; now is your time to work for yourself.

Are Searches and Conventions Scams?

To fly in all those agency people, put them up, rent a hall, give those seminars, do the recruiting for the convention, do the advertising . . . that costs a lot of money. And it has to come from somewhere. At most there will be 20-30 aspiring models (out of all the hundreds who attend the convention) who will actually have the potential to be successful in the major markets. But that doesn't pay the bills, at least not at a price those few hopefuls can afford. So the organizers do what they must: they "select" lots and lots of people to attend.

Now the very, very few with the right "look" will be there to be "discovered", but the rest – almost everybody – will be there to pay the bills. That's what it's all about. Each of them will be told the same thing: they have been "selected" – so nobody knows which is which. The organizers themselves may not know – they don't need to, since they get their money anyway.

So you went to the Model Search and nobody offered you a contract. Maybe you didn't even get a callback from an agency. There are lots more like you, and in the course of comforting each other, someone uses the word "scam". At that moment it's certainly easy to feel as though it is true. There are two primary issues:

1. Because so many people attend who aren't of interest to agencies.

2. Because the attendees feel they were misled into believing their chances were much higher than they actually turned out to be.

It's easy to sympathize with someone who had just spent a lot of time and money pursuing a dream, and find themselves no closer to it. But it can also be seen as their fault. They haven't done the research to find out what the industry wants and they go expecting to be snapped up (and they weren't helped to be realistic by the sales pitch of the search company). They call "scam" when they it doesn't happen.

The model search companies will point out that:

1. Their mission is not to keep people from pursuing their dream, but to give them a chance to find out if they can have it.

2. The good ones do at least some screening to keep the most unqualified candidates off the event. (You would not believe some of the people who think they ought to be models!)

Both of those are self-serving, of course, but they are also true. Another truth: they promised you a chance to be seen by representatives of many good agencies, and they delivered.

There are a large number of ways that people can waste money – lots of money – pursuing this dream before coming up against the hard, cold reality that it is not to be. It seems that if someone goes to a model search and doesn't get any callbacks they ought to take that as useful, if painful, information: information that is probably worth what it cost them to get it, however much they don't want it.

Callbacks don't mean much. They don't cost anything but a little time to give, and the event organizer encourages them to be given. Getting a callback is only a mildly encouraging sign. Not getting any is a strong signal. Rather than shouting "scam" because they don't like the outcome, people should take it as a wakeup call to get out of their dream world and try an alternate reality.

These are painful lessons, but if you find yourself in that position they may need to be learned. Despite what you may have heard (and may even be told at a convention seminar), modeling isn't something you can do if only you want it badly enough.

Pageants

There would seem to be a close relationship between beauty pageants and the modeling industry. After all, pageants and modeling both require beautiful men and women, and sometimes modeling agency representatives acts as judges for the pageants.

That in itself is something of a problem; often less prestigious pageants advertise that they have invited judges from model agencies to leave the impression that entrants may be seen by agencies, and possibly offered agency representation. Sometimes the "invited judges" decline and don't show up; even when they do, they don't expect to find models in the pageant.

There isn't much in common between beauty pageants and modeling. Pageantry is an industry unto itself, with its own customs and standards. There are magazines devoted solely to pageantry; design houses which specialize in pageant gowns, and even television specials devoted to it. The best known is the Miss America pageant, but it is only the culmination of countless local contests, and there are hundreds of other local, regional and national pageants around the country.

There is one major commonality: scams. Although there are many legitimate pageants with substantial prestige and prizes for the winners, there are also plenty of scam pageants. Companies advertise in newspapers, radio and the Internet, set up shop in a hotel ballroom one day and hold a contest. The contestants have to pay hundreds of dollars to get in (and can literally buy a spot in the contest with a title to go along with it). At the conclusion, someone wins a title nobody outside the ballroom has ever heard of, gets a cheap trophy to immortalize their victory, and everyone goes home. Along the way there are the usual secondary scams: clothing, photos, advertising and accessories that the contestant "needs" to be in the contest.

The more legitimate pageants are also the most expensive. Competition gowns can cost thousands of dollars, and some of the top contestants also spent thousands more on personal training, grooming and pageant coaching and preparation.

If the skills and customs of pageantry are different from modeling, the standards of beauty are different too: fashion model types tend not to do all that well in the pageant world. A beauty queen crown isn't something agencies put much weight on when recruiting models.

There is a different type of pageant: "fitness pageants", some of which are quite well known and respected. Again, the criteria to enter and win these is quite different than for most types of modeling, but they can be a good vehicle for "fitness models" to come to the attention of related magazines and model agencies with fitness divisions.

Scams

Man will occasionally stumble over the truth, but most of the time he will pick himself up and continue on. – Winston Churchill

Sturgeon's Law: Ninety Percent of Everything is Crap.

What Scams Are

The dictionary defines scams as "a fraudulent or deceptive act or operation." That's somewhat ironic in the modeling industry since, when done well, modeling and advertising are largely a matter of deception. A model is made to look more desirable than she really is to enhance the perceived desirability of an otherwise mundane product. Right from the outset we have a problem of what's legitimate "deception" in this business and what isn't.

For as long as there has been a modeling industry there have been scams. Some "scams" simply come with the turf; others are deceptive but not really fraudulent, since they deliver what they promise, even if it isn't worth what they want you to believe it is. Some of them are complete frauds, with no intent other than to separate you from your money and give you little or nothing of value in return. This chapter will deal with all of these, and deciding which is which is an exercise is left to the reader.

Not Scams, But . . .

There are a lot of things in modeling that some people refer to as scams, but in fact deliver what they promise, if not what they lead you to believe. Some of them have already been described: Modeling Schools, Model Searches and Model Conventions.

Then there are the "*almost-agencies*", also already described. These folks do get substantial work for models, but charge you a variety of fees for registering with them, for portfolios, for being on their website, for classes, or take a commission on pictures from the photographers they send you. When a high percentage of the income of a company is from these kinds of fees, the "agency" starts looking like a scam, even though at least some of those same things are done by many legitimate agencies. It's more a matter of degree than of kind.

Outright Scams

These are the companies that promise great things for you with no intention of delivering anything of real value. Some of them look real; others rely on no more than hype and bluster to separate you from your money:

Model "Exposure Books"

The Pitch: A model or actor pays to have their pictures put into a book or magazine, the book is to be sent around to Casting Directors and/or agencies who would "discover" their new talent by finding them in the books.

The Reality: These books look something like a legitimate agency marketing tool: the headsheet book. Nobody ever explains why a fashion agency in New York might want to "discover" a 5'4" model in North Platte, Nebraska. But never mind that - send in your pictures and your money and take your chances. A few of this sorry breed of entrepreneur actually does produce the books and deliver them to some casting directors and agencies, where they hit the wastebasket within minutes of arriving at the office.

This scam has been going on for decades and still is, although it is much less prevalent these days. Now the Internet is used instead of a printed book; it's cheaper for the scam artist.

Model Scouting Websites

A few of these are entirely legitimate and valuable, even if not always in the way the customer anticipates. The trouble is, there are lots of others. The largest scam in the history of the modeling industry used this approach.

The Pitch: Model "exposure" Internet sites are a new wrinkle on that old "exposure book" theme. The premise now is that a model would pay to have their pictures on the site, the site would be seen by Casting Directors and/or agencies who sit in front of their computers each day, just waiting for the next batch of hopefuls

to be put on the site, and the CDs and agents would "discover" their new talent. Nobody ever explains why a fashion agency in New York might want to discover a 5'4" model in North Platte, Nebraska – but never mind that. Sound familiar?

The Reality: In fact the better of these sites actually do have some such value, at least for people that agencies are willing to search for (read: fashion models, or good commercial models in the agency's area). As long as the cost is not too great they may be a good idea. $30-$100 a year seems reasonable, especially if there is high-quality content and a good modeling forum to add value to the purchase price. But a high percentage of their subscribers will be disappointed: no agency will call. With the best of them most people use it for what it is really good for: an opportunity to learn about the business and network with people in it. With the worst, it's a total waste of money.

The Casting Calls Scam

The Pitch: They have hundreds of castings from producers and casting directors around the country that you can use to submit yourself for jobs. The site may want you to pay a monthly fee for access, it may be a come-on for a model listing site, or it may be used by a "model agency" that requires upfront fees or is a portfolio mill. Sites that claim to be free usually will ask you to "upgrade" to get the "full benefit" of their services – at extra cost.

The Reality: There really are two or three sites with relationships with mainstream casting directors, which get breakdowns for agencies. None of them charge models or actors for access. Some of these breakdowns are available to the public. But there are dozens of other websites who make these kinds of claims and have little of real value to offer. The "casting calls" may really be ads by model or talent agencies to recruit talent (and may not even placed by the agency itself). Jobs may be lifted from public sources such as *Back Stage*, *The Ross Reports* and legitimate, open casting websites or even craigslist. They may simply be made up. These sites tend not to ensure the reality and quality of the jobs posted, and they often are open to anyone at all to list a "casting call".

Some online "agencies" have been using this "stolen casting calls" technique to make themselves look legitimate, so they can attract applicants that they can extract money from in a variety of ways.

The Traveling Portfolio Mill and Agency

The Pitch: we come to your city, take "professional pictures" of you, we list you on our nationwide roster of models, and then we get you modeling work.

The Reality: Nonsense! These people will take your money for those pictures, the pictures will be far from professional quality, and you will never make your money back on modeling jobs. Sometimes they do have some promotional jobs to give out, so you can make your thousand dollars or so back at $12 an hour passing out flyers. Is this what you had in mind when you set out to be a model? Here's a hint: if they are from a long way away from you and they aren't a famous fashion agency it's almost certainly a scam.

The Local Portfolio Mill and Agency

The Pitch: The agency photographer is chosen because he knows how to take the kinds of pictures we need.

The Reality: That may be true, which is why it's so hard to tell if this is real professional advice or part of a scam. Outside the major markets there may be no more than one (or perhaps there is no) photographer in the area who can reliably deliver the kinds of pictures models need. A primary job of a good agency is to find good photographers, make sure they know what is required for models, and make them available to you. If they don't do that, you are likely to waste a lot of time and money on inappropriate pictures.

But it's also true that scammers arrange kickback schemes and make a lot of their money getting you to shoot with their photographers. Those pictures may or may not do you much professional good. From the scammer's standpoint it doesn't matter, since your check cleared and he isn't much worried about you getting modeling work. A legitimate agency is motivated to send you to photographers who can get you what you need to be successful. A scammer isn't. It's amazing how long things like this can stay in business. Sometimes they exist for months or even years before they disappear, only to show up in another name, or in another city.

The Catalog Scam

The Pitch: buy our clothes, have pictures taken of yourself, and you can be a model in our catalog (or calendar, or other publication). We'll even pay you for it!

The Reality: Nobody needs that many pictures to put into their catalog, and nobody wants the kind of amateur shots you are likely to produce in their catalog. In fact, there probably isn't going to be a catalog. You send hundreds of dollars to them, you get some cheap, cheesy clothes back in the mail, and nothing else of any value ever comes back to you. If you're lucky (sort of) you may get some home-made "ad" that they cobbled together on their home computers that they claim you can use as a "tearsheet" – but it's worthless in the real professional world.

The "We Don't Trust You" Scam

The Pitch: we will get you work, but you need to leave a deposit with the agency as insurance against your performance, or for a background check

The Reality: clients do want to be sure the models they hire are reliable, and the agency has to guarantee that reliability. It's also true that making the model invest in his career greatly increases the probability the model will follow through on his commitments.

So, as in any good scam, they use that truth to separate the model from his money. They charge an up-front "insurance fee to indemnify the agency if you don't do a job you've booked". Or they make you pay for an up-front "background check" which they claim is needed to keep "convicted felons" from being hired by their clients. Real agencies don't do that; they may make you spend a lot of money, but it will be on things that do you good, not things that just line their pockets.

The Pay to Play Scam

The Pitch: Some promoters will advertise "opportunities" for models. Typically it is to be in a fashion show for some designer or retail store. The catch is you have to pay to audition for the show – sometimes as much as $25-$100 just to get into the audition. Then, if you are very lucky, you might get chosen and you may get paid some small amount. Or the promoter will advertise what great "exposure" you will get from their event, and pay you nothing.

The Reality: These things are almost always of little to no real value except to the "hobby model". They are simply another way for scammers to separate you from the contents of your wallet. Some of them are also run by modeling schools, which use the "opportunity" to tell applicants that they need training which, by great good fortune, they can provide - for a price. Some are merely another form of "party promoter" exercise, where the point is to charge people tickets to see a fashion show, or to use the "fashion show" as a draw to bring patrons to a night club or restaurant. The professional press and fashion industry have little interest in such things, and they rarely to never lead to anything for a professional model.

The Name Game

The Pitch: A person claims the identity of a real, highly respected and well known personage in the industry: a famous fashion photographer or producer, for instance. This happens most frequently on the Internet, where it's easy to create email addresses in any name you like. The scammer will ask a model for things he wants, usually revealing or fetish-oriented photos. Only rarely does this scam involve a request for money, but it can turn into stalking.

The Reality: Famous photographers and producers don't go roaming around the Internet looking for models. Models approached by "someone famous" should ask for their office telephone number and call the office during business hours. If that request is refused it's a virtual certainty that the person isn't who he says he is. If he complies, the model should check on the telephone number and make sure it is listed in the name of the company he says it is.

The Vertical Integration Scam

An agency in New York has hit upon a new way of making money. They advertise that they "no longer deal directly with the public", and that models who wish to work with them have to do so through referral from an industry professional or a search company. Another well-known agency in Miami is doing something similar.

Helpfully, they refer models to such a company, which they say will screen models' applications for them, and present qualified models to "agencies". What they don't tell you is that the search company is owned by the same person who owns the agency, and that the "screening fee" is really just an up front application fee under another name. Other real agencies allow models to apply in person or by mail for free.

The Nigerian Scam

Various versions of this have been around for nearly a century, but with the advent of the Internet the scammers have gotten more sophisticated and are able to target likely victims with a pitch tailored to them. Although most of the scammers using this technique seem to be in Nigeria (which has a very permissive government when it comes to things like this), they could be located anywhere. Lately the UK has been a favorite claimed location for them.

The Pitch: We want you to do something for us, and we will pay you a very large amount of money for it. It could be a "commercial job" or a "fashion show" or anything at all related to the industry. The specifics of who they claim to be and what they are offering change, but in all cases they will say they will pay you a lot of money up front, even before you do the job. They may refer you to real-looking websites announcing the event, and use the names of real designers or clients.

The Reality: There is no commercial job, no fashion show, no nothing. Never was. Any website they refer you to either has no association with them, or is made by them to dupe you. If you give them your contact information, they will send you real-looking certified checks just as they promised they would. But "Oops! We made a mistake! We overpaid you and need you to refund some of the money to us." They hope you will deposit their check in your account, then send them real money in return before your bank notifies you that their check was a forgery.

There is a variant, where all they do is ask for your identification information – enough that they can do an identity theft and charge things to your accounts.

The Webcam Interview

The Pitch: The scammer claims to be a scout or booker for a well-known model agency, and says that he found the model's information on a model listing site or something like myspace.com. The contact will usually be made using an interactive system like AIM, where the model and scammer can interact in real time. The scammer says they are interested in the model, but need more information and pictures to make sure she fits their requirements. The model is sometimes asked to email additional pictures, but most often is asked to do things for her webcam so the scammer can see her. As the "interview" progresses, the model is asked to do ever more revealing things for the webcam.

The Reality: Major agencies rarely go cruising around myspace.com or model listing sites looking for models. If they happen to find one on such a site, they don't contact them with a yahoo email address or through AIM. They might contact a model through email, but using their company domain, and asking for a telephone interview. They will never, ever ask for nudes to be sent to them, or for a model to do anything at all on a webcam.

The Model's License

This one has been around for years, and seems to be making a comeback.

The Pitch: The model is told that she is wanted for work (or for an agency) in Europe, and is made all sorts of promises, often using real-sounding names. Preparations are made for a trip, and it all begins to sound very good. Then in the middle of the conversation, the scammer will tell the model that to work in Europe she needs a "modeling license", and asks her to confirm that she has one. She won't have one, of course, so the scammer tells her he has an attorney who can get her one – for a fee.

The Reality: There is no such thing as a "model license" in Europe (although there are a variety of visa issues, depending on the country, that he European agency will have to take care of). Money sent to the scammer for the "license" buys nothing at all, and once the money is sent, communications stops. There never was any work or agency for the model in Europe.

The Fake Magazine

This happens mostly on the Internet.

The Pitch: Work with me and I'll put you in this new magazine I'm about to publish. It's a come-on line used by mediocre photographers to entice models to shoot with them, or shoot in a way they normally would not.

The Reality: There is no magazine, there never is going to be a magazine. At best the photographer will put up some kind of "magazine" on the Internet, as though that means something. Appearance in it is worthless to the model, and cannot be counted as a tearsheet.

Danger Signs

It's possible for any of these things to be done by legitimate companies, but all of them are "red flags" that suggest you ought to investigate carefully before getting involved.

The Model Scout

A perfect stranger comes up to you in the mall and tells you that you have what it takes to be a model. It's flattering, and models can be anything from high-fashion types to "real people". So why not you?

Major model agencies actually do sometimes cruise the malls looking for models. But they are after the 5'10" size 2, 16-year old. When they find her, they don't tell her to get expensive pictures done or take classes before they send her to the agency in New York or Los Angeles. Model agencies don't go scouting in malls for "real people" types, and if you aren't that 5'10" 16 year old girl, the "scout" is almost certainly a scam.

Advertising

Modeling is a business-to-business activity. Real agencies spend their time finding and developing clients who hire models. They don't advertise in newspapers, have large display ads in the Yellow Pages, or advertise for models on the radio. If you see an "agency" doing any of those things, they are almost certainly a scam.

Guarantees of Work

Major model searches by agencies like Ford and Elite have sponsors who guarantee that the winners will be hired. With those exceptions, agencies cannot and will not guarantee a model work. Agencies don't hire models, clients do, and the agency cannot control who gets hired. If someone offers you a guarantee, it's likely a scam.

Work Full or Part Time

Except for a few in-house fit and showroom models, modeling is intermittent. There is no such thing as "full time" work. A company that even talks about it is suspect.

Flexible Hours

Real agencies require that you have flexible hours, but the modeling jobs don't. They shoot when they shoot, and you have to be available for them. On occasion you might be able to get small changes in a shoot's time to accommodate your schedule, but you shouldn't count on it. Any "agency" that advertises their modeling work has "flexible hours" is suspect.

Where is the Audition?

If you see a modeling job advertised, or agency advertising for models, the open call or audition ought to be at a professional office or studio. If it's at a night club or in a hotel room you should assume it's not worth doing, if not an outright scam. Party promoters hold "model open calls" at clubs just to attract more patrons.

"No Fee"

Often the scammer will advertise their services come with "no fee". Excuse me? Agencies are businesses. They need to make money, and they take it from you in the form of a commission (a fee) for work they have gotten you. If an agency advertises they don't do this, they are making their money some other way – and that's not good for you.

Looking for Children and "Real People" Types

There is work for "real people" models and children, but anyone who says they are scouting these types for agencies hundreds of miles away is very likely a scam. "Real People" and children's agencies don't search for models in other parts of the country. There are far too many applicants at home.

Up Front Fees

There are a few services provided by agencies (head sheet books, if anyone still uses them; listings on the agency web site) that they may charge you for at the beginning of your relationship with them. But with those exceptions, no agency should charge you just for the privilege of being evaluated or listed.

Focus on Scouting

Every agency needs new models, and all have some process to get them. It may be open calls, mail-in or email-in submissions, attendance at model searches, or relationships with scouts and mother agencies. But if the advertising you see, the meeting you attend or the agency website makes a much bigger thing out of scouting than out of getting work for models, it's a very suspect agency.

How to contact them

If an agency website doesn't make it very easy to telephone the agency to book models, it's likely a scam. It's fine to use emails to communicate, but a client wants to be able to pick up the phone and talk to a real, live person about his modeling job. Real agencies understand that and put their telephone numbers and address prominently in all their advertising. If the company doesn't, it's likely either a scam, or ineffective at getting models work. If they use yahoo.com (or other freebie) email addresses, or communicate over interactive systems like AIM, it is very unlikely that they are real.

If it's Too Good To Be True . . .

As a rule of thumb, the bigger, more important the claims, the less likely they are to be true. Everyone knows stories of models found in airports or in a mall and whisked off to do great things. Some of those stories (a very few) are even true. But the chances of it happening to you are virtually nil.

Anyone can claim connections and association with well-known names. A claim is not the same as reality. People with the power to make large things happen for you have the trappings of power: offices, studios, and support staff. They are known in the industry, and appear in trade publications and are referenced on the Internet. If you don't have an agent to check for you, check and verify claims for yourself.

Let's Meet for Dinner

The business of modeling is conducted during business hours in offices and studios. That's not to say that during the course of a business relationship people can't meet outside a professional environment and socialize. They do and they should. But it shouldn't start that way, except for the first contact. No matter where you encounter someone the first time, the *second* time you meet him should be in a business environment during business hours. When someone approaches you and asks you to call him at home, meet him for dinner or at a club, it's time to be very wary.

Grammar and Spelling

There's no law of nature that scammers have to be illiterate, and some of them aren't. There is also no firm rule that good, legitimate photographers can't have difficulty with the English language, especially if it isn't the language they grew up with. Even so, success in business tends to imply the ability to correspond in a businesslike manner, and literate, educated people usually have something more productive to do with their lives than scamming models. Foreign businesses that have the means to hire foreign models also have the means to hire competent translators.

Whatever the reason, years of experience with scammers shows a high correlation between rotten grammar, non-standard English, inability to spell, and scamming. If an email reads like it was written by a dyslexic 14 year old boy, it's a strong red flag.

Belligerence

The best defense is a good offense, and scammers love to put you on the defensive. When someone asks him reasonable questions about his background and credentials, a professional normally responds in a civilized and helpful way. Scammers tend to respond by belittling you for asking the question, making vague but important-sounding claims about their abilities and contacts, and trying to make you feel that by questioning him, you are losing out on the best opportunity you will ever have in your entire life. When this happens, ask yourself

if he is really someone you want to work with, whether he is legitimate or not. Then assume he is a scammer until he can prove otherwise.

Required Training

Models do not need to go to modeling schools or boot camps. Most agencies will give whatever training a model needs for free, or for a very nominal cost. Agencies that say they give preference to, or even require, a model to go to some expensive school so they will represent them are really making money from the school. If they could make money getting you jobs, they'd take you without the school.

Mass Recruiting Meetings

A good agency will sign no more than a few models a month. At most, a large commercial agency may sign no more than one new model per day, and that is unusual. If the "agency" is having mass meetings of people to screen them for representation, and it looks like they are taking more than a tiny percentage of people there, it's almost certainly a scam.

Distance

If they are a long way from you, they can't do you any good. Yes, there is such a thing as direct booking, but it applies very, very rarely to new models a long way from major media centers. If someone in another state says they want to represent you, and they ask for an exclusive contract or any kind of money from you, or for you to spend money, it's not of value to you and may be an outright scam.

Cheesy Presentation

Model agency clients are paying a lot of money for models. They want to think what they are getting is worth paying those high fees for. Legitimate agencies have to compete, not only with each other, but with the Internet and people off the street. To do that, they make sure their presentation, and the way they present their models, looks like it is worth paying for. If the pictures on their site don't look like excellent professional shots, or the models don't look like models, they won't do you any good.

Checking Them Out

Good agencies should be listed in professional reference sources and be known by people who hire the kinds of models they represent. If they are in *The Workbook*, *Le Book* or similar references, they are likely to be legitimate. Some of the more inclusive books that are aimed at mass audiences (not at professionals) are less reliable. Many scams get themselves listed in those.

If you are in a State like Texas, California or Florida (not New York City, no matter what the law says) that requires agencies to be registered and licensed, check to see if they are.

Call advertising agencies and see who they use (or recommend) when hiring models. If they don't know about the agency you are interested in, it's a yellow flag, although in a city with many model agencies, ad agencies may only know their few favorites.

If it's a company that wants you to pay them for photography, call agencies of the type that represent people like you and ask about the company or photographer. If they don't know of him it isn't necessarily a bad sign, but it isn't encouraging either.

If the company has been in business for any length of time, someone has dealt with them and knows if they are any good. The better Internet modeling forums can be asked for experience with a company, and it's very likely that one of the regulars will have heard of them.

Support Organizations

Throughout the country there are organizations devoted to consumer protection. Some of them have a broad charter and the modeling industry is only one of many that they try to regulate; others (particularly on the Internet) are specifically devoted to modeling. Sadly, few of them have people with a deep understanding of the industry they are protecting.

Governmental (Federal Trade Commission, Departments of Consumer Affairs, Attorney General Offices and the like) and quasi-governmental organizations rely on three primary sources of information: consumer

complaints, the press, and interviews with people in the industry. That exposes them to real information, but they get a strong bias because of the limited sources and experience they have.

Better Business Bureau

Often you will see suggestions to check out a company with the Better Business Bureau. The notion is that if they aren't good, the BBB report on them will tell you that.

It's usually true that a really awful scam has a bad rating with the BBB. But frequently, for a variety of reasons, they will give "satisfactory" ratings to companies that have a lot of problems with the public. In 2004 there was a "model agency" in New York City that was the subject of two class action law suits and a Federal criminal investigation. The BBB showed them as "satisfactory" and with no complaints filed. Another agency delayed payment to its models by a year or more, had been doing it for several years, and was the subject of legal action. They have the same "satisfactory" rating with the BBB.

If a company has a really bad BBB report, that means something. If the BBB says they are "satisfactory" you should never rely on it.

Internet "Scambuster" Sites

"Scambuster" websites (type "modeling scam" in a search engine to find them) rarely are staffed by people who have actually worked in the industry (except, sometimes, as models). They rely on some of the same information sources, but can have even less confidence in what they hear. If a BBB or city prosecutor's office hears of a complaint, they can be reasonably sure they know who it is coming from and that there is some accountability for the information. The Internet lends itself to anonymous, often false assertions from people who are not who and what they claim to be and have a personal hidden agenda. It isn't surprising that most of the false, lurid information comes from the Internet. That said, there is a lot of useful information available from these sources. You just have to understand its limitations and not put too much trust in what you are hearing.

For the most part these organizations are well-meaning and sincere in their desire to help (although there have been some very nasty personal agendas pursued by the owners of some Internet "scambuster" websites). But well-meaning or not, few of these organizations really understand the advice they give, and they usually present it in a way that can make matters worse.

INTERNET MODELING

Advantages of the Internet

Almost as soon as the World Wide Web came into common use there were people heralding a revolution in the modeling industry. The power of this new technology opened the way for everyone to communicate ideas and pictures much more efficiently and cheaply than ever before. Some went so far as to predict the end of the modeling agency system, concludint that clients would no longer be dependent on the old-tech traditional agencies to find models. Even today we hear gurus proclaiming some new, revolutionary Internet idea that they claim will change everything.

Although the Internet certainly has changed the modeling business, most of these claims turn out to be bunk. We have already discussed the impact the Internet has had on mainstream agencies, but that's only part of the story. Here's what else happened.

New Access to Markets

In pre-Internet times the agency system had a choke-hold on modeling. If you wanted a model, you paid their rates – if they would even deal with you. Many people wanted models for things agencies would not support, or at rates that weren't high enough for the agency to be interested. People who wanted models for low-budget productions had several options, but none of them very good: advertising in newspapers and college bulletin boards, talking to friends, using employees and relatives for advertising. Models who wanted work had a bigger problem: there was little way to advertise themselves, and it was hard to find people to hire them or shoot with them unless those people happened to advertise. None of these things worked very well.

The Internet changed all that. We now find hundreds of thousands of models on line, usually several of them near anyone who is looking. Models can place themselves on model listing sites and model-oriented forums for little or no money, and potential clients can find them easily. Jobs can be posted on those forums, or on local or national job listing services like Craig's List (www.craigslist.com), and they are widely read.

None of this has affected the agency system much, but it has brought a huge number of models and photographers (and a much smaller number of commercial clients) into the market. The opportunities available to models for these non-agency jobs have risen enormously since the late 1990s.

Direct Advertising and Booking

Under the old system, even if a model and photographer (or client) found each other through an ad or networking, there was the problem of somehow getting enough information exchanged to make the deal work. What does she look like? What is the nature of the job? What does the photographer's portfolio look like? What are the booking conditions?

All of these things were hard to do, especially if the model and photographer didn't live close to each other. Now they are all simple and cheap. Portfolios can be put online, or pictures exchanged in emails. Documents can be exchanged. Where it might have taken days or weeks in the past, now it can be done in minutes. The information each side needs to understand an offer is readily available.

Anonymity

There is some danger when models give personal information to people who say they want to work with them, especially when there isn't an intermediary like an agency in the conversation. In the past models had to use cumbersome processes to keep their addresses and telephone numbers hidden until the client needed to know them. Now *bona fides* can be exchanged and the work negotiated using anonymous websites and email addresses (such as yahoo.com, gmail.com or hotmail.com) until both sides are comfortable that a deal is struck. That is very much to the model's benefit.

Record Communications

Things go wrong in modeling, just as they do in any business. Exactly what information was sent to the agency or model by the client? What deal was proposed by the agency? It's very handy after the fact to have a written record to refer to when a miscommunication seems to have happened. Castings taken and worked entirely on the telephone (which is very common in mainstream modeling) don't have that advantage. Fax exchanges can serve the same purpose, and long have, but they are less often used for the informal conversations in which a deal is negotiated. Email fixes that problem.

Quick, Accurate Communications

If you have a casting, sides or a call sheet to disseminate to several people, the Internet is an excellent way to do it. It's faster and higher quality than telephone calls and sending faxes, and accessible to more people than faxes are.

Access to Reference Data

The client just named a celebrity that they want a look-alike for. You've never heard of him. A quick search on the Web can turn up pictures of almost anyone, or any other type of data you might need to support a casting request. Mainstream agencies use the Web this way all the time. Web models can use it to research people who are contacting them about jobs. Who are they? Who is their client? You can find out quickly on the Web.

Disadvantages of the Internet

For all the gloom and doom about the fate of agencies once the Internet was widely used, the agencies are still here and apparently not going anywhere. If this technology is so good at getting clients and models together, what happened?

Here are some factors that limit the application of the Internet to modeling:

1. *It's a slow form of communications.* For moving large blocks of text, data and graphics around the Internet is superb, but if you want to get in touch with someone immediately, a telephone is better. Most people spend a lot of time away from their computers. (This may change as email-capable cell phones become ubiquitous).

2. *It's a cumbersome way to negotiate.* Talking to someone is far superior to emails in getting agreement on business deals. Even if you and they are both sitting at terminals and communicating real time in email or IMs, much of the richness of voice communication is lost. It's easy to miss subtleties in what someone means if all you have to rely on is the written word.

3. *It's less reliable than the telephone.* Emails get lost in spam filters or just go to bit heaven. They are noticed by the recipient or not. They are answered or not. The person on the other end of the email is or is not the person you think he is. If you reach someone on the phone you know for a reasonable certainty that a message has been received and an agreement come to, or notification (such as the shoot needs to be put off for some reason) is received. You may not know that in email.

4. *It's harder to build a personal relationship on the Internet.* The modeling industry is as much about who you know and having supportive relationships as it is about having the right models. Emails don't build relationships nearly as well as a telephone call or personal meeting does.

The other problem with the Internet is that once you start communicating with someone on it, you tend to rely on it even when you shouldn't. People tend not to switch modes, and miscommunications result.

Model Listing Sites

What They Are

There are now hundreds of "Model listing sites", most of which claim they will provide models "exposure" to clients around the country or around the world. Some of these work more-or-less well within their domain: jobs of a type that mainstream modeling agencies won't support. That tends to mean glamour/nude work, or low- or no-paying jobs that are of dubious benefit to the model, and of no benefit to a real agency. They are also a very prolific source of TFPs/TFCDs, which can, under the right circumstances, be helpful to a model.

Listing sites don't act as agencies, but simply as communications conduits. They let you put up pictures and information about yourself and give potential clients the ability to find and contact you. The better ones let clients search on geography and model attributes.

Listing yourself on such a site can serve three purposes: to attract the attention of a real agency, to attract the kinds of jobs available on the Internet, or to have a convenient site to refer people to when you want to discuss modeling for them. In selecting such a site, look for participation by a large number of diverse, real (not Internet) agencies, a lot of glamour/nude photographers (to find paying work) or a clean, easily accessible and inexpensive site (to refer clients to). The most prominent sites for Web models are Models.com (www.models.com), Supermodelscouts (www.supermodelscouts.com) (requires a fee) One Model Place (www.onemodelplace.com), Glamour Models (www.glamourmodels.com), Musecube (www.musecube.com) and Model Mayhem (www.modelmayhem.com).

Models.com is primarily of value because of the participation of excellent agencies who are certified by the management as real and ethical, and which do use the site for scouting. Membership is granted free to agencies on approval. It also has excellent articles on fashion modeling and agencies, and is a source widely quoted in the mainstream press. The forums on Models.com are supported by good agencies, professional photographers and working models, makeup artists and stylists. The focus of the site is fashion modeling, although commercial modeling is also supported. Its models' portfolios are clean and professional. In addition to detailed search by approved agencies, they also have an "open search" feature that allows potential clients to search for models by sex, age and geographical region.

Supermodelscouts uses a different business model. The orientation of the site is fashion and commercial modeling through agencies. They have tens of thousands of aspiring models in their database, and qualified agencies (which are researched and approved my management) search for models by sex, stats and location. Agencies are granted free membership on approval. When they find a model they are interested in, they are sent contact data for that model. Models are allowed to list themselves for free, but charged a membership fee to have access to contact emails sent to them through the site. The agencies do, however, have the option of contacting models directly, without fee to the model. The site does not provide much in the way of additional content for its membership – the function is limited to scouting.

One Model Place (OMP) has over a hundred thousand models and tens of thousands of photographers listed. Its interface is cluttered and not appropriate to send a commercial client to. It is strongly oriented toward glamour/nude photography, even though a fairly high proportion of its membership says they wish to do "fashion and commercial" modeling through the site. There are some excellent commercial photographers and photographic artists and a few fashion photographers on the site, but the overwhelming majority of photographers are "glamour" or fetish oriented, and few are of professional caliber. OMP is not congenial to real agencies. They charge agencies a fee for membership (a substantial fee if the agency is to be able to search for models with the usual criteria they care about) and do not do much checking for legitimacy. Many of the "agencies" listed there are of doubtful utility to models.

Models (but not photographers or agencies) can join OMP for free (with very limited portfolios), which tends to encourage lots of people with little modeling potential or interest from signing up.

OMP does provide some useful articles and a set of forums ("message boards") on which members can interact, netw and seek advice. As is always true with forums open to the general population, there is both meaningless or bad as well as excellent advice available on the forums, so models have to sort through the information and evaluate what to believe. The forums are moderated, but not quality controlled by management.

The management is slow to impede the activities of scam organizations which join, so caution is advised in dealing with "agencies", "managers" or photographers there. There are casting notices available on the site, but the quality of most is low.

Musecube is on the opposite end of the spectrum. Although there is no lack of glamour/nude orientation in the membership, the presentation of model portfolios is clean and attractive, if not as detailed as on OMP. Many mainstream professionals use it as an inexpensive personal Website to showcase their work. Musecube also has forums for members which suffer from the same problems as others, and seems less well moderated and allows more extreme personalities on the forum.

Glamourmodels is entirely oriented towards glamour/nude photography. There is no pretense of anything else, and that keeps a lot of the "models" with no hope of ever doing mainstream work from cluttering up the place. It has a much smaller number of models and photographers listed, but the management has done a good job of balancing presentation and utility on the site. The search function is excellent, the presentation clean and attractive, and it can be used by non-members to find and contact models. It does require members to pay for listings, so the quality of members listed is much higher, on average, than on the free sites. There is a forum associated with glamourmodels also, which is very well administered and open to the general public.

Model Mayhem (MM) bills itself as similar to myspace.com, but focused on models, photographers and other members of the modeling industry. It has become one of the largest, most active modeling sites, with hundreds of thousands of members. There is an attempt to keep membership limited to those who are at least somewhat involved in the industry, although the bar is set quite low. The site is free, and attracts all sorts of people. Model Mayhem prohibits agencies or managers from being members, which severely limits the chances of a model finding a good agency through MM, but also greatly reduces the incidence of incompetent "model managers" collecting models on the site. They do have very active forums, with robust and uncensored commentary on some of them. As is true of all forums open to the general public, the range of advice ranges from excellent to ludicrous.

All assessments of modeling sites are as of the date of publication; sites and site policies change, so reader discretion is advised.

Quality of Members

One of the problems of Internet listing sites is that the barriers to getting on them are very low. Many are free; most of the others are low cost. Anyone who wishes to can join, create a personal profile and call themselves a model or photographer. For those which list "fashion models" and "commercial models" but have no required criteria for listing, a huge percentage of people are on the sites who have no realistic chance of doing what they say they want to do.

That leads to lots of opportunities for mischief. It is common for someone to list another (a friend, a girlfriend, even an enemy) as a model on these sites without the "model" listed even knowing about it. It's more common for people to join up on a whim, put up a profile, and never do another thing involving modeling. Estimates that 10% of the models on such sites are really who they say they are, and really serious about modeling, seem overly generous. Photographers routinely report that emails sent to members get less than a 10% response rate. Photographs of "models" often are simply bad snapshots or webcam shots, and they don't change over the lifetime of the membership. The number of agency-quality models on such sites is very small, although there are a fair number of credible glamour models.

The photographers aren't a lot better, on average. There are some diamonds in the rough, but many "photographers" should be put in jail for going near a camera. All too many Internet photographers produce trash; a lot more of them shoot routine, badly executed pictures, but at least they are trying. Some of them know how to shoot publishable fashion or commercial pictures, although virtually all of them will show pictures they label as "fashion" or "commercial" on their personal profiles, and a high percentage say they will produce "models portfolios". Models have to learn to tell the difference between those who offer, and those who can really produce. If it seems the above is harsh, you haven't spent a lot of time on these listing services.

Demographics

If a client wants to use models for a commercial project, he has to find the kind he needs in the place he looks for them. It seems silly to point that out, but it's critically important to understanding the problem of the Internet for commercial clients.

The average age for a commercial print female model is 35, and 39 for males. There is work for young men and women, but it's a relatively small part of the commercial market. The majority of work is for models over 30, and the demand for men and women is about equal. In fact, over age 30 more male than female models are hired.

So who is in the model listing sites? Membership is by self-selection, and by a wide margin more young girls self-select than any other category. Here is the distribution of adult membership on the largest of the model listing sites:

Age	Female	Male
18-30	67%	23%
31-40	6%	2%
41-80	1%	1%

Nearly half of the commercial market is for male models in their 30s or men and women in their 40s and up. If a client relies on Internet listing sites, he has very few to choose from. Then consider the high percentage of listed "models" who are not really ready, willing and able to do a commercial job, and a client could easily find that there is no good choice available near him for his project. It's worse: many of the models in their 40s on such sites have a "glamour" orientation to their pictures. They aren't suitable for commercial needs. If, on the other hand, he wants to hire a young woman, his chances are much greater.

As you can imagine, the only commercial clients who would routinely use model listing sites are those who primarily hire young, female models, or those whose budget is so small they have no other choice. For others the experience would be too frustrating, even disregarding the problems of setting up commercial shoots through the Internet listing sites.

Internet "Managers" and "Agencies"

You know how dumb the average guy is? Well, by definition, half of them are even dumber than that. --
George Carlin

Internet "Managers"

Many of the models on Model Listing sites use "managers" as intermediaries to receive and screen their emails and help maintain their listings and pictures. There are some responsible, capable people who provide management services and support to Internet models. But the vast majority of people those calling themselves "managers" are bad for an Internet model's career. They tend not to have much if anything in the way of professional qualifications. Often they are photographers of little distinction who collect models for what might best be described as less than fully professional purposes. Even worse, some of them are a model's boyfriend (or want to be) who feels the need to control her modeling career.

It's very common for someone to put up a Website (or a page on a Model Listing site), declare himself a manager, and promise all sorts of wonderful benefits for models who put themselves in his care. The best of these pass on reasonable offers to their models after vetting the offers to ensure their legitimacy, as well as providing knowledgeable advice and guidance to their models. There are very few of those. The worst refuse to answer queries or pass on job offers to models, or to guide them in ways that would expand their career opportunities. After all, if some other photographer starts working with his Internet model, she may decide to leave his fold! And for many of these people, it's about ego and control much more than it's about doing business. There are all too many of this type.

Many experienced Internet photographers and clients refuse to work with models who have "managers". Models on the big model listing services have often said that when they show a manager on their listing the number of offers they get from photographers and clients declines precipitously. No doubt some of these lost offers weren't worth having in the first place, but some are worthwhile.

To steal a phrase from politics, that manager is best which (appears to) manage least. If the manager has a visible presence on your sites on the Internet, or gets into email conversations with clients, or keeps you from seeing your email, you are very likely to lose jobs.

In this as so many other things, it's the exact opposite of the "real world": real agency models are perceived to be the most desirable, and good clients prefer to hire them through agencies. Internet models with Internet managers are perceived as the least desirable.

Internet Agencies

Modeling on the Internet is new and rapidly evolving, and organizational structures and distinctions haven't had time to mature. There are organizations (typically one-person organizations, though not always) which create their own Websites, gather models to represent, market their models and take bookings for them. Just as in the non-Internet world, they may call themselves agents or managers, depending on the laws where they operate.

Where a traditional agency would work almost exclusively with models in their own area, an Internet agency may list models nationwide, or even worldwide. The notion seems to be that clients from all over the nation or world will hire their models through this nationwide agency. It is not clear why a significant client in Seattle who wanted to hire a model in Orlando would get her from an agency in Indianapolis.

They generally they do not personally meet their models, and often do not have or use contact telephone numbers for them. Their knowledge of the real availability, capability, reliability and appearance of the models is much less than in a traditional agency.

Most communications with the "agency" takes place through email. Some Internet agencies do not even publish a telephone number, fax number or street address. Their business exists almost exclusively on the Web. This is not the way sophisticated clients want to work with agencies.

Demographics

Internet agencies mostly get their models from model listing sites, and the natural tendency of young females to self-select on those sites is amplified by the natural tendency of the people who run the Internet Agencies to select young women.

That is further amplified by the fact that the Internet Agencies rarely select on the characteristics of fashion and commercial models. They select what they like, not what clients want. The net result of all these selection forces is that most Internet agencies have few if any male models and few models over age 30. The models that they do have are often not suited for most commercial work, or are of a type that is already saturated in the commercial marketplace.

It doesn't have to be that way, of course. In principle there is no reason why an Internet agency couldn't recruit men and women, and go after the high-demand older types. But as a practical matter it almost never happens. The reason usually is that the operators of the "agency" are less interested in booking mainstream modeling work than in being associated with pretty young girls.

Quality Control

When mainstream commercial print agencies have non-exclusive relationships with their models it can lead to frustration over trying to control the pictures a model uses to market herself. The problem is far worse for Internet agencies, which not only have limited control, but may be dealing with "models" with only a tenuous relationship to the business. They tend to get what the model wants to give them or, if they are photographers, what the "agent" wants to shoot. Not surprisingly, there is a heavy emphasis on "glamour" pictures on their sites, despite the fact that most commercial and fashion clients do not want to see models presented that way.

It's made worse by the fact that few Internet agencies are run by people with any experience in mainstream modeling, and they don't know what fashion or commercial pictures are supposed to look like, nor can/do they produce pictures of the quality that a mainstream client expects to see.

Again, there is no law of nature that says Internet agencies have to be this way, but to date nearly all of them are. The limited opportunity to attract commercial clients to an Internet agency, even with a stable of credible models and good pictures, constrains the number of qualified agents who might want to get into these agencies. Anyone who knows what they are doing doesn't do it on the Internet.

However, these "quality" differences make a difference only to models who aspire to "mainstream" commercial or fashion work. The great bulk of work available on the Internet is for attractive young women for "glamour" or nude jobs, not for commercial assignments, so the practices of the Internet Agencies are congruent with the real market they operate in. It's an issue only if the model doesn't want to be a glamour/nude model.

Differences In Operation

Some Internet agencies take booking requests for models. Some may negotiate with the client and then email the model with the request, or pass the request directly on to the model and let her be involved in the negotiation. At least one Internet Agency plays no role in the booking process at all; they leave it up to the client to contact models directly and work out whatever deal they can. Internet Agencies generally do not support client requests for go-sees; jobs are booked directly off the Internet or not at all. Again, that greatly limits the willingness of commercial clients to use Internet models.

Mostly these agencies do not have a number of similar models in the same city that could come in to replace a booked model if there is a problem, and they make no guarantee that they can support the client in the event of an emergency. Again, there is no reason why an "Internet Agency" has to operate like this. In principle they could use the telephone to arrange bookings and go-sees, and could recruit a critical mass of talent in a city to enable them to offer a range of alternatives and emergency models. But few if any of them do.

The reason a web site works for a traditional agency is because there is a real staff of people, with real telephone numbers, and real, ready, willing and able models where the agency is who can reliably be booked. Internet model listing sites and agencies can't support those kinds of jobs, so they can't attract the kinds of commercial clients that demand that level of support and reliability. Inevitably they can attract only the lower rung of commercial clients (f that). Even so, the best Internet Agencies are well suited for dealing with the typical Internet photographer who wants to hire models for glamour work, and often has more flexibility in his projects than a commercial client might.

Types of Internet Modeling

We've just looked at how traditional, land-based agencies differ from Internet-based agencies and listing sites. The result is that Internet models, acting on their own, through listing sites or through Internet agencies, can't attract many commercial clients. So Internet modeling is like what modeling has always been outside the agency system, but on a vastly larger scale.

Recreational Modeling

A lot of Internet models have no realistic chance of being agency models (although not all realize it). Many of them don't want to do the kinds of work that they *can* get on the Web. That still leaves modeling for fun as an option. A model can get "modeling pictures" or "art" pictures easily through contacts she makes on the Internet, and many are satisfied to do just that. Almost any reasonably attractive person can find someone to shoot with if they just want to get together and play with a camera. There are also a variety of non-professional fashion shows which recruit on the Internet and which can be a fun outlet for girls who aren't tall enough to be mainstream fashion models.

The best of these recreational models sometimes attract the attention of excellent artistic photographers, and outstanding work can result. Even when the result is more mundane, it's often better than the person would otherwise ever have - keepsakes that they will enjoy for years. The modeling forums and listing sites have created robust opportunities for people interested in recreational modeling and photography to find each other.

TFPs/TFCDs

Models can set up TFP (Time For Prints) or TFCD (for a CD of pictures) shoots in which both model and photographer donate their time. Sometimes other specialists (stylists, makeup artists) will join in. This is the Internet version of "testing". It's not uncommon for an attractive and diligent model to work with 20-50 TFP photographers from contacts on the Internet.

In the Internet culture TFP photographers generally will want a release from the model, and will agree to a promotional copyright waiver for the model to use the pictures. Each model and photographer has their own policies, however, and release issues have to be discussed prior to the shoot to avoid problems afterward.

What will be delivered by the photographer? Some models insist on getting all images immediately after the shoot. Some photographers (usually the more professional) insist on giving only a few of the pictures (the best ones), and only after retouching. The possibility of conflict is obvious, and again the parties have to discuss the "deliverables" prior to the shoot to avoid misunderstandings. Timing of delivery is also a frequent problem, and needs to be agreed upon before the shoot.

Shoot Up

Models should strive to work with other TFP team members that are at her level or above. At first she may be able to attract only beginning photographers, but with a little experience and some pictures to market herself on the Web, she can aspire to more. Success comes from being selective and creatively involved in the shoot process with an ever increasing quality of photographic team.

Preparation for Mainstream Modeling

A common perception on the Web is that models need portfolios to get into agencies and that agency-quality photos can be gotten free from photographers through the Internet. It's usually not true. The overwhelming focus of Internet photographers is art or glamour and nude work, and frequently that is what they will suggest for a TFP shoot. The number of photographers willing to do commercial/lifestyle shots is quite small; the number of who can do them at professional level even smaller. Virtually nobody on the Internet understands contemporary fashion photography and is willing to do it in TFPs with a model. A model who finds such a photographer has found a rare treasure indeed.

It's very common for the model's needs and the photographer's desires to be different, which requires negotiation. Typically a model will ask that some of the pictures be of the type she needs, and some be of the kind the photographer wants, within her limits.

Photographers have to be carefully chosen. If their work doesn't look like what you see in magazines for models of your type, they probably can't do agency-quality work. Even if they can, good professional quality

images require support staff like makeup artists. *(This is very important. If there isn't an excellent makeup artist for the shoot it is <u>very unlikely</u> that anything useful for mainstream modeling will come out of the TFP.)* Finding good makeup artists and stylists (if a fashion shoot) who are willing to work for prints is not easy. You may have to pay them, even if you and the photographer are working for free.

Models who ignore these facts tend to get stuck in an endless TFP loop, continually doing more shoots to try to get what they need.

Aside from trying to create book-worthy images, a model can gain something very valuable from TFP shoots: experience and skills. If she works with good photographers she will gain something new with each session. She will learn what it is like to be on set, what is expected of her, how to be comfortable in front of a camera and to interact with photographers with very different personalities and styles. She should learn by working with makeup artists and asking questions. As she transitions to the "real world" of mainstream modeling that experience will be very valuable in winning jobs and performing well.

Commercial Work

We've already discussed the difficulties that commercial clients have trying to hire models from the Internet. It's not surprising that there isn't a lot of commercial work available online. But it's not zero.

Some mainstream jobs are listed with online breakdown services, and are discussed in the Mainstream Modeling "Self Marketing" chapter. But clients do use modeling forums and listing services to find models. Because of the demographics of these sites, the jobs tend to be glamour oriented (bathing suit catalogs, calendar work, pretty girls to dress up a local business' newspaper or TV ad) They usually do not pay well – sometimes don't pay at all. They are almost exclusively for pretty girls in the 18-25 age group. Another infrequent type of casting found on the web is for unusual types (Big and Tall, character, special skills) that may not be listed in abundance with the agencies.

A small number of high-quality fashion and commercial jobs can also be gotten indirectly through the web. Models who have done TFP shoots with good commercial photographers will sometimes be used later by the photographer. Networking-through-shooting is a time-honored approach to finding work on the web as well as off. But for it to work, the model has to choose photographers who really have that kind of work to give them. That's hard to do, since photographers frequently exaggerate the amount of commercial work they do. The best approach is to try to find photographers on the web who have several good-quality commercial tearsheets in their portfolios.

Glamour and Fetish

By far the largest amount of work available for models on the Internet is glamour (frequently including nude) and fetish shooting. Millions of dollars are spent on such models each year, both by commercial companies and by individuals who shoot for their own purposes. The great majority of such work is for female models.

Few agencies service the glamour market, and very, very few work with fetish clients. Given the substantial demand and the difficulty of bringing models and prospective clients together, the Internet has both greatly expanded the amount of such work being done and the number of models and photographers doing it. What used to be accomplished by word of mouth and local networking now happens readily and frequently through the Internet listing sites and specialized glamour/fetish forums and sites.

Artists' Models

In principle, artists should be able to recruit models from the Internet, and some do. But the Internet modeling culture has set prices at a point where they exceed what "real world" artists and schools are willing to pay, so more traditional means are normally used by art schools and established artists to find models. The "art" modeling done through the Internet model listing sites and forums is not very different from "glamour", and tends to be done by photographers with little artistic skill or exposure to the legitimate artistic community. It usually pays better than traditional art modeling. There are some excellent photographic artists on the listing sites, however, and models can approach them. These people usually do not pay – if they are very good, they don't have to.

The Internet Model Stereotype

Everyone knows the stereotype of the mainstream model: the tall, impossibly thin, beautiful girl who jets from one exotic set to another, and doesn't get out of bed for less than $10,000 a day. The reality is quite different for almost everyone, of course, but the mass media has presented this image of the Supermodels so much that it's easy to get caught up in the hype.

The mass media doesn't tell us much about Internet models. They are discussed rarely, and almost never from the single point of view that makes the Supermodel image so compelling. The great majority of people don't know there is such a thing as an Internet Model, and would likely think she is something like a Mainstream model if they thought about it at all.

But the perceptions that count aren't those in the mass media or the minds of the general public. It's the image in the minds of Internet photographers and clients that matters. Despite the lack of media coverage, there is a rich literature on the web about Internet models and people's experiences with them. The people who hire models are familiar with all this.

So what does all that subculture communication say? Let's recall what it takes to put yourself on the Interenet modeling market: a small set of webcam photos or vacation snapshots, a free Model Listing Site page, and you're open for business. So the common stereotypes of the Internet model reflect that reality, and are more true to life than the mainstream stereotype. Because it's from a variety of experiences and perspectives, they are more varied than the single "Supermodel" stereotype.

There are hundreds, if not thousands, of models making a substantial living, or enjoying a rewarding avocation modeling, and doing it well. But in the minds of people who have tried working with Internet models:

1. The "model" happened across a free model listing website one morning, put up a profile of herself for fun, and then never gave it another thought.

2. A model's boyfriend or photographer put up a listing for her (or advertises her on the forums) and the model doesn't even know about it.

3. They have a jealous "manager" who interferes with communications with people who might actually want to hire them.

4. For all the above reasons, they usually don't answer query emails from potential clients.

5. The probability that they will actually show up for a booked shoot is about one in four. The probability that they will show up on time, ready to shoot, and looking like their pictures on the web is one in ten.

6. They will have a boyfriend who is an unemployed rock musician and who insists on sitting within four feet of the model during a shoot, drinking his beer and giving insistent suggestions on posing.

7. They don't have a clue what skills a model is supposed to have, or what is expected of one, and they aren't much interested in learning.

8. Their expectation of what they will get from a photographer is out of line with reality.

That's quite a list, and it isn't very pretty. Obviously if all Internet models were like that, there would be little or no real Internet modeling – just a lot of frustrated photographers and clients. But the stereotype is close enough to people's everyday experiences on the web that anyone entering the field has a considerable perception problem to overcome. You shouldn't be surprised if initial contacts on the web are colored with those perceptions.

Your Role as a Model

In mainstream modeling the role of the model is relatively simple. She is one of many qualified applicants for jobs; she is in a strong buyer's market where she has relatively little control or bargaining power. Her role is to be pleasant and inoffensive to work with, and to act as any job applicant might.

On the Internet it is different. When dealing with traditional types of clients who happen to be recruiting through the 'net for some reason, normal "mainstream" rules apply. But usually that's not the position the model finds herself in. In glamour/nude/fetish work (the majority of paid work available on the net) the model may be one of only a few qualified applicants in her area. Her bargaining power is considerably stronger than in a mainstream casting. She is much more able to propose (or even dictate) terms and conditions of the assignment.

That's true even for recreational "TFP/TFCD" shoots. A model can and should negotiate for pictures that benefit her from at least some of the shoot. The model is closer to being a partner in the shoot, and the more experienced models may be much more capable than the photographers they are working with.

Then there is the uncertainty factor. Mainstream modeling, especially when a good agency is involved, tends to be pretty predictable. Clients are who they say they are, are doing what they say they will do, and show up as agreed to do it. A model can normally trust the assurances of her agency or the client without much regard to safety or reliability concerns. Not true on the Internet. Models have much less reason to assume the validity of what is being offered, or the reliability of the photographer or client. So it's necessary for models to question potential clients or team-mates more carefully than a mainstream model would. Caution and information exchange dominate the conversation.

On the Internet, models come to assume that they should be paid for modeling, or at the very least should get whatever pictures they want for free. The concept of paying for test shoots is virtually unknown, and looked on with disdain. That can be true for three reasons: models experience much less competition than in the "mainstream" world, and the photographers they work with tend to be much less demanding of the kinds of excellent pictures that would have to be paid for, and there are many photographers available who produce pictures suitable to market an Internet model, and may even pay her to produce them.

The result of this is that Internet models, as a class, are used to interactions with photographers that are very different than would be tolerated in the "real world". Photographers and clients who are used to the mainstream system usually find Internet models demanding, (relatively) abrasive, and more likely to assume or request conditions that would not be accepted in the mainstream.

Models making (what photographers consider) outrageous demands tends to color the reputation Internet models get, and those who are fairly described by that reputation have great difficulty transitioning to mainstream modeling later.

The Value of Experience

Experience is of value in any business. It makes a model more able to deal with the demands and pitfalls of the profession, if only by having encountered so many things before. It also has a perception of value in the marketplace.

There is a difference in the way a model's experience is viewed on- and off-line. Although commercial and fashion photographers value talented, experienced models, normally experience is not a requirement for getting work, and except toward the top of the fashion market, doesn't play much of a role in rates paid for models. Online it's different. Many photographers refuse to pay for models who don't have enough experience and a well-developed online portfolio. That tends to be true for two reasons: the photographers themselves don't have the ability to get the best from any but very talented, experienced models, and it is self-serving. By telling a model she isn't experienced enough to warrant being paid, they hope to convince her to pose for free. Some photographers actually believe what they are saying; others recognize it as a ploy to get free models.

There is another, more legitimate role that experience plays in Internet modeling. Photographers aware of the stereotype of the flakey, irresponsible Internet model are very concerned about the reliability of models they want to work with. In mainstream modeling that is rarely much of an issue, since the agency takes care of filtering out the flakes, or the sheer difficulty of self-marketing makes them uncommon. On the web it's different, and photographers will use "experienced" as a surrogate for "reliable". A model who can put up a portfolio of many good shots from many photographers can be judged to have shown up at least some of the time – which puts her ahead of the pack.

Types of Clients

Internet Photographers

The distinction between "Internet client" and "Internet Photographer" is hardly meaningful, since in most Internet work the photographer is the person who hires the model.

There are some excellent mainstream photographers who engage the Internet modeling community. Some of them do use Internet models for their commercial jobs, but normally only after they have met with, or even worked with the model earlier to confirm her abilities.

Still, they are a distinct minority. With some exceptions a person is an Internet photographer either because he can't compete in the "real world" or does (at least in part) a kind of work that is not supported by mainstream model agencies. He is on the 'net looking for models who share his interest in non-mainstream work, or who are so naïve that they will accept whatever he tells them as truth. Real agencies tend not to deal with such photographers.

It is common for Internet photographers to claim experience, contacts and abilities they do not have. They nearly all claim they can do "model's portfolios" even though many have never seen a real agency portfolio in their lives, and couldn't produce work like that on a dare. The promise to produce a "portfolio" is really just another way to get a model for free, or worse, to get her to pay him.

In a sense none of that really matters if the model aspires only to Internet-type of work. The standards are very different, and the culture accepts what Internet photographers do much more readily than the "real world" does. A model can work with one Internet photographer after another, each shoot giving her experience, contacts and pictures that help her with the next Internet job. But if she wants to graduate to commercial or fashion modeling, the Internet experience may not help her, and it could even hurt.

Rates

Prices charged by Internet models tend to be higher than customary for non-commercial work. Offline, artistic photography models might get $10-$25 per hour for their services, and non-nude models for hobby photographers would be lucky to get paid more than a nominal amount. On the 'net, "fashion" (meaning, typically, any shoot that the model keeps her clothes on) may pay $50 per hour or more. Nude models will ask more; $100 is not unusual.

There is also an interesting inverse relationship in models' rates based on experience. Models new to the Internet sometimes ask unreasonably high rates and set onerous conditions. It's not unheard of for a new model to ask $150-$200 an hour for non-commercial nude work, insist on getting all or many of the pictures taken, and other considerations. They can do this (and get it) because there are a few hobby photographers who will actually pay those rates. What happens, though, is that after that relatively thin market gets played out, models find that the majority of photographers on the Internet will not pay that kind of money or agree to those conditions. As a result, the better, more experienced models tend to set rates of $50-$75 an hour (with no or little requirement that pictures be delivered as well) for most work, and perhaps $100 per hour for fetish work. Models at the very top of the market may ask more than that, but there aren't many who routinely get it.

Websites

In the beginning there were bulletin boards on which glamour, nude and fetish pictures would be placed by the owners or members. Some were free, others required a paid membership, and people could use a modem to dial into a computer hosting the bulletin board to see the pictures.

As the Internet came into use, these morphed into Newsgroups (affinity-based proto-forums), then web pages that featured photographs of models, again primarily glamour/nude/fetish oriented. The dialup bulletin boards disappeared, replaced by thousands of locations on the World Wide Web.

Pay Sites

The primary outlet for "sales" that can be used to generate models fees are pay sites: web pages that require paid membership for people to view or download their content. The number of these has grown to the point that it's impossible to know how many there are, but there are certainly hundreds of thousands of such sites, probably millions. They are hosted on servers all over the world, and often are immune to legal and regulatory

pressures for all but the most extreme content. They are also often nearly impossible to influence if they happen to be doing something a model or photographer doesn't like, such as hosting unauthorized pictures. Other than child pornography, local officials in many jurisdictions have limited interest in bringing pressure to bear on such sites.

The pay site industry is now mature and robust. They may have the latest in streaming video or image search technology and may include tens of thousands of pictures online. The appetite for new content (again, almost all nude, erotic or fetish oriented) is voracious, and hundreds of millions of dollars are available to produce or purchase that content.

Online Magazines and Specialty Sites

There are specialized websites that deal with every conceivable interest. It's not surprising that many of these are modeling-related, or use models to attract viewers to the site in much the way traditional magazines do. In fact, many of those "e-zines" are much like paper magazines and newspapers.

In general these sites are not lucrative sources of income for models. Site owners tend to act as though appearance on their site, and the "exposure" that it gives, are sufficient compensation for models – or else they pay something like traditional (low) editorial rates. There are exceptions: normally sites which are the online presence of a "real world" organization such as a news outlet, print magazine or commercial company.

Internet Models

It may seem strange, but Internet models are themselves clients – either for pictures of themselves, or for other models. Many of them have their own pay sites, and they supplement their content (pictures of themselves) with pictures of their "friends". To get that supplementary content, they may trade their pictures for pictures of another model, purchase shots outright, or take part in joint photo shoots designed to generate content for themselves and others. They also market themselves through exchange of links with other, similar pay sites. A model may offer reciprocal linking as part of a compensation package to get other models to work with or for her.

A well-known, well marketed model pay site can yield a model one to several thousand dollars a month. Those that do not get enough good marketing or don't have sufficiently appealing design or content may end up making the model little or nothing.

Commercial Clients

It's not that there are no commercial clients on the web. There are. As we have described earlier, they are sparse and usually cheap, but they do exist. A major class of Internet commercial client is businesses which are themselves Internet-based. They are more comfortable with the web culture, more likely to seek models on the web, and more willing to put up with some of the reliability issues that come with the Internet.

Recently mainstream Casting Directors have begun to use the more professionally oriented websites such as actorsaccess.com, and even Craig's List (craigslist.com) as a supplement to commercial print and TV commercial castings they give to model agencies. This is by no means true of all casting directors or jobs, and it has caused something of a backlash from the agencies, but there are an increasing number of such jobs available to the public to self-submit. Casting Directors do not normally place such jobs on the glamour-oriented model listing sites, however.

Becoming an Internet Model

Few people start off trying to be Internet models. The usual pattern is that they try mainstream modeling, either through conventional means or by trying to use the Internet to get into it. For whatever reason, it doesn't work. They don't find an agency interested in them, or they don't find as much work or personal fulfillment from their efforts as they would like.

It's easy to become exposed to the market the 'net provides to models. Any attractive girl with a listing on the more popular model listing sites will find that she gets offers for Internet-style work. Inevitably, some try it. Some find that Internet modeling provides, if not what they set out to achieve, at least something they find rewarding in one way or another

For those who do choose to pursue Internet-style work, there are a lot of things models can do to improve their acceptance in the market.

Model Listing Sites

The single most powerful thing an Internet model can do is take out a membership on a popular Internet Model Listing Site. On the biggest sites a new model who is attractive and willing to do Internet-style modeling may get hundreds of "hits" on her modeling page within the first day, and usually several (sometimes hundreds) of offers will come in shortly after a model first sets up her site. Other, more specialized model lists such as Glamour Models get a smaller number of hits and offers, but the offers tend to be of higher quality.

What To Do With Your Listing

Present yourself as appealingly as possible. This is your primary sales tool.

1. Either in your "data" (if the listing site has check marks for information about you) or in your self description be honest about what you are and what you do and don't want to do.

2. Show pictures that tell a potential client what they need to know about you. At least one clear head shot, one body shot, and if you are interested in doing nudes, one elegant nude that shows what your body looks like. If more "artistic" or "edgy" pictures are appropriate to the kind of model you are, that's fine too. As you work and gather pictures from shoots you can update your listing with better pictures.

3. List your location and age.

4. See the Glossary for how to measure waist and hips, and give your stats.

5. Keep it simple. Don't overwhelm the viewer with clutter. Put up five good pictures until you can convince yourself that you have six excellent ones.

6. Update it frequently. Remember the stereotype? Internet photographers do, and they look at "last updated" dates on a model's page to determine who is real and who isn't. If a model hasn't updated her page in months, it's a sign that she isn't very committed.

What Not To Do

Although it is easy to set up a listing and start getting offers, there are several things that will improve the quality of your responses:

1. Do not list any contact data on the site other than an email address.

2. List the nearest substantial city to you, but nothing more specific as a location.

3. Use a stage name, not your real name.

4. Do not say you have or want a "manager" even if you do have or want one.

5. Don't list rates on the site. Rates should be a variable, depending on the quality and kind of photographer or client who contacts you. If your listed rates are too high, you will miss good offers. If they are too low, you will miss out on money you could have had.

6. Don't list a kind of modeling you really don't want to do. Understand that "Glamour" doesn't mean "Glamour Magazine"-style pictures, and that "Adult" doesn't simply mean you are over 18.

7. Don't show pictures doing something you don't want to be hired to do.

8. Don't get too upset when you get offers to do things you aren't interested in, even if you've said you aren't interested in them. It will happen a lot.

9. Don't put more on your profile than a modeling client needs to know. Your poetry skills, sun sign, cat's name and your interest in origami don't help market you. Leave them off.

10. Put up only the best pictures you have of yourself. "More" is not nearly as good as "better". If webcam shots are all you have, put up a few of them to get started. But replace them as rapidly as possible with something better.

11. Don't be argumentative or abrasive in your text. It's easy to become upset at some of the things you will encounter on the web, but keep that anger off your site. Your listing should make people want to work with you.

12. Don't say that your boyfriend will accompany you on shoots. You may feel the need for an escort on some jobs, but saying in your listing that your significant other will be along for the shoot will cost you lots of legitimate offers.

13. Don't say "paying assignments only." Even supermodels do free shoots now and then, and if you foreclose it at the outset, you may miss offers from excellent photographers.

14. If you are under 18, don't put up a page full of provocative swimsuit, lingerie and glamour pictures. If you do, you really won't like the kinds of attention and offers you get. Make your pictures appropriate to the kinds of work you really want to do.

In addition to putting up a page on a listing site, you should use the resources of the site to find people to work with you. Search for photographers, makeup artists and others in your area. Write to those that interest you, and propose that you work together.

Personal Web Sites

It almost seems like a contradiction, but a personal web site with her own domain name is less important for a web model than for a "mainstream" model who is self-marketing. The mainstream client or agent, if he is willing to look at a website, wants to see something clean and professional – and most of the model listing sites aren't like that. A client who is used to the web-model culture, on the other hand, is much more willing to accept a reference to an OMP page to look at a model. They don't expect the same degree of finesse and conservatism of presentation that a more traditional client might.

Even so, a model who has a substantial body of good work to show is well advised to get her own domain and produce a personal website. As we have seen, some take it a good deal further and turn their personal sites into pay sites to generate income; others will have a "straight" site for client contacts and another site to send paying customers, perhaps under a different name.

Most of the rules for a web model's personal site are the same as those for a mainstream model, although the content may be quite different. A model may choose to have a site with lots of bells and whistles for her pay site, but that's not what she should use to refer clients to. It's like a resume, or your application letter to an agency. Keep it simple!

If you absolutely must save money and use one of the freebie site hosts such as Yahoo or MSN, make sure a client does not have to become a member of the site, join anything or use passwords to see your page. If they do, the best clients will go away without ever looking at you.

The *first page* of the site should contain your stage name, location, stats, email address and a small number of pictures. You might have one large (500-600 pixels or so high) headshot on the first page, but all other pictures should be thumbnails that a viewer can click on to bring up a larger image. That saves kilobytes; kilobytes equate to time, and professionals want a site that loads very quickly.

Site layout should be simple, clean and attractive. Do not clutter it up with complex graphics or lots of different fonts. Keep animation to a minimum. Zero animation is best. If you want to have a more complex site and fancy animation, do it on another page that a viewer can choose to look at or not.

Do not include an excess of biographical data. Professional modeling experience, if you have it, should be briefly described. Include experience that would show special skills, like dance or acting classes. Nothing else.

You may include a post office box. Other contact data should be reserved for email, and only after you are comfortable with the potential client. Do not ask a site visitor to contact an agent or manager. If you do use a manager and they need to be part of the conversation, reserve that piece of information until the client is hooked. It won't help you get jobs.

No pop-ups or advertising on your page! Keep it clean. Nobody wants to have to spend their time closing popup ads.

Networking

Net models largely act as their own agencies. A large part of their self-marketing effort needs to be through networking with others who can help them find jobs and support services. There are many ways to do that:

Forums

The Internet modeling-related forums, particularly those devoted to glamour modeling, are populated largely with photographers who shoot 'net models (either TFP, content shoots or paid jobs). Models who join in the discussion on the forums become known to those photographers and to the many lurkers who read the forums but don't contribute.

A model should strive to not be confrontational, but to be positive, cheerful, and upbeat. She is making a sales presentation, no matter what she does. When she has a shoot she can share some pictures with the forum. She can thank photographers she has worked with, and join in the discussions (always in a positive, helpful way). Such participation can go a long way to creating popularity in the net photographer community – which is small, and talks amongst itself constantly. There are many examples of models being given jobs simply because a photographer liked the way she conducted herself on a forum.

What a model should not do is spam the forums with solicitations for work. One or two of these is acceptable on most forums, but it gets tiresome, and doesn't do anything but raise awareness in an annoying way. It's much better to be a member of the forum who sometimes talks about herself and her work than to simply say "I'm available, hire me!" over and over.

Model Expos and Group Shoots

There are a variety of formal organizations and informal groups around the country which meet at intervals to network and shoot. In Los Angeles, for instance, companies hold shoots which can attract as many as a hundred models and photographers. Sometimes it's a local camera club or interest group that holds an expo. Sometimes it's in informal group that just comes together one time, or once a year, to network. Glamourmodels (glamourmodels.com) combines with people in Phoenix to hold group model shoots twice a year, and models and photographers come in to them from all over the country.

All of these things are good opportunities for models to come to the attention of photographers. It is very common for a model to attend such an event, collect business cards, and book paying shoots as a result – or even book the shoots as part of the event.

These kinds of events are publicized on some specialized websites and most of them are advertised on the national and regional modeling forums. Models have even been known to organize their own group shoots and publicize them on the modeling forums, just as a means to make contacts.

Photographers

Photographers know other photographers with similar interests. If a photographer likes a model he might try to keep her for himself (all too common) or become her "manager" (also all too common). But he may be happy to recommend a model to others he knows who might be willing to hire her.

A model can ask her photographer about other contacts during a shoot. She can also do it through email conversations with photographers she "meets" on forums or who email her as contacts from her website or model

listing site page. It's always wise to keep on good terms with photographers. Not only are they clients, they know others and can help or hurt you.

Other Models

Models know photographers and they also understand that photographers have a constant need for new models. There is a rich exchange of information, contacts and introduction between models in related fields. An important element of a net model's self marketing is to find other members of her sorority and connect with them to share those contacts.

Support Staff

You should never forget that the other members of a shoot (makeup artists, for instance) work with other photographers and models, and if they like you, can help a great deal.

Model Safety

Internet modeling by its very nature is much less safe than mainstream. Many of the clients (whether for paid or TFP shoots) are not professionals. No small number of them aren't even photographers in the conventional sense; they are just people (primarily men) who enjoy taking pictures of women, and may or may not much care about the pictures.

The Internet allows models and photographers who are concerned about costs (and may insist on keeping them at zero) to meet each other. Non-professional photographers and Internet models are much less likely than those in the mainstream to use support staff (makeup artists, stylists, assistants) at a shoot. The predictable result is that Internet models frequently find themselves in one-on-one shooting situations with photographers of unknown reputation, in locations like hotel rooms or apartment studios, with no system to rely on as a backup.

Despite the obvious dangers which could arise in such situations, the great majority of such shoots go off without incident, and are enjoyed by both model and photographer alike. Serious assaults seem to be rare (although it seems many more minor problems are not reported. Minor assaults and harassment are far from the norm. Still, they do happen, and happen often enough that an Internet model is wise to be concerned and take precautions.

That's easy to say, but much harder to put into practice. There is necessarily a problem of balance between cost, the hassle factor associated with some kinds of protective solutions, and problems caused by the "solutions" themselves. Models are stuck with the having to make choices among sometimes unappealing options, and it's hard to get it right all the time.

Choose Carefully

Especially at the beginning of a model's time on the Internet, she will likely be faced with a large number of shooting opportunities. For models open to fetish or nude work, there may be hundreds of offers. Even for less revealing types of photography, attractive models may find that they have a surplus of offers. There is a tendency to accept too many of them. Other models, perhaps in low population areas, find that they do not have enough offers, and are tempted to take things they should not. Whether from ignorance of what good photography is, desperation at not finding enough of what they want, or just enthusiasm, they often rush into ill-advised shoots.

A good way to avoid many problem shoots is not to do many shoots. A wise model is careful to examine the work of a photographer (or client), determine if it is really good enough to help her or meets high quality standards, and choose only those that really meet the test. If a model is charging for her services it may be hard to turn down a lucrative offer, but there is a correlation between quality of work and the treatment a model will receive on a shoot. The obvious exception is the rank amateur, new to the field, who may be both gracious and inept. Models will have to decide for themselves how to handle such opportunities.

Danger Signs

There is no foolproof way to tell dangerous from safe photographers. Even the most professional can have hidden personality issues that make them dangerous, and some who, on the surface, appear questionable may turn out to be just fine. Circumstances that seem safe (a known studio, another model at the shoot, and a photographer who even has his own "model safety" website) can be disastrous. But a model can greatly improve her odds by paying attention to danger signs that tend to point to problem shooting situations.

Quality of Presentation

Someone who cares about his work and the way it is presented is less likely to be a problem than someone who doesn't. A professional-looking web site, with excellent pictures, effective graphics and well-written text is a sign of someone who cares about his craft. A site or email riddled with spelling and grammatical errors, or which makes excuses for the quality of the pictures shown, is much less likely to come from someone whose motivation is quality work.

Allowances have to be made for special considerations like a photographer who is not a native-speaker of English, for instance – but the less literate the email, the more caution a model should show when dealing with a photographer.

Tone of Communications

A photographer who is abrasive in email isn't likely to be better in person. Claims of great things a photographer can do for a model should be treated with extreme skepticism, if not as danger signs. If a photographer makes a point of how much a model will be missing by not working with him, it's also a danger sign. Shoots aren't that important; good photographers can find good models without wild claims, abusive or threatening communications or control tactics.

Emails and telephone calls should be clear, not evasive, without overtones of bluster, bravado or threat. A shoot should be a cooperative effort between model and photographer. If communications aren't that way, it's reasonable to worry about what will happen at the shoot.

Type of Communications

Most Internet photo shoots start off as emails. It's natural to keep them that way, and sometimes there is good reason. But in the "real world" at least some part of the conversation is always by phone or in person, and it should be for Internet models too. At some point in the negotiations for a shoot, models should insist on talking to the photographer or client on the phone. He should be happy to give them his business, home or cell phone number. If he isn't, it's a red flag.

On the other hand, there are some photographers and "model managers" who insist on telephone calls. They want to use the call to manipulate the model, often in very misleading or abusive ways, without leaving a written record of it. If a photographer insists on a telephone call at the outset of the conversation, that's a red flag. The communications ought to use both forms, with email being used for preliminary investigations, and the telephone to finalize agreements (perhaps with a confirmatory email to follow up.)

Type of Shoot

The more intimate the intent of the shoot, the greater the possible risk. An Internet photographer who wants to do "fashion", commercial or portrait types of pictures is less likely to be a danger than one who prefers nudes, particularly "erotic" nudes. There are not many perfectly safe, excellent photographers in all kinds of photographic specialty, but greater care is called for in some kinds of work than in others.

A model should ask a photographer exactly what he has in mind for a shoot, and to use the answer to evaluate the dangers it may present. The greater the level of detail, the better. Sometimes a contact between a photographer and a model starts off with neither of them having a particularly clear idea of what they want to do together. A photographer may see a model's web page, decide he wants to work with her, and plan on deciding exactly what to do with her as the conversation develops. There isn't anything dangerous about this, but it is wise for a model to try to refine her understanding of the photographer's intent as the discussion progresses.

Of particular concern is fetish photography. By its very nature it may involve both nudity and bondage or physical restraints, and may even be deliberately painful to some degree. A model may find herself with no effective means of self defense in some fetish shoots – she is entirely at the mercy of the photographer's good will. In addition, some fetish photographers use the fetish itself to play out their own psychological issues – leading to the possibility of unanticipated incidents in the studio.

It's easy to overstate this danger, since there are many fetish photographers who are entirely benign, and who can produce excellent work. Still, this type of shoot is one that should be undertaken only with great care. New models, who aren't sophisticated about the Internet culture or photography, are well advised to be exceedingly cautious about fetish work. Only those with considerable personal maturity and self confidence should pursue the field.

Identification

When asked, a photographer or client should have no hesitation about fully identifying themselves. That should include full (personal or corporate) name, physical address and contact telephone numbers. It should also include URLs for their website or a good explanation for why they don't have one. If it is a business, it should be described in specific terms. Vagueness and evasion on any of these issues are strong danger signs.

Meeting

If at all possible, the model should meet with the photographer or client before the shoot. It's absolutely amazing how impressions can change between an email and a personal encounter. All of us have evolved

sensitivities to body language, eye contact and demeanor that add enormously to the literal meaning of words spoken.

References

For clients or photographers who primarily have a web presence, it should be relatively easy to find references from others who have worked with them. For mainstream professional photographers and clients, it's a lot less likely that they will have (or be willing to share with you) references that you can check on. The people least likely to be a problem are the most likely not to be able to demonstrate it.

The Internet culture supports people checking up on each other, and understands why it is done. Most Internet models will find nothing odd about another model asking questions. Photographers who typically use Internet models will understand this also, and the request will not seem untoward. For those kinds of people it is a good idea to ask for verifiable references, and a possible danger sign if they are not given. Even if references are given, you need to be sure who they really are. One of the tricks of scammers and stalkers is to give out reference names and email addresses which really are themselves under another name, often with freebie email addresses such as yahoo, aol, hotmail or gmail.

As an alternative to asking for references, a model can find them for herself. This is preferable, since she will know for sure who she is actually getting the information from. If a photographer's website shows an email address or other contact information for other models he has worked with, you can follow those to contact them directly. If his models are active on the Internet, other photographers or models in the area are likely to recognize them, even if credit is not given. Networking with others to do that research is very useful.

"Real world" clients and photographers are understandably reluctant to give references to web models. The last thing they want is their clients or other (non-Internet) models to be calling, asking about them and if they are safe to work with. The very question is a red flag to them, since it is not customary off the Internet. In addition, photographers and clients are obligated to preserve the privacy of their models; they cannot normally give out contact data for them to third parties. Even if you can identify them for yourself, it is very poor form to contact them directly, and you can expect a negative reaction to doing so.

In such cases the model can use a surrogate approach: determining the status of the client or photographer in the industry. Do they have a variety of published tearsheets? A solid client list? Are they listed in mainstream professional reference sources? Do they have a Yellow Pages or Business Pages listing? Are they known to other photographers or models that you know? If so, the probability is much greater that you can shoot with them without concern.

Shoot Location

The safest location is one that is public, frequented by lots of other people, and widely known to others. The most dangerous is one that is private, secluded and virtually unknown. Unfortunately, safe, public sites are inappropriate for many kinds of photography, so compromises have to be made. It is common for TFP or other Internet shoots to be in a hotel room or the photographer's residence, and that doesn't necessarily mean there is a safety issue. Still, in evaluating their safety concerns and responses, models need to understand the proposed location, and take it into account.

Others at the Shoot

Having someone else, particularly another woman, at the shoot gives a much greater probability of safety than a one-on-one. A makeup artist, stylist, photo assistant or other crew member is very desirable for other reasons also – in fact, for most commercial or fashion style shoots if a makeup artist isn't part of the team the outcome is of doubtful utility anyway. If a photographer refuses to allow a makeup artist or other crew member to be present on such a shoot, even at the model's cost, the risk is a good deal higher. (Some shoots, like "art", don't require a makeup artist, and a photographer might reasonably object to having to get one.) Like the other "danger signs" in most cases a one-on-one turns out not to be a problem, but it is an additional indicator that needs to be factored into a model's decision-making.

Researching Clients

It's wise for models to know and use techniques to research whom they are corresponding with. On the Internet anyone can claim to be anything, and you shouldn't simply assume that they are who and what they say

they are. There are a wide variety of sources and techniques that models can use to confirm what a potential client says about himself.

Search Engines

The most obvious source of data is search engines. If Joe Schlabotinsky claims to be an important casting director in Los Angeles, do a search on him. If he is at all well known in the industry there is likely to be at least one reference to him. Search engines like google.com offer you chance to see what information is available.

Some simple tricks help. Use quotation marks around words that necessarily will be together (e.g. "Joe Schlabotinsky") to reduce false hits on Joe and Schlabotinsky separately. Add the name he gives you for his company to the search term, or search for it separately. If it's made up of common words and you get too many hits, add in qualifiers like "casting," or "talent," or "Los Angeles" or some other word that might appear in an article on him.

On Google and some other search engines you can also search on his email address or his telephone number (usually using the format XXX-XXX-XXX) or street address (in quotation marks) to see what pops up. If it happens that other businesses are located at the same address, is their nature consistent with what you would expect for Joe?

MapQuest/Google Maps

Ask for a full address for him or his studio. Even if you don't have that, if you have any geographical information about him (zip code, even just city), put it into Mapquest (www.mapquest.com) or Google (maps.google.com) and look at the map. Just from the location you may be able to get important information. Is it a residential area or business? On Google you can also switch to a satellite picture of the neighborhood. Is it near a population concentration or off in the boonies somewhere? Few good New York City agencies are located in Long Beach, NY, for instance – even though it may be considered part of NYC.

If Mapquest says the address doesn't exist, you know something else important.

Email Address

It's not unheard of for a good photographer or agency to use AOL or a freebie email address like Yahoo or Hotmail – but it's not a good sign if they do. Ask for a real, ISP-generated email address, and be suspicious if they won't give you one.

If you do have a real email address, what can it tell you about the person?

1. *The top level domain* (the last bit after the dot, as .com, .edu, .gov) is important. If someone is using a ".edu" domain it suggests he may be a student posing as someone else. ".gov" is reserved for governmental organizations; ".mil" for the Department of Defense. Many domains are also outside the US. If it ends in only two letters (".ru" for instance) it is hosted in another country. You can find out which country here: http://ftp.ics.uci.edu/pub/websoft/wwwstat/country-codes.txt and then ask why he is using that email address.

2. *The second level domain* (the stuff before the dot. In webmaster@newmodels.com, the second level domain is "newmodels". Turn it into a website URL (www.newmodels.com), type it into your browser, and see what comes up. The answers can sometimes be revealing. Even if there is no associated website, does the domain seem to signify something? Is it something you ought to worry about? Or did it turn out to be a freebie email address site?

3. *Location as part of the domain*. Someone claiming to be a high-class New York photographer whose email is highclassnyphotog@charleston.rr.com had better explain why he isn't from New York.

4. User name. That is his self-definition (although it may be assigned by someone else in an organization). If it's "screwloose" perhaps he thinks of himself that way – and perhaps you should too. Or it may be a name (initials and last name, perhaps). Is it the same name he gave you? Why not?

IP Numbers

Spammers and scammers have become adept at spoofing email addresses, and a really determined scammer can set up a fake email to keep you from being able to trace him. But the Internet protocols that transfer messages

around keep a record of how they do it and what the source was, so you may be able to find out more about him by looking at those numbers. The "header record" of the email will contain the Internet Protocol (IP) numbers associated with the source.

For users of Outlook, the Header can be seen by clicking View>Options at the top of the message page. In Outlook Express, click File>Properties and select the details tab. Other email clients normally let you access the header through the "Options" tab, although the specific route will vary. You can use the "Help" file to find how to do it. If you use a web-based mail system (like Hotmail) instead of a mail browser, you may not be able to get access to the header data.

When you have the header record it may look something like this:

> Return-Path: <reallybignycphotog@yahoo.com>
> Received: from web41824.mail.yahoo.com (web41824.mail.yahoo.com [66.218.94.158])
> by mail.netmagic.net (8.13.1/8.13.1) with SMTP id iBVNoa3i024220
> for <curiousmodel@newmodels.com>; Fri, 31 Dec 2007 15:50:36 -0800
> Received: (qmail 17260 invoked by uid 60001); 31 Dec 2007 23:52:31 -0000
> Message-ID: <20071231235231.17258.qmail@web41824.mail.yahoo.com>
> *Received: from [220.78.217.222] by web41824.mail.yahoo.com via* HTTP; Fri, 31 Dec 2007 15:52:31 PST
> Date: Fri, 31 Dec 2007 15:52:31 -0800 (PST)
> From: Joe Schlabotinsky < reallybignycphotog@yahoo.com>
> Subject: test message
> To: curiousmodel@newmodels.com
> MIME-Version: 1.0
> Content-Type: multipart/alternative; boundary="0-1596984842-1104537151=:17171"
> Status:

Well, that's a bit much to wade through, but you can make sense out of it. In this case it says someone who claims to be Joe Schlabotinsky, who took out the email address reallybignycphotog@yahoo.com sent the message from Yahoo, but Yahoo got it from IP address 220.78.217.222 (see the italicized part), which, as it turns out, is Joe's IP number at home. That can be traced, and in this case it traces to a town in Korea. Something is not right about Joe.

Whois

How do we know that Joe's IP number is in Korea? We run a "whois" check on it. Websites like www.whois.com, www.whois.net, www.betterwhois.com and others let you type those IP numbers in and tell you what Internet Service Provider (ISP) owns them and where it is located. In this case we got a reference to an IP number listing service in the Pacific (www.apnic.net) which told us that the IP was in Korea.

An even better way to do these kinds of searches is to get a free tool that does them for you, and helps you understand what the results mean. An excellent one is Sam Spade, which is available as a free download at www.samspade.org/ssw/.

You can do a whois search on more than just IP numbers. If Joe has a website, you can type in the URL (without the www) and see who owns and administers it, and may be able to find companies it is associated with and other sites they own. All those things are useful in assessing what Joe is really about.

Published Reference Sources

There are many professional listings of agencies, photographers, casting directors and others in the modeling industry. The average Internet photographer won't be in them, but if he claims to be more than just the average, it might be useful to check these books to see if he is in them. Some are expensive (Le Book and The Workbook), although they have much of their listings online as well: www.lebook.com and www.workbook.com. Listing in these high-status sources is a very good sign, although not being listed isn't very significant, since many good professionals are not.

In addition there are the affordable books published by Peter Glenn Publishing, "Model and Talent" and "Fashion and Print", which offer extensive lists of agencies, talent reps, personal managers, casting directors and other industry professionals. A good professional may well be in these books.

Forums

Earlier we talked about photography and modeling forums as sources of information. One of the things they can be used for is checking on a potential client. If you are a regular you can post a question about Joe. Has anybody worked with him? What was their experience? Ask readers to email you. Frequently that's the best source of information about an Internet photographer. That technique should be used with care, however. If Joe is also a regular on that site, he may take offense to the question. Reference to modeling and photography related forums is contained in the "For Further Reading" section toward the end of this book.

Networking

Many Internet models report that the most useful source of information on clients is from other models who work in the area they do. A new model should seek some of them out (through forums or listing services), explain who she is and what she is doing, and see if they are willing to share information. Many models are very helpful, and the more experienced ones can offer very useful insights to new models.

Telephone Calls

Above we discussed books that could help you locate modeling industry professionals near you, or near where a potential client works. You can use those listings to find people to call and ask about the person or company. Have they heard of them? What do they do? Would they recommend them? This probably doesn't make sense for the average Internet photographer, but for someone claiming to be an agent, casting director or other industry professional it does.

Risk Reduction

A model needs to understand not only the risk factors in a shoot, but also the ways she can reduce those risks before deciding to accept an assignment. Risk reduction is rarely perfect; it usually comes with difficulties or costs attached. Those difficulties have to be included in the final plan for the shoot. Here are some possible approaches.

Additional Crew Members

Low-to-no cost TFP shoots usually are set up to avoid the cost of an additional crew member, but for quality reasons as well as safety, models would be very well advised to ask for (and even contribute to the cost of) a makeup artist or other crew member as part of the shoot.

Contingency/Communication Plans

A model should always make sure that others close to her that she can count on in an emergency are aware of her shoot, its location, and who it is with. They should know the exact address of the studio and the projected time of the shoot. If something goes wrong, they need to be able to find out about it and get to the site.

The model should always have a cell phone, and visibly check in with her "backup" person when she first arrives at the studio. She should also make a point of calling out during a shooting break to give a progress report – and it should be obvious to the photographer that she is doing it. Still, it needs to be done in a friendly, non-threatening way to avoid hurting the shoot.

Escorts

A common recommendation is that Internet models take an escort to the shoot. That is unacceptable (except for children) in a mainstream professional shoot, but it is less so in Internet assignments. It has the great advantage that the presence of a person the model trusts may dissuade inappropriate or dangerous behavior by a photographer. But bringing an escort is not a perfect solution. Many photographers, including the better, more experienced ones, have had problems with non-crewmembers at a shoot. A common attitude is that nobody should be at the shoot who isn't there as part of the creative staff. There are several reasons for this:

1. A model who brings someone they are emotionally close to and they seek approval from is likely to be concerned with the opinion of the escort more than the needs of the shoot. It is common for models to frequently glance over at escorts seeking approval, and to react to the feedback they get. That is disruptive, even if neither person means it to be.

2. Escorts are a risk to the photographers. It is not only the model who can be in danger from an Internet shoot. Photographers have been assaulted, had things stolen, and had shoots deliberately disrupted by escorts. They can have concerns similar to a model.

3. Escorts, especially boyfriends, can be a risk to models. There are many cases of controlling boyfriends who disrupt a shoot or assault the model during or after the shoot if she does something he doesn't like.

4. Escorts can get in the way in a small studio.

5. Escorts can come with their own agenda: "I have to pick up my kids from the babysitter at 5." Or, "Why don't you try doing a shot with that nice new sweater I bought you?" Photographers understandably get aggravated about these kinds of things.

All that is not to say that an escort cannot be brought to a shoot. It may be necessary. But there are ways to reduce both the actual problems an escort may cause, and the photographer's perception of possible problems.

1. Don't bring your boyfriend. It's not that there aren't boyfriends who can do perfectly well as an escort, but all too many of them cannot, and photographers know it from hard experience. Choose an escort you trust, but do not have a strong emotional bond with.

2. Bring someone who can actually help; suggest a support crew member you know and trust. A makeup artist is always helpful; stylists may help as well. However, you must be careful not to make the photographer feel your helpful escort is interfering with his creative control of the shoot.

3. Consider having your escort simply drop you off and pick you up, or sit where he cannot make eye contact with you while shooting. It will reduce distractions.

4. No alcohol or drug use by anyone prior to or during the shoot.

5. Make sure the escort does not roam around the photographer's studio or house unattended. The escort may be perfectly honest, but a photographer can be expected to be anxious about it, which doesn't help the shoot. He needs to be paying attention to you, not the escort.

6. Don't expect the photographer to pay for bringing the escort or feeding him. That's your problem.

Stage Names

It is very common for models to adopt something other than their real first and last names as "stage names". Often a first and middle name are used, or sometimes a name that is entirely made up. A model will have to use her real name when signing legal documents like releases, but that can be the first time a client finds out who she really is.

Self Defense

Models have been known to bring pepper spray or weapons to a shoot to help them defend themselves. It isn't clear how often that has helped (other than making the model feel more confident), and how many times the weapon has been used against her. Prudence is the best guide, together with the laws of your state.

Don't Do the Shoot

If the risk factors seem too high, or you just don't feel comfortable with the photographer, the best course may be to decline the shoot. Few shoots are that important, and if you are concerned for your safety, or you and the photographer don't get along, it's unlikely you will have a successful shoot anyway.

Crossing Over

Many Internet models aspire to a mainstream modeling career. In safety as so many other things, there is a cultural difference between the two areas. If a model approaches a mainstream agency or client with the kinds of skepticism and distrust that is accepted in the Internet world, she will find that she is treated like foreign protein. Outside of the Internet that kind of behavior is not accepted. That is not to say that a model should go into things blindly just because the Internet is not involved. But she should recognize that quiet research and a friendly, cooperative attitude will take her a lot farther than suspicion.

NOTES

Terminology

We have provided a Glossary which explains most of the terms used in modeling. Two terms requires special note, however: "agency" and "casting director." Whenever the term "agency" is used in this book it means both a true agency and a booking "model management company" unless otherwise specified. Similarly, "casting director" is often used to simply mean "the person who is in charge of running the casting" even though that may be a photographer or advertising agency employee and not a professional casting director.

Names

This book is devoted to educating models on how the industry works, not to naming names of particular good or bad companies or people in the industry. Except when a famous model or company is meant or photo credit given, all names used in the body of this book are fictitious. If someone thinks they are seeing themselves being described, it's simply a matter of coincidence.

Sampling Error and Statistics

In the discussion of age, race and sex an analysis was presented based on thousands of job requests in the commercial print industry. It would be easy for someone who isn't familiar with statistical analysis techniques to see this discussion as more precise than it really is.

Anyone who has taken a stat class knows that the statistical error of a sample of about 3,400 is on the order of 3%. Even that assumes some things about the sample that are demonstrably not true for our sample: random selection from the population (of NYC or all national commercial print castings), for instance - which we don't have, and which makes the accuracy worse.

It's worse still. All castings do not come in nice, convenient terms that fit well into the analytical categories. Sometimes they say something like "Women from 25-45, all ethnicities" and we have to allocate that somehow to the groups in the table. We made what seem to be reasonable choices, but they are not the only possible choices, and certainly problems like that tend to fuzz things up some. Despite our best efforts, casting directors have proved very resistant to asking for people in a way that fits our study cleanly.

Finally, who gets asked for is not always the same as who gets hired. These numbers reflect requests; we have countless stories of people getting hired who are nothing like what the casting specified.

So if anyone with better data wants to say "No, Caucasian women in their 30s are really used 6.8% of the time in commercial print ads" based on some better sample, we'd cheerfully yield to them. These numbers should not be taken as absolute, or even especially accurate. They are just the best data we have.

Still, given all that, we think that useful impressions of the industry can be gotten from this kind of analysis, as long as we don't take it too literally.

Legal Disclaimer

This discussion in the Law chapter reflects many years of working with and studying the legal issues surrounding photography and modeling, and have been read by several lawyers, who want to make it clear that they are not certifying to the accuracy of everything said. The author is not a lawyer or accountant. Even if this were written by a lawyer it would probably not be authoritative where you live. Laws and customs are very different in different States, even in different cities within one State. Some of the issues are complicated enough that even Supreme Court Justices can't agree on what the law is. So the best we can do is sensitize you to some of the things you ought to be concerned with. **Nothing said in this book should be construed as legal advice.** For specific legal advice, talk to a lawyer who is a specialist in "entertainment law" in your State. Other kinds of lawyers usually are not very familiar with these kinds of issues.

EPILOGUE

You will find a lot of strong statements here about various aspects of modeling and the businesses that surround it. These statements reflect years of experience in the business, and years of study. They are an attempt to be as honest as possible about what you may encounter and need to know.

Still, other books and other commentators have opinions which differ from what you will see here. In part that reflects their own interests. Some authors make a good deal of their money from their continued association with modeling schools and conventions, for instance. It would be unseemly of them to speak less than well of those kinds of institutions. Others are still active in the industry, and publishing the kinds of comments you see here would not be good for their careers or companies. In many cases industry professionals have to quietly live with unfortunate aspects of the business. This book could not have been published while the author was still running a New York modeling agency, for instance.

But it's also true that some disagreements you may encounter come from informed, thoughtful, honest observers who simply disagree. That's the way of the world, and as it should be. It is your job, in this new profession you are considering, to educate yourself from whatever means you can, and make your own decisions.

FOR FURTHER READING

There are many books, periodicals and websites on modeling and related areas. Here are some of the ones that are most useful, even if they don't always agree with this book:

Modeling Tutorial Books

Commercial Modeling:

1. Here's Looking At You (An Actor's Guide to Commercial Print), Scott Powers, Publisher: Heinemann Press, 1997. An instructional guide from the point of view of an actor who supplements his income with commercial print work, and explains in detail how to be successful making the crossover. Mr. Powers is also a casting director and operator of commercial print and acting seminars in New York City. Information available at www.scottpowers.com.

2. How to Become A Successful Commercial Model, Aaron Marcus, Publisher: Marcus Insitute of Commercial Modeling, 2003. A hands-on guide to being a commercial model from a man who has done over 1,000 commercial jobs. An excellent how-to resource from a model's perspective. Mr. Marcus continues to act and model, and makes numerous presentations in modeling conventions, model searches and seminars nationwide. Information available from www.howtomodel.com,

3. *Kids Plus Modeling Equal Money*, Donna Lagorio Montgomery, Adventure Publications, 1984. Written by the mother of four successful child models, this book presents a somewhat optimistic view of the market for children, but is chock full of well thought-out advice that applies specifically to the problems the parents of child models face.

Fashion Modeling:

Many books are available, of highly varying quality and utility. Below are the ones that seem to be the best:

1. The Complete Idiot's Guide to Being a Model, Roshumba Williams and Anne Marie O'Connor, Publisher: Alpha Books, 1999. The best of the how-to books for a new model from a model's perspective, full of useful inside tips on how to be a model.

2. Model, The Ugly Business of Beautiful Women, Michael Gross, Publisher: Harper Collins, 2003. A thick, complex page turner, full of all the gossip and behind the scenes goings-on you could imagine. Richly researched and documented, this book presents the seamier side of the fashion modeling world. In large measure (but not entirely) the practices he documents are reduced or gone in today's American fashion modeling scene, although not much changed in Europe. A must read for parents and young women who are considering becoming editorial fashion models. It is an extreme look at reality, not representative, but sufficiently accurate that it's message should be understood.

3. The Professional Model's Handbook, Linda Balhorn, Milady Publishing Company, 1990. An enormously detailed, thorough discussion of how to be a model, from creating your image, makeup and hair styling, and wardrobe to the business aspects of modeling. Includes some useful data and reference information not available from any other source. Unfortunately it has not been updated, and much of the "image" related information is now obsolescent. Still, a wonderfully useful and unique resource for the very committed professional model.

Printed Reference Periodicals

1. The Black Book, A national showcase listing for photographers, graphic designers and artists' reps. Information available at www.blackbook.com.

2. *Backstage,* (weekly) Newspaper which focuses on the entertainment industry (primarily acting) and contains many ads for photographers, plus a listing of casting calls and job openings. Information and listings available at www.backstage.com.

3. *Fashion and Print* (Fashion and Print Directory – The Madison Avenue Handbook), (annual) published by Peter Glenn Productions. A comprehensive national listing of ad agencies, casting directors, catalog houses,

client companies, department stores, event marketing companies, fashion design houses, artists' reps, magazines, and prop houses, with contact data for each. Information available through www.pgdirect.com.

4. *Le Book,* (annual) A showcase of industry talent, including photographers, artists, ad agencies and model agencies. Listings available at www.lebook.com.

5. *Model and Talent,* (International Directory of Model and Talent Agencies and Schools) (annual) published by Peter Glenn Productions. Includes an international listing of model agencies, talent agencies, casting directors, personal managers, modeling schools, modeling associations and conventions and scouting companies. This is the most comprehensive such list in print, but inclusion in it is no guarantee of a quality agency. Information available through www.pgdirect.com.

6. *The Ross Reports,* (monthly) is a listing of movies and TV shows in production, casting directors and union-franchised talent agents, plus special articles on the industry. Listings and locations to purchase the magazine available at www.rossreports.com.

7. *Women's Wear Daily* (daily) is the bible of the fashion industry. If you want to know who is who in the business, what they are doing, and what is going on with fashion houses, ad agencies, retailers and others, this is the best, most timely source.

8. *The Workbook* (annual) A showcase of industry talent, including photographers, artists, ad agencies and model agencies. Multi-part series that includes a comprehensive national listing of support services for models and production houses. Listings available at www.workbook.com.

Internet Resources

Some of these resources are free; others require either a free or paid membership.

AFTRA (www.aftra.com) the website of the American Federation of Television and Radio Artists (an actor's union).

The Better Business Bureau's view of modeling, for what it's worth:

 http://www.newyork.bbb.org/library/publications/tt1903.html

Child In Film (http://childreninfilm.com) an information and guidance site for parents who are interested in having their children model.

Jillian Ann, a model with a remarkable resume of mainstream fashion, Internet and glamour modeling has written a thoughtful series of articles based on her own experiences. Her thoughts are not universally accepted, but they are intelligent and thoughtful, and well worth reading. Find them on the Internet at www.jillianann.com/MODELGUIDE.html

Models.com (www.models.com) The de-facto website of record for the fashion modeling industry. Editorial opinions there are widely respected, followed in the industry, and quoted as authoritative in the mainstream media. The site also includes a model listing service with over 100 excellent model agencies who subscribe to and scout from it, a wide range of modeling and photography forums, and an archive of Question-and-Answer sessions with modeling agency professionals around the country. It gives some attention to commercial modeling as well as fashion. Their modeling forum includes contributions from several legitimate industry professionals, and is generally the most professional of the modeling forums on the Internet.

Resource Advantage (www.rasource.com) an online listing of professional Photographers, Stylists, Hair & Make-up Artists, Agents, Studio Rentals, Props and Resources.

SAG (www.sag.com) the website of the Screen Actor's Guild.

Model and Photography Forums

The best, most frequently updated list of modeling forums is at Bill Brent's website: www.bbrent.com/forums.html . There are scores of forums listed. Some are excellent, some little used, and some that are infested with some very unfortunate personalities and lax oversight by the administrators. Users should

always read the most recent 100 or so posts on any forum at a minimum to get a sense of the culture and topic of that particular forum. They vary widely.

Among the best administered modeling forums:

Glamourmodels (www.glamourmodels.com/forum) which focuses on Internet glamour modeling and photography, and hosts a website. The same administrator operates two regional forums: The *Southwest Models and Photographers Message Board* (www.glamourforums.com/southwest) and *Southern California Photographers and Models* forum (www.glamourforums.com/socal).

The Theta Group, also administered by an experienced, level-headed owner who keeps the signal to noise ratio in check. The main forum is *Webmodels*, which has a rich history on the web (www.webmodels.com/forum) and the main forum page contains links to other well-run forums. *Webmodels* and the regional forums in Theta are primarily oriented toward Internet glamour modeling, but also have discussions on more mainstream topics.

The Fashion Only Forum (www.duroi.com/fashionforum). Founded by the late Jacque DuRoi (a noted fashion photographer), Fashion Only continues the tradition under the ownership of his wife. It is the best of the near-professional fashion modeling and photography forums, and allows little content other than fashion.

Emelle's Industry Forums (http://pub123.ezboard.com/bmakeupandrelatedindustries) Intended for makeup artists, hair stylists and wardrobe stylists, but contains a sub-forum for models and agencies, and an opportunity forum for test and paying job listings. It is an excellent way to get information on hair styling and makeup, and good for networking with professionals who may work with you on test photography. It is "mainstream" fashion and commercial oriented.

One Model Place (www.onemodelplace.com) contains a forum available to its members, including several specialized forums for photographers and models, and listings of job and test opportunities. It is devoted primarily to Internet modeling and photography, with a heavy glamour emphasis, and the administrators tend to encourage positive views of those topics.

Model Mayhem (www.modelmayhem.com) is a relatively new addition to the modeling world, but has become wildly popular as a model/photographer/makeup artist listing site, and has very active forums. The site has a free-for-all atmosphere that can be offensive to some, and a large number of contributors who don't know what they are talking about. Recommended for open-minded adults only. Even so, it also provides access to a substantial, and unique, body of experienced professionals on all aspects of the modeling industry.

Glossary of Modeling Terms

Like every specialty, modeling has its own jargon that outsiders and new models have trouble understanding. The definitions below will help you understand some of the confusing terms you may hear in the business. Because models also often end up doing TV commercials, we have included a few key terms from acting as well.

3/4 SHOTS: A photograph that shows a model from head roughly the middle of the thigh.

8x10 GLOSSY: A picture 8x10 inches in size, printed on high-gloss paper. It is the standard for actors' headshots, and the term is often used as a noun. ("Eight-by-Ten Glossy")

4 Plus 1: Actually the numbers could be anything. In this example, a client has booked a model for a four hour job, but is not comfortable that they will get done in four hours, so has requested the model be available for an extra hour if needed. In this case, the model would be paid for the four hours, but would get a fee for the extra time only if he actually worked it.

A

ACCESSORIES: Items worn to compliment the look of your clothes (jewelry, belts, hats, scarves) or to add function (handbags).

ACCOUNT EXECUTIVE: In an advertising agency, clients (or products) are referred to as "accounts". The primary person in the agency responsible for that account is the "account executive" and may be the primary decision-maker in choosing a model.

ACTION: Actor-speak for "roll the cameras and start acting"

ADULT: "Adult" photography or film/video work is synonymous with nude, sexually oriented (perhaps explicitly sexual) projects.

ADVANCE: Money which may be given to high-demand models to secure their agreement to accept a booking. If you aren't well known, don't expect an advance.

ADVERTISING: The process of raising demand or creating awareness of a product, person, service or organization.

ADVERTISING AGENCY: The company which designs, creates and places advertising materials in media. Generally they will be the people in overall charge of selecting the creative team, including models, for an ad.

AFTRA: American Federation of Television and Radio Artists. The guild (union) with jurisdiction over much of radio and television production. Their charter overlaps somewhat with SAG. Generally, AFTRA has jurisdiction over products shot on tape, and SAG controls those shot on film, although that delineation is by no means precise.

AGE OF MAJORITY: The age at which a person is legally able to contract in his own name. In many States it is 18; in a few it is still 21.

AGENCY: A company which acts on behalf of their clients. See "advertising agency" and "modeling agency" for examples.

AGENCY BOOK: See Headsheet.

AGENCY FEE: In many markets it is customary for the client to pay a service charge to the model agency in addition to the fees they pay the model. An "agency fee" of 20% is common in New York and many other markets.

AGENT: The person who represents you and acts in your behalf when promoting your services and booking work for you. Agents may work alone or as a part of an Agency.

AIRBRUSHING: A term used for retouching photographs to remove flaws or make adjustments to the picture. The term derives from the use of an airbrush on prints or film, although it now is used generically to refer to digital retouching as well.

APPROPRIATION OF LIKENESS: A legal term involving use of a person's image without their permission, often in advertising.

ART DIRECTOR: At a magazine or advertising agency, the person responsible for creating the look and layout of an ad or editorial presentation. Their decisions may determine the kind of models used in the production, and even the specific model chosen.

ART MODELING: Modeling for photographic artists. Although some art modeling does not involve nudity, a prudent model should assume an "art" assignment means nude until proven otherwise.

ASSIGNMENT: A job (also called "a booking").

AUDITION: An opportunity to appear in front of people involved in the hiring process and do what they need you to do to demonstrate you are appropriate for a modeling job. The term "audition" is normally used for acting jobs, but also can be used for modeling. See "casting" or "go-see".

AVAIL or AVAILABILITY: A query to determine if a model is free of other commitments and willing to do a modeling job at a specific time. It may be a precursor to a "hold" or "booking", or it may simply be a question asked of all applicants for a job. It does not put the client under any obligation to the model, nor is the model prohibited from accepting another job (although it is courteous to notify the client when another job or hold is accepted.)

B

B&W: A photograph, video or movie in which the image consists only of white, black and shades of grey, with no other colors.

BACKDROP: The things in the picture behind the model in a studio photo shoot. It may be a set with props or a simple seamless sheet of paper.

BACKGROUND: An "extra" or non-featured person, often not recognizable, in a photograph or TV commercial.

BATHING SUIT SHOT: A picture of the model wearing a bathing suit. Often used on a composite card or in a portfolio to show the lines of the model's body.

BEAUTY SHOT: A closeup (head and shoulders) shot of the model which accentuates his or her good looks. Similar shots may be used in cosmetics, skin care or jewelry advertising. For many models the Beauty Shot is used similarly to a Head Shot, and may be on the front of a composite card.

BIO: A brief biography of the model. Generally this is not used unless the model has achieved some fame, and the bio is released to the public or interested clients or public relations firms. It normally has very limited personal data and a summary of notable professional modeling work done by the model. See also "resume," which is a different but related concept.

BLACK AND WHITE: See B&W.

BLOW-UP: Enlargements of an image from the original negative, slide, or digital file.

BOARD: The models represented by an agency, usually categorized into specialized divisions. There may be a "New Faces Board," a "Men's Board" and a "Classic" board, for instance. The term derives from the practice of putting model's composite cards on the wall, either by tacking them up to a cork board or by putting a number of comps for each model into individual holders so they can be easily grabbed by agents for composite pulls, or given to visiting clients.

BODY DOUBLE: A person who takes the place of another for body work. Typically used when a star of a movie does not want to personally do a nude scene.

BODY WORK: A photographic assignment that focuses on the body of the model. It may include posing in lingerie, bathing suits or nude. A "body model" is one who specializes in body work, normally based on excellence of physique, but also sometimes on similarity to a celebrity in body dimensions.

BONUS: Money given to a model in addition to the session fee. Bonuses are most commonly for usage rights, although they may be compensation for an unusually long or difficult assignment.

BOOK:
1. (verb) To make a commitment between a client and a model (or her agent acting on her behalf) for the client to hire the model at a specified place and time.
2. (noun) A model's portfolio.

BOOK OUT: To tell your agency that you will be unavailable for assignments for some specified time period, due to health, other commitments, vacation or other reason.

BOOKING: A modeling assignment that has been agreed upon.

BOOKER: A person at a model agency who negotiates with clients to get and contract for work for models. The booker may have other responsibilities as well.

BOOKING AGENCY: A "booking agency" is one that primarily makes its money by getting work for models, as opposed to a "mother agency" or "personal manager" who prepares and presents models to the market, and then takes a percentage of the model's earned fees when she gets work through a booking agency.

BORDERLESS: A photograph that extends to the edges of the paper with no margin. In printing, referred to as "full bleed".

BREAKDOWN: A listing of the types and numbers of models or actors needed for a production, sent to model and talent agencies.

BREAKDOWN SERVICE: A company which distributes breakdowns to subscribers, typically to modeling and talent agencies.

BRICK AND MORTAR: A real, physical office that does business from a location known to and accessible to the clients of the business. As distinguished from a web-based business, in which the physical location of the people doing business may be unknown and not contacted by clientele.

BUMP UP": See "upgrade".

BUST: For purposes of a model's stats and composite card, the bust measurement is the same as her bra size.

BUYER: The person who selects what to purchase from a clothing designer or manufacturer. Buyers attend fashion shows and designers' showrooms to make purchasing decisions.

BUYOUT: The client is purchasing unlimited usage rights to a model's image, although a buyout may be only for a designated time period, geographic region or type of media. An example would be "two year print buyout in Spain, except for Internet". If there are no qualifiers on the term, it means unlimited use for an unlimited time. See "usage".

BY NAME REQUEST: A client has become aware of you somehow (from a previous job or go-see, from seeing your composite card or pictures on the agency website) and calls the agency specifically requesting you for a job. The request may be for another go-see or to book you into the job without further action on your part.

C

CALL-BACK:
1. A request for a model to return after an initial go-see to help the clients make a final decision on who to book for a job. It means you have passed the first cut and are strongly in the running for the job. There can be more than one call-back before a final decision is made.
2. At a model search or convention, a request for an interview made by a model agent for a particular model.

CALL TIME: The time the model is due on the set. Generally the model should show up 15 minutes or so before the actual call time.

CALL SHEET: A detailed listing of who the creative team is for a shoot. It may include everyone from the photographer, stylist, makeup artist, drivers and caterers. It should give the precise location and directions to the shoot, and instructions on how the model should arrive. Any makeup, hair, wardrobe or other requirements may be on the call sheet. Many modeling jobs do not use call sheets (or at least do not distribute them to agencies), and the information the model needs to know will be given by phone call to the agency, or directly to the model.

CAMPAIGN: A word used to describe a set of ads for a particular product. It may be as limited as a single print ad, or several coordinated print and TV ads.

CANCELLATION: The client cancels the model's participation in a booked shoot (or cancels the shoot itself). Depending on agency booking policies and the timing and circumstances of the cancellation, the model may be paid some or all of the session fee even though the assignment is cancelled.

CASTING:
1. The process of choosing models for a job.
2. A go-see.

CASTING CALL: An announcement of an upcoming modeling job, giving the specifics of the type and numbers of models wanted, and the way to engage the process (send in composite cards, email pictures, send models on go-sees).

CASTING DIRECTOR: Normally an intermediary between the advertising agency (or client) and the modeling agency (or models) who finds and assembles a group of candidate models for a job and may make preliminary selections from among the applicants. There are casting companies which specialize in this role (also sometimes referred to as "casting agents"), but the casting director for a specific job may be the client, an advertising agency or magazine employee, the photographer or even the model agency.

CATALOG MODELING: Posing for photographs which will be used in a client's catalogs. Usually this means modeling clothing for the catalog, although sometimes a model will be used to demonstrate other kinds of products.

CATTLE CALL: A casting that a large number of models (often hundreds) show up for because the casting director gave relatively broad direction to agencies, and may have used many agencies, or opened the casting to the public or advertised in in a newspaper, magazine or on the Internet. The probability of a model winning a cattle call casting is not great.

CHARACTER MODEL: A model who is hired to portray something other than an attractive role. They may be cast as medical patients, plumbers, computer nerds, Mafiosi or any of hundreds of other "non-modely" roles that are used in commercial advertising and editorials.

CHILD MODEL: The line between "child" and "adult" isn't very distinct. Obviously it means a young model (the line between "child" and "not child" may be anywhere from 12 to 18) and often means the model will be paid substantially less than adult models on the same job.

CLASSIC: A term used to describe older models, often in their 40s or later in life.

CLEAN-CLEAN: Part of the specification for how a model should arrive at the shoot. It means "clean face, no makeup, clean hair". The opposite would be "hair and makeup ready" for a shoot that did not have a makeup artist or hairstylist for the model.

CLIENT:
1. The person or company which pays for the production the model is hired to appear in.
2. Whoever hires the model or gives the casting call to the model agency. In this usage the "client" could be the photographer, ad agency or, possibly, casting director if they are the ones who make the initial or final choices on which models are used.
3. A model who is signed with an agency is often referred to by the agency as a "client". This obviously can lead to some confusion, and the meaning has to be determined from context.

CLOSED SET: When a shoot will involve nudity or other types of posing about which a model may be sensitive, the studio may be closed to all but key members of the photographic team.

COLLECTION: A group of clothing or accessories produced by a designer. For instance, the clothes used in a single major fashion show may be referred to as a "collection".

COMMENTARY: The description of the clothing at a fashion show. For major shows it is normally written, but it may be spoken by a commentator during the show.

COMMENTATOR: The person who describes the clothing at a fashion show.

COMMERCIAL:
1. A TV advertisement.
2. Modeling work which is used in advertising such as magazine print ads.
3. A type of model (see "commercial look")

COMMERCIAL LOOK: Generally refers to "mainstream" attractive, upscale looks. "Pretty" and "approachable" are commonly associated with "commercial". Distinguished from "character" or "editorial" looks.

COMMERCIAL MODEL: A model that specializes in modeling for advertising, normally print advertising. Commercial fashion models may do catalog or showroom work, or may appear in designer campaigns. Commercial print models typically appear in non-fashion print ads.

COMMERCIAL ACTOR: An actor who specializes in working in TV commercials. Frequently commercial print models also work as commercial actors.
COMMERCIAL AGENT: An agent who specializes in finding TV and radio commercial work for his actors.

COMMERCIAL FASHION: See "fashion print", "showroom modeling:, "fit modeling" for examples. A term used to distinguish more mundane fashion advertising from the high-end editorial and campaign publications.

COMMERCIAL PRINT ADVERTISING: Formally, any advertisement that appears in print. However, the term is used to distinguish it from "fashion print," which is clothing advertising such as catalog work. Generally, "commercial print" refers to modeling to advertise or promote anything except clothing, high-end hair and cosmetic products and jewelry. The definitions are not precise, and there is overlap between the various types of commercial modeling.

COMMERCIAL PRINT AGENT: A model agent who specializes in finding commercial print work for his models.

COMMISSION: A fee taken by an agency or manager based on fees earned by models. Typically it is a percentage of the model's fees.

COMPOSITE CARD: (also "composites," "comps" or "zed cards".) A group of pictures (from one to as many as a dozen or more, depending on size and layout) of a model printed on card stock. The typical composite is printed on both sides of heavy, coated card stock and is roughly 5 ½ x 8 ½ inches. Some very experienced models produce "double" or even "triple" composite cards. A typical layout includes one headshot/beauty shot and the model's name on the front of the card, and three or four pictures, the model's stats and contact information on the reverse.

COMPOSITE PULL: One of the ways that models may be introduced to clients. A client may ask an agency to send them comp cards for a particular casting, or may simply ask that all models of certain types be sent to them to keep on file for upcoming jobs. The agent "pulls" the comps out of the files and sends them as asked, or may simply send a batch as part of a promotional mailing.

CONFIGURATIONS: A term used to describe the number of models used in a photograph.

CONFLICTS: Work that a model has done for another client with a product or service that competes with a new client. An example would be a model who has appeared in a Xerox ad and is being considered for a Ricoh Copiers ad.

CONSUMER PUBLICATION: Publications (typically magazines or newspapers) which are aimed at the general population or consumers with a particular type of interest (such as a fishing magazine). Distinguished from "trade publications."

CONTACT SHEET: Originally, a sheet of photographic paper which was exposed by laying the film directly on it and shining light through the film to produce a group of pictures the same size as the original negatives. Since digital photography come into common use, the term is also used to describe an equivalent group of small images on a page. In both cases, the purpose of the "contact sheet" is to assist the photographer or model in choosing which pictures to blow up. Contact sheets are largely being replaced by CDs of images that can be looked at on the computer.

CONTINENTAL: A term used primarily in Europe to describe a particular type of explicit nude photographic modeling.

CONTRACT: A written or oral agreement between two or more parties, to provide a service, product or money. A model may have a contract with her agency. The model or her agent on her behalf may make a contract with a client for a job or a long-term commitment by the model. Model releases and vouchers are also other forms of contract.

CONVENTION MODELING: see "trade show modeling".

COPY:
1. The script to be spoken by a model in a TV commercial, or the words on a print ad or editorial page.
2. A physical or electronic reproduction of an original work.

COPYRIGHT: Literally, the right to make copies. Normally, the photographer or production company owns the copyright to photos unless there is a written agreement to the contrary. Virtually all photos made since 1989 are protected by copyright, and many made prior to that are also protected.

COPYRIGHT INFRINGEMENT: Illegally making copies of a photograph (or other copyrighted work) without the permission of the person who owns the copyright. Depending on circumstances, it may subject the person who made those copies to fines, civil penalties or even imprisonment.

CRAFT SERVICES: The catering service for a shoot.

CREATIVE DIRECTOR: An advertising agency (or magazine) employee with overall responsibility for the creative design and direction of an ad (or editorial).

CYC STUDIO: A studio with walls which curve smoothly at the bottom to give the impression that there is no edge or corners at the bottom. Seamless paper is used to create the same effect. "Cyc" is a contraction of "cyclorama", which describes that kind of backdrop.

D

DAY RATE: What a model gets paid for a day's work: the "session fee" for a full day assignment. For fashion models this may be determined by the status of the model herself; for commercial models it is usually determined by the job, and whoever wins the job gets that rate.

DAYLIGHT STUDIO: A photography studio that allows pictures to be taken with natural light, normally through large windows or skylights.

DEMOGRAPHIC: The target audience for a particular ad. It may be defined by age, economic status, race or other characteristics of groups of people. Music videos normally don't target a 50-80 year old demographic, and "urban" designers may primarily aim their ads at large city youth. The models chosen for an ad will be determined by the target demographic.

DEMONSTRATION MODELING: A model demonstrates the operation of a client's product, typically at a trade show or exposition, or perhaps at a large department store.

DESIGNER: The primary creative director of a fashion house, responsible for the overall conception and direction taken by the clothing produced by that line of clothing. Depending on the size of the design house, the designer may or may not personally design individual pieces. Designers have a strong vote (or determine) which models are used in their fashion shows, showrooms and advertising.

DEVELOP:
1. Turn exposed film into a picture.
2. Turn a person with modeling potential into a model who is ready to compete in the professional market.

DIRECT MAIL: Mailing advertising directly to the homes or offices of potential customers. This may also be done electronically through email. It is one of the forms of usage that a model may get paid for.

DISCREET NUDE: A shot in which the model is partially or fully nude, but the breasts (of a woman), genitalia or full buttocks are obscured in some manner so they do not show. Also called "implied nude".

DOMAIN: A unique name that identifies a location on the Internet. It always consists of two or more parts. The part on the left is specific to the owner; it is separated from a general "top level domain" identifier (like "com" or "org") by a dot (or period).

DOUBLE-PAGE SPREAD: A photograph which is printed in horizontal format across two pages of a magazine.

DRESSER: A person who assists models in getting dressed at fashion shows. Dressers are needed because many fashion shows have very short turnaround time for a model from one outfit to the next.

DROPPED: Your agency chooses to no longer represent you.

E

EDGY: A model or photograph may be considered "edgy" if she (or it) is characterized by non-standard features. The precise content of what is considered "edgy" varies with time, since the "cutting edge" moves as the industry and society evolve.

EDITORIAL: Material (text and illustrations) produced by or for a publication, and representing news, commentary or the opinion of the staff of the publication. Editorial works may appear in newspapers, magazines or even on television or the Internet.

EDITORIAL LOOKS: Generally "edgy" or "beautiful in her own way" appearance, as opposed to mainstream, pretty, "commercial" looks. So called because the frequent use of such models in contemporary fashion editorials.

EDITORIAL MODELING:
1. Modeling for any "editorial" use, regardless of the subject matter. Covers of magazines, public service advertising, and photos used to illustrate a news story are all examples of editorial modeling. Generally, if a picture isn't advertising, it's editorial.
2. Modeling in pictures which illustrate stories or fashion trends in a fashion magazine. This is a subset of all editorial modeling, but is what fashion models and agencies refer to when they use the term "editorial".

EDITORIAL PHOTOGRAPHY:
1. Photographs used to illustrate an editorial (regardless of type of editorial) story.
2. When used by fashion models and agencies, photography which is used to illustrate stories in fashion magazines
3. Photographs shot in the style of contemporary editorial fashion photography, regardless of how the pictures are actually used.

EDITORIAL RATES: Usually magazines, newspapers, book publishers, public service announcements and similar uses pay very little compared to commercial rates for models. In part this is because some editorials (by no means all) produce tearsheets which help advance a model's career. In part, it is simply because they can, and models and their agencies have come to accept it.

ELECTRONIC MEDIA: Depending on the project, this can refer to CDs, the Internet, television and other means of disseminating pictures or advertising.

EMANCIPATED MINOR: Someone who is below the age of majority but who has gotten the legal right to contract in their name and live without parental supervision, either by court decree or marriage.

ESTHETICIAN: A person who has been trained (and is licensed, in most States) to do hair styling and apply makeup and other cosmetic procedures.

EXCLUSIVE:
1. An agreement between a model and an agency that the model will work exclusively through that agency. Exclusive agreements may be limited by time, geography (only in New York, for instance) or modeling/acting discipline (exclusive for on-camera TV commercials).
2. An agreement that a model will not allow her image to be used to advertise any competing product for a specified period of time. It may also include a prohibition against public criticism of the client's product.

EXPENSES:
1. Money you have to spend to support your modeling business. Haircuts, photographs, agency commissions, travel, clothing, cosmetics and many other things can be business expenses for a model, and may be tax deductible.
2. Money spent by a model to enable her to do a specific job that may be reimbursable by the client. Examples might include travel, parking, manicures and other things requested by the client.

EXPOSITIONS: ("Expos") Similar to trade shows, but open to a wider audience.

EXPOSURE:
1. A picture that is taken, as "we got 36 exposures of that look".
2. The amount of light falling on film or a digital sensor, compared to the "normal" amount needed for the average picture. A shot may be deliberately "underexposed" to give it a dark, moody feel, for instance.
3. Publicity or presentation to the view of the public or potential clients that a model gets from doing a job. Exposure can be highly advantageous (as in appearing on the cover of Vogue) or hurtful to a model's career, depending on the project and its distribution. Most often "exposure" simply has no value, especially when a producer offers it as an explicit inducement to get a model to do a job for little or no money.

EXTERIOR SHOT: Any picture photographed outdoors. See "location".

EXTRA: See "background".

F

FACTOR: Most commonly, an agency will receive a model's payment from the client, deposit in the bank, wait until the check is known to have cleared, and shortly thereafter send the model's fee (less commission and expenses, if any) to the model. Some agencies offer payment immediately after a job is completed, which means the model may get paid two or three months earlier. Sometimes the agency itself finances this early payment, but often it is an investor (known as a "Factor") who puts up the money and charges a fee (typically 5%) for the early payment.

FAQ: Frequently Asked Questions. The portion of a website that collects the questions readers most often ask about there area of interest, and provides answers to them.

FASHION COORDINATOR: The person who chooses and coordinates the outfits in a retail fashion show.

FASHION DISTRICT: See "garment district".

FASHION MODEL:
1. A model who works with the fashion industry. She may appear in fashion editorials, fashion advertising, catalogs or TV commercials, or may do showroom or fit modeling.
2. A model who is represented by an agency which specializes in fashion modeling.
3. Short for "editorial fashion model", which many people consider "real fashion models". These are the highly specialized models who appear in high-end fashion editorials and campaigns, and normally meet the stringent height, stats and appearance specifications that people associate with "a model".

FASHION PHOTOGRAPHY:
1. Photography used to sell clothes or other appearance items such as makeup, hair products and fashion accessories. Includes catalog style pictures.
2. Photography appearing in editorials in fashion magazines or high-end fashion advertising campaigns.
3. Photography in the style of contemporary "fashion editorial" or fashion advertising campaign pictures, however the shot may actually be used.

FASHION PHOTOGRAPHER:
1. A photographer who specializes in shots used to sell fashion items, or which appear in fashion editorials.
2. A photographer who specializes in the style of photography typically found in fashion magazines or on composite cards used by fashion models.

FASHION PRINT: Print advertising to sell clothing or other fashion items. Typically refers to catalog-type work rather than high-end editorial or fashion campaign work. Often referred to as "commercial fashion".

FASHION SHOW: Generally, a formal presentation to an invited audience at which models display clothing and other fashion items. Typically includes a runway. Fashion shows may be produced by designers to show off their own collections, or by retail outlets to show off the range of fashions they sell.

FASHION WEEK: See "market week".

FAVORED NATIONS: See "most favored nation".

FETISH PHOTOGRAPHY: Photos that are typically adult in nature (although may not involve nudity or explicit sexual poses) and which appeal to any of the specialized sexual or psychological fantasies for which there is an audience. "Foot fetish" and "bondage" photography are two common examples.

FIGURE MODELING: Nude modeling, generally for art photographs (or painting or sculpture) rather than glamour, although the term is more broadly used, so it's wise to check on what the person using it really means.

FIRST OPTION: See "option".

FIRST REFUSAL: The acting jargon for "first option" or "first hold".

FIT MODELING: The model has specific, exact measurements wanted by the designer, and puts on sample clothes to allow the designer or tailor to modify them to fit and move properly. Fit models can be of any type, although typically are size 6 for women, and size 40 regular for men.

FITTING: Trying on clothing before a fashion show or photo shoot to make sure there will be no surprises when the real event happens. For commercial shoots this may be simply to ensure the stylist has bought the right size clothes. For fashion events it may be more extensive, involving modifications to the clothing to make them work for the model.

FLAT FEE:
1. A single amount of money given a model for a job, which includes the session and usage fees. Generally a flat fee is not based on an hourly rate, and (within reason) the model gets paid the same no matter how long the job takes.
2. An amount of money which includes both the model's fee for the job and the agency service charge. This can lead to some confusion as the agency explains it to the model.

FLIP CARD: A simple version of a composite card, often used by new models or by experiences models as a supplement to their comp card. It may have only one picture on it, or one on each side of the card, together with their stats and contact data.

FLIPPER: A temporary denture used to fill gaps in a model's teeth. Typically used for children.

FORUM: On the Internet, a website that allows the public (or, for some sites, members only) to interact and discuss topics relevant to the theme of the forum. Many forums exist that relate to the modeling industry. Also referred to as a "messageboard".

FREELANCE:
1. A model working without agency representation.
2. To work with multiple non-exclusive agencies.

FREEZE MODELING: A form of modeling in which the model remains motionless, simulating an inanimate mannequin. Often used in store displays.

FULL BLEED: See "borderless".

FULL-LENGTH: A photograph that shows the entire model from head to toe. Normally a standing shot.

FULL NUDE: A photograph in which the model is completely unclothed; often the word is used to indicate the picture may show the genitalia of the model. By comparison, see "discreet nude".

G

GARMENT DISTRICT: The area in a city in which there is the largest concentration of fashion designers and manufacturers. In New York the Garment District is centered around Fashion Avenue (7th Avenue) but covers from 6th to 9th

Avenues, roughly from the Fashion Institute of Technology (FIT) on 27th Street to Bryant Park (40th Street). There are subsets within the Garment District; a small area around FIT is the Fur District, while the Millinery District is just south of Bryant Park. In Los Angeles it is in the center of the city, and extends roughly from 6th Street to 14th Street between Broadway and San Pedro St.

GLAMOUR MODEL: A model who appears in glamour photographs.

GLAMOUR PHOTOGRAPHS:
1. A photograph which uses lighting, makeup and posing to enhance the attractiveness of a model.
2. A photograph used in an editorial or for advertising where a very attractive model (typically female) is the principle focus of the image, and it draws the viewer into paying attention to the picture and, incidentally, also receiving the secondary message which may be product-related.
3. Photographs where the model herself (or, more rarely, himself) is the product. Calendars are a good example.
4. Especially on the Internet, photographs of scantily clad or nude models in attractive, revealing or provocative poses. When corresponding with an "Internet Photographer" about glamour work it should be assumed that the term means "nude photography" until proven otherwise.

GOLDEN LIGHT: During the time immediately after sunrise or around sunset the sun is very low in the sky and has an attractive, golden hue. This is a very desirable time to take photographs of people.

GO-SEE: Literally taken from the phrase "go see someone". In commercial work generally a go-see involves going to see (or be seen by) a person who is casting for a particular job. In fashion work it may be more general: you go see people who have a history of hiring models, so that when they have a job come up they will know who you are. Go-sees may be general (you are one of a type of model the client has asked for) or specific: the client has requested you specifically. See "by name request".

GROSS: The amount a client pays for a model's services. From that amount taxes, expenses or a model agency's (or manager's) commission may be taken before the model sees the check for the job. See "net".

GWC: Guy With Camera. A man who may or may not have any skill as a photographer, but who likes to take pictures of models for his own purposes. A common client for models on the Internet.

H

HAIR STYLIST: A person who arranges and styles your hair prior to a shoot or other modeling job. Generally this will not involve coloring or cutting the hair.

HAIRDRESSER: A person who may cut, color or style your hair prior to a modeling job.

HALFTIME: One half the model's negotiated hourly rate, typically paid for travel time to and from a remote shoot location.

HAND MODEL: See "specialty model".

HAUTE COUTURE: A French phrase meaning "high fashion".

HEADER DATA: When an email is sent to you, it contains a (normally invisible) record of where it came from and the path it took to get to you. By making this "header" information visible you can get information about the real source of a message.

HEADSHEET: A compilation of photographs of its models put together by a model agency to send to prospective clients. It may take the form of a book, poster, foldout or, more recently, an Internet website.

HEADSHOT:
1. In acting, an 8x10 glossy picture which normally shows the head and shoulders of the actor. Except in California, headshots are almost always Black and White.
2. In modeling, a head and shoulders shot, often used on the front of a composite card. Frequently the same as a "beauty shot".

HIGH FASHION: Extremely high-end, sophisticated clothing and accessories, often one-of-a-kind items.

HIGH-FASHION MODELING: Modeling sophisticated clothing for editorials in prestigious fashion magazines or high-end fashion advertising campaigns.

HIPS: A model's "hips" aren't really measured at what people normally think of as her hips. The measurement is made around the fullest part of the butt.

HOLD: See "option."

HOURLY RATE: The base fee rate negotiated for a model's time on the set of a job. Other fees (travel time, overtime, weekend or lingerie/nudity bonuses) may be based on that rate.

HOUSE MODEL: A model who is employed by a designer, showroom or, sometimes, a high-end retailer to routinely do modeling for her employer.

I

ILLUSTRATION MODEL: A non-photographic artist's model.

IMAGE:
1. The way you present yourself and the effect it has upon the viewer. "An upscale image."
2. A photograph or other illustration.

IMPLIED NUDE: See "discreet nude".

INDUSTRIAL: A video production that is not intended for broadcast, often used by a company for in-house training or sales.

INFORMAL MODELING: Generally an unstructured fashion show in which the model performs in a natural setting (as a store in a mall) and simply walks around among the customers showing them the clothes. Also called "tea room" modeling.

IN-HOUSE: A function that is integrated into a larger organization, even though similar functional organizations exist as independent entities. A large corporation may have an in-house advertising agency, for instance, or an ad agency an in-house casting director.

INTERNET MODEL: A model who largely markets herself to a clientele which hires independent models from the Internet. Most commonly this means a glamour or nude model.

INTERNET PHOTOGRAPHER: A photographer who may or may not be a professional, but who is primarily known for his interaction with Internet modeling forums and modeling websites, and whose reputation is largely based on work shown on the Internet. The overwhelming majority of Internet Photographers specialize in nude artistic, fetish or glamour modeling, or adult work.

IP NUMBER: An Internet Protocol Number. Every computer connected to the Internet has a number assigned to it so other computers on the 'net can find it. It is four numbers (from 0 to 255) separated by periods. An example would be 255.0.255.0. An Internet user may have the same IP number every time they log onto the 'net (a "static IP"), or it may change (normally within fairly restricted bounds) each time they log on, depending on the type of connection they have. Websites are associated with a non-changing IP number because they are hosted on a site that remains permanently connected to the Internet.

ISP: Internet Service Provider. The company that you use to connect to the Internet, or that hosts a website that you use.

J

JOB NUMBER: A model may assign a tracking number to each job their models work. It is used to follow a job from inception through payment of the model. Advertising agencies also sometimes assign a job number to an assignment, but this is not the same thing.

JUNIOR MODEL: A model who appears to be younger (and usually is smaller) than the typical adult model.

K

KKILOBYTES: Thousands of bytes. A byte is eight bits of information. A megabyte is a million (roughly) bytes. The more of them on a website (or in an email) the longer it takes to get it through the Internet.

KNOCK-OFFS:
1. Copies of original designer clothing or accessories made by unauthorized companies.
2. Incorporation of major design elements from one designer line by another designer.

L

LAYOUT: The specific design or presentation of a print ad or editorial.

LEG MODEL: See "specialty model".

LIFESTYLE: A type of photography most often described as "real people doing real things." In fact it is neither; the people are usually stereotypically mainstream upscale and attractive, and the things they are doing are idealized versions of what we envision people like that would do. Lifestyle photography is often referred to as "commercial".

LIGHT BOX: A box containing a light source, and with a translucent side that transparency film (like slides) can be put on and viewed. Also "light table".

LINE: The collection of clothing issued by a particular design name.

LINE-UP: The order and position models take at a fashion show.

LINES: The script to be spoken by an actor.

LIVE PROMOTION: See "promotional modeling."

LOCATION: Any place pictures are shot that is not in a photo studio.

LOOK BOOK: A book of photos of a fashion designer's current line, compiled to show to buyers and the press.

LOUPE: A small magnifying glass designed to be use close to the eye to see small things like contact sheets.

M

MADISON AVENUE: A street in Manhattan which is known for advertising agencies. Often used to refer generically to advertising.

MAGIC HOUR: See "golden light".

MAJOR MARKET: A city with a wealth of modeling jobs and opportunities. For fashion models, New York is the only major market city in the United States; Paris, London, Milan and Tokyo qualify as major markets overseas. For commercial models, New York, Los Angeles and, to a lesser degree, Chicago, Miami and Dallas are major market cities. See "secondary market".

MAJORITY: See "age of majority"

MAKEUP ARTIST: Applies makeup and may do minor cosmetic changes such as plucking eyebrows before a modeling job.

MAKEUP KIT: A bag containing makeup and supplies to allow a model to do his/her own makeup before a shoot, if necessary.

MANAGER:
1. A person or company which provides a wide range of services to a model, including development, marketing, placement with booking agencies, professional advice, accounting assistance and whatever the model needs to gain and maintain success in the marketplace. Also called a "personal manager". These people usually have a relatively small number of models or actors under contract, and almost always require an exclusive contract with the model.
2. A company which provides many of the same services as a "personal manager" but also actively attempts to book jobs for the models. This is legal in some States and not in others. Where it is legal, this type of manager (or management company) is often referred to informally as an "agency" even though, formally, they are not. The management company may have many models, and may use either exclusive or non-exclusive contracts with its models, depending on their area of specialization and the customs of their city.

MANNEQUIN:
1. A model, specifically a fashion model.
2. A model doing freeze modeling (or "mannequin modeling").

MARKET WEEK: A periodic time when a group of designers (clothing or accessories) show their lines to assembled buyers and the press. It may consist entirely of presentations in the designer's showrooms or may include formal fashion shows. If the latter it is often referred to as a "Fashion Week".

MEDIA:
1. The press.
2. A means of communication. Media include Television, magazines and newspapers, movies and the Internet.

MESSAGEBOARD: See "Forum".

MINOR: A person who has not yet reached the age of majority in their State, and hence is not legally able to sign contracts or model's releases for themselves.

MODEL AGENCY:
1. Formally, a company which employs agents. Agents act for models and actors in negotiating and booking performance and modeling work, and often can sign contracts in the name of the model or performer and may collect the model's fees from the clients. Generally has a contract of some sort with the model, and is compensated by taking a percentage of the model's fees. In many States agencies are regulated and required to be licensed as employment agencies.
2. Informal term for a management company which also sometimes books models on jobs. The term is imprecisely used in this way, but that imprecise use is very common. In most States such management companies are regulated differently (if at all) from agencies and may not be required to be licensed. Informal use of the term "agency" may not necessarily mean the company is a true agency – it may be a management company instead.

MODEL BAG: Equivalent to a briefcase for an office worker. All of the things the model may need during a day of go-sees or shooting may be in the bag, from composite cards and a portfolio to makeup and hair products and flat, comfortable shoes, and any support or undergarments that a job may call for.

MODEL LISTING SITE: On the Internet, a website that hosts pictures and stats of models, and provides a means of contacting the model when a potential photographer, agency or client is interested in working with her.

MODEL RELEASE: A legal document which gives a photographer, production company or advertising agency the right to publish and use a model's photographs in specified ways.

MODEL WEB SITE: A website on the Internet which the model uses to present herself for work. It typically contains photographs, stats, location and modeling interests, and a means to contact the model. Some model websites stand-alone, others are part of a model listing site.

MOST FAVORED NATION: A term (now fallen into official disfavor in Washington) taken from international trade policy. "Most favored nation" (MFN) trade status meant that in any tariff for that nation's goods it would be treated no worse than the most favored nation (the one who received the best treatment) on that issue. In modeling, the term has been adapted to mean that all models doing similar work, or appearing with similar prominence in an ad, should receive the same pay. It is common in commercial modeling, much less used in fashion modeling where models tend to have individually established rates.

MOTHER AGENCY: An agency or manager who puts a model under an exclusive contract and then promotes the model to booking agencies. Normally the mother agency develops the model. Generally the mother agent sponsors models to cities far from where the model lives and manages relationships between the booking agency and the model. A good mother agency will provide continuing advice, support and assistance to a model who is with another booking agency. Mother agencies are compensated by taking a percentage of the model's earnings for some period of time.

N

NEGATIVES: Processed film which is used to produce photographic prints.

NET: What's left of your pay after all the deductions for expenses, taxes and commissions are taken out.

NON-UNION: A job that is not being performed under a production contract with the relevant actor's union (normally SAG or AFTRA). Print and live modeling jobs such as promotions and fashion shows are not within the jurisdiction of the unions, so the term "non-union" is not applied to them. Members of the relevant union (SAG for TV commercials) are prohibited from working on non-union productions. The performers' unions (SAG, AFTRA, AEA, AGMA) also have reciprocal rules prohibiting their members from working on non-union productions within the jurisdiction of one of the other unions, but these rules are frequently violated by actors.

O

ORIGINAL: The first, and perhaps only, sample of a particular garment design.

OPEN AUDITION: (In modeling, also an "open casting".) An audition or go-see which is open to anyone who knows about it and meets the description in the breakdown. See "cattle call".

OPEN CALL: A time when a model agency opens its doors to any aspiring model who wants to come in for an evaluation. Frequently open calls will be limited to certain types of person (as, "only men from 18-25 and 5'11" to 6'1" tall.)

OPTION: Also referred to as a "hold". A client has requested the right of first refusal on a model during a specified time. That means the model is obligated to be available for the client's job if booked, and may not accept any other assignment. A "first option" means that client has priority over any other for that time period. A "second option" (or "second hold") means the client has a claim to the model if the person holding the first option decides not to book the model for that time.

OVEREXPOSURE:
1. Allowing more than the standard amount of light to hit photographic film or a digital sensor, resulting in very light pictures.
2. A model who has appeared in the public eye too much, so that they are becoming tired of her, or are no longer interested in her.

OVERTIME: Work that goes longer than eight hours, or past normal business hours. A model may get more than the normal hourly or day rate for overtime work.

P

PARTS MODEL: See "specialty model".

PAY SITE: A website on the Internet which makes money by charging members for the right to see pictures or other content on the site. In modeling usually pay sites deal with nude and sexually oriented photographs, although there are other kinds of content (news from major news organizations, for instance) which may also be pay sites.

PAYROLL COMPANY: Sometimes clients hire "payroll companies" to formally act as the employer of a model during a shoot. The payroll company will withhold taxes, make the employer's contribution to Social Security and Medicare taxes, and send the model a W-2 at the end of the year, as a company would treat any other employee.

PER DIEM: Latin for "per day" which really means money you get for your living expenses while on assignment.

PETITE MODEL: Different kinds of modeling define what is "petite" differently. In fashion work a "petite" is normally a model who is 5'7" or less and wears a size 6 or less dress. In other kinds of modeling the meaning is closer to the general meaning of the term: small, without regard to specific criteria.

PERSONAL MANAGER: See "manager".

PHOTO SESSION: The time spent by a model having her in preparation and having her picture taken. Time spent in makeup and hair prep, for instance, is part of the photo session.

PHOTOGRAPHER'S RELEASE: A legal document which gives the model the right to make copies of pictures taken by a photographer, normally for limited purposes like self-promotion. Also referred to as a "license" or "waiver of copyright."

PHOTOSHOP:
1. (noun) Image editing and manipulation software produced by Adobe Systems, Inc. Generally considered to be the industry standard tool for editing images. The name "Photoshop" is a trademark of Adobe Systems.
2. (verb) "To photoshop" is a term widely used to mean to edit and retouch an image, so called because of the wide use of Adobe Photoshop for that purpose.

PLUS MODEL: (Also "Plus Size Model") In fashion modeling, refers to a model who wears a much larger dress size than the standard fashion model, but otherwise is similar to a typical fashion model. In most markets Plus models are from dress size 10 to 20, sometimes larger. The term is not widely used in commercial print modeling, although it is understood to mean someone of average or greater body dimensions.

PLUS TWENTY: (Also "plus ten" in acting.) A custom of adding a percentage to the model's fee as a service charge to the model agency. The fee is paid by the client to the agency, and not counted as part of the model's income. See "agency fee."

PLATFORM MODEL: A model who is used in demonstrating a new product or technique, while on a stage in front of an audience.

POINT OF SALE: A display at the place where a customer actually would purchase a product; typically a poster in a retail store. Also called Point of Purchase in other contexts.

POLAROID:
1. (noun) A Polaroid instant picture. The term is a trademark of the Polaroid Corporation.
2. (verb) "To Polaroid" means to take simple pictures using an instant camera or digital camera, which show what the model actually looks like. Often done by clients at go-sees, or by agents for their new models.

P-O-P: Point of Purchase. Another term for Point of Sale.

P-O-S: Point of Sale

POWER OF ATTORNEY: A legal document that gives someone else the right to act for you in certain specified ways.

PORTFOLIO: A collection of photographs and tearsheets of a model, compiled and presented in a book.

PORTFOLIO MILL: A company that makes its money from selling pictures to models while pretending to do something else for them (like getting them work).

PRINCIPAL: The main or featured people in a photograph or TV commercial. Distinguished from "background" or "extra" models who have a much less prominent presence in the shot.

PRINT: A communications medium which includes newspapers, magazines, billboards, signs on the sides of buses and in subways, inserts in newspapers, catalogs and many other forms.

PRINT MODEL: A model who specializes in being photographed for print materials, as opposed to live appearances such as fashion shows.

PROMOTIONAL MODELING: A model appears at an event or location to promote a product or service. The model may hand out samples, draw attention to a tradeshow booth or product, or demonstrate the use of a product to a crowd of people. Sometimes a promotional model is simply "eye candy" for an event.

PROOF: A photograph or set of pictures used to make a choice of which shot to print or use in publication. See also "contact sheet".

PROP: A moveable item which appears in a picture to add to the veracity of the shot.

PUBLIC RELATIONS: The process of creating a favorable impression of a person, product or company.

PURCHASE ORDER: A formal, written request which an advertising agency may send to a model agency to request the purchase of a model's time and specified usage rights to pictures of the model.

R

RATES: The fee charged for a model's time. See "hourly rates" and "day rates".

READING: Used as a noun to indicate an audition in which a script will be used.

READY-TO-WEAR: Clothing that can be purchased right off the rack at a retail store. This is to differentiate from one-of-a-kind clothing specifically made for that customer by the designer.

REAL WORLD: Term used to distinguish activities that take place in normal day-to-day life and business, as opposed to "Internet" activities, which tend to have a different dynamic.

REEL: A collection of an actor's work on video tape, CD or DVD which gives samples of performances the actor has done.

REFERENCE PICTURES: Often a casting director will have a particular look in mind for a job, and may have a picture of someone who looks like that but isn't available to them for the job. It may be a picture of a celebrity, a picture from a previous ad or test, or simply a shot found somewhere that they liked. They will share these "reference shots" with agencies as a guide to what they are looking for.

REFLECTOR: A flat, light-colored surface that is used to reflect light to lighten parts of a picture. Often a fabric in a collapsible frame, or light material such as foam core.

RELEASE: See "model's release" or "photographer's release".

RESIDUALS: Money paid to a model or actor for continued use of their pictures after the photo shoot. In modeling "residuals" typically are paid when the usage rights originally purchased by the client have expired, and the client wants to continue to use the pictures.

RESUME: A one-page listing of an actor's height, weight, contact information, and the most important acting jobs and training the actor has done. A resume is not normally used by a model, since her portfolio and composite card serve that purpose. See also "Bio".

RETOUCHING: The process of changing parts of a picture to remove flaws or adjust imperfections in the shot.

RIGHT OF PRIVACY: The legal doctrine that a person has the right not to have their pictures or private information about them published without their permission. The degree of this right that a model has varies widely from State to State, but it is one of the foundations on which the use of releases and usage fees is based.

RIGHT OF PUBLICITY: The legal doctrine that a person's image has commercial value, and it should not be used to advertise a product or service without the consent of the person. About half of the States have statutes establishing a Right of Publicity. It is another of the foundations on which use of releases and usage fees is based.

ROUNDS: Model agencies often send their models to see prospective clients to introduce themselves. These are called "rounds". Sometimes independent models do the same thing, from a list of photographers and other kinds of clients.

RUNWAY: The place that models walk during a formal fashion show. Typically it is an elevated long platform, but can take any shape, and may put the models on the same level as the audience.

S

SAG: See "Screen Actors Guild"

SAG-FRANCHISED: An agency that has signed an agreement with SAG to abide by their regulations and guidelines.

SAG SIGNATORY: A company that has signed a contract with SAG requiring them to follow SAG rules on a production.

SAMPLE: See "original".

SAMPLE SIZE: The size that the designer chooses to make sample garments in for models to wear. The sample size may vary depending on the intended customers: junior, plus, petite etc.

SASE: Self Addressed Stamped Envelope.

SCALE WAGE: The minimum wage and expense allowances allowed by union rules on a union production. Does not apply to print modeling jobs.

SCOUT:
1. A person who finds models with the potential to succeed and brings them to the attention of a modeling agency.
2. A salesperson for one or another of the many modeling scams that infest the industry.

SCREEN ACTORS GUILD: ("SAG") The guild (union) which represents actors whose work appears on a TV or movie screen. SAG jurisdiction overlaps with AFTRA. Also see AFTRA.

SCRIPT: The words an actor will say in a production.

SEAMLESS: A roll of wide, heavy paper of various colors which can be used to create a backdrop that does not contain edges. See also "cyc".

SED CARD: (also in Europe, "SET CARD".) A common misspelling of Zed Card

SECONDARY MARKET: A city in which a substantial amount of modeling opportunity exists, but without the large concentration of major advertising agencies, production companies, magazine publishers and fashion houses that exist in a major market city. In the United States, Miami, Atlanta, Dallas, Phoenix and San Francisco are generally thought of as secondary markets. Some commentators refer to Los Angeles, Chicago and Miami as secondary markets as well, although in some limited senses each could be considered a primary market city.

SESSION FEE: The amount a model is paid for her work at a shoot, paid at an hourly or day rate, or flat rate. She may make other money from usage fees.

SET:
1. The props, furniture and backdrop at a photo or television studio. The things that will be in the picture.
2. The location where the pictures will be taken.

SHOE MODEL: See "specialty model".

SHOWROOM: A place where designers show their collections to buyers and the press. Some designers have permanent showrooms, others do not. Most showrooms are not open to the public.

SIDES: Selected pages from a script that will be used during auditions.

SIGNED:
1. Under a representation contract with a model agency.
2. Under an exclusive contract with an agency. Many models who are freelancing are not considered "signed" even though they may have a contract with multiple agencies.

SIGN-IN SHEET: A sheet of paper at a go-see where models put their name, agency contact information and other data that the client may request from them.

SLIDES: 35 mm. transparencies cut into individual frames and mounted in cardboard or glass mounts for display.

SPEC SHOOT: A photo shoot undertaken in the hopes that it can be sold to a client, but without a specific contract from the client. Another term for "I don't want to pay you for doing this."

SPECIALTY MODEL: A model who specializes in body parts such as hands, feet, legs, backs and other parts. Shoe models are a subset of this, since they have to have standard sized feet (size 6-7 for women, 10 for men).

SPOKESMODEL: A model who makes public presentations on behalf of a client to explain a product or service to an audience.

SPOT: A TV commercial.

SPREAD:
1. See "double page spread".
2. A form of nude photograph in which the legs are opened wide to display the genitalia.

STAGE PARENT: A derogatory term used to describe a pushy parent of a child model or performer.

STAND-IN: A person similar in size and appearance to a principle actor or model in a production, who takes the spot that will be taken by the real principle while the photographer is setting up the set and lights. Also see "body double".

STATS: ("Statistics") A description of the model's basic appearance parameters and sizes. For female models, stats usually include height, bust/waist/hips measurements, hair and eye color, shoe size and dress size. For male models stats include height, jacket size, neck, sleeve waist and inseam measurements, shoe size, and hair and eye color. For actors stats are limited to height, weight, hair and eye color. See "bust," "waist" and "hips."

STILL: A photograph, as opposed to motion pictures and TV,

STOCK PHOTOGRAPHER: A photographer who produces pictures without a specific client or job in mind, but with the hope of selling them to one or more clients later for use in advertising or editorials.

STORYBOARD: A sequence of drawings that show the layout of each scene in a commercial or print ad.

STROBE: An electronic flash used in photography.

STUDIO: An indoor location where a photographer can control all aspects of the background and lighting for a shoot.

STYLIST: A person who may select and assemble clothing and accessories for a shoot and assure fit, assists in achieving the look and feel that a photographer wants on a set, or assists with accessories at a fashion show. The stylist may set the design of hair and makeup for the production, but will not normally do hair and makeup herself.

SUPERMODEL: A model who has achieved household name status.

T

TALENT: Anyone who is hired to appear in the picture on a photo shoot, movie or TV production. The term has nothing to do with whether or not the person is actually talented.

TALENT AGENCY: An agency who represents performing artists such as actors, singers and dancers.

TEA ROOM MODELING: See "informal modeling".

TEARSHEET: The actual printed page from a newspaper, magazine or ad that a model's photograph is published in. So called because it is "torn" from the magazine. Appearance on a website does not result in a tearsheet.

TELEPROMPTER: A TV or computer monitor in the field of view of the actor which scrolls the words to be spoken by the actor.

TESTIMONIAL: A form of advertising in which a person personally vouches for a product or service.

TEST SHOOT: In years gone by, a "test shoot" would be when a photographer had a new film, technique or equipment he wanted to try out, or a model he wanted to try shooting, perhaps in anticipation of using her for a job. Usually in such shoots no money changed hands, and at most the model was asked to pay for the cost of having prints made for her book. More recently, "testing" has also come to mean any shoots for a model's portfolio or composite card, and it is common for photographers to charge for their services.

TEST PHOTOGRAPHER: A photographer who specializes in doing test shoots for model's portfolios. Usually test photographers charge for the shoot.

TFP/TFCD: (Time for Prints/Time for CD of pictures.) A term used almost exclusively among Internet models and photographers for a shoot in which little or no money changes hands and the model receives prints or a CD of digital images for posing for a photographer. Somewhat analogous to "testing", although photographers may charge a model for a test.

TRADE SHOWS: An exposition by vendors to show potential customers and the press their products. Trade shows may or may not be open to the public, and are held in hotel ballrooms, auditoriums or convention centers.

TRADE SHOW MODELING: A form of promotional modeling, in which the model may simply draw attention to a client's booth or product, or be used in a demonstration.

TRADE PUBLICATIONS: Newsletters, magazines, Internet websites and similar publications which are aimed at members of a specific trade or profession, and aim to give them useful professional information and exposure to products relevant to the trade.

TRUNK SHOW: An informal fashion show of a particular designer's line in a retail store, so called because of the image of the designer trundling around a trunk full of clothes to unpack for the show, then packs them up and moves on to the next city. The models may be hired to travel with the designer to do the shows.

TYPE: One of the fundamental concepts of commercial print modeling. Everyone has an image of what a banker, a dirt biker, a computer nerd and a young father look like. These stereotypical images define a "type", and people who resemble them and other types are chosen to go on castings when the breakdown calls for their "type."

U

UNDER FIVE: In acting, a small role in which the actor speaks five or less lines.

UPGRADE: Often a model will be hired as background, and when the shoot actually happens they are changed to a principle in the shot, and given more money. This is an "upgrade".

URL: Universal Resource Locator. This is an Internet term which refers to the "address" you type into your web browser to visit a website. It might look like www.newmodels.com

USAGE FEE: Models get paid for two things: work they do on the set, and the right to use their images in advertising. Sometimes the fee will be "flat," meaning it includes both. But often the two will be separately listed in the booking, and the model will get paid for a specific, limited use of their pictures. If the client wants to do something more than what they paid for (different kind of publication media, different target audience, longer time, different geographical region) the model will get more money for additional usage.

V

VOICEOVER: Dialog that is dubbed over an existing TV commercial by a person off-camera, often after the commercial has been shot.

VOUCHER: A form used by agency models to document the work they did on a job, the fees that are to be paid for it (and usage agreed to), and the agency's fee. Most vouchers are signed by both the model and representative of the client. A copy is then given to the model, the client and the model agency. It is used by the model agency to bill the client for the model's work. The voucher also acts as the model release for the job.

W

WAIST: For models, the waist is measured around the smallest part, without sucking the stomach in.

WEATHER PERMITTING: A shoot is booked for a particular day, but contingent on the weather being suitable for the shoot. If it is not, there may be a "weather day" or "contingency day" pre-booked.

WHOIS: A query that tells you who the registered owner of a website is. If he has followed the rules, it will contain the name, address and telephone number of the owner or his representative.

WORKSHOP: A gathering of instructors and students to learn and practice the arts of photography and modeling.

Z

ZED CARD: On the West coast of the United States, a synonym for "composite card". Derived from the fact that a "triple" composite card can be folded into the shape of a "Z" (in Britain and the Colonies, "Z" is pronounced "zed") when viewed from the side. See "composite card."

Appendix:

MODELING FORMS

This is the type of release you will most often encounter from stock photographers and Internet TFP/TFCD photographers. It essentially lets them do anything they want with your pictures. Contrast it with the voucher, which is very specific in what uses are allowed. A release can be written to have usage as broad as this, or as narrow as a voucher, or anywhere in between. It's in your best interests, if possible to keep the usage as narrow as possible. A test photographer will not normally ask for a release.

Sample **Adult Buyout Model Release**

In consideration of my engagement as a model, upon the terms herewith stated, I hereby give to _____ (photographer), his/her heirs, legal representatives and assigns, those for whom photographer's name goes here is acting, and those acting with his/her authority and permission:

a) the unrestricted and irrevocable right and permission to copyright and use, re-use, publish, and republish photographic portraits or pictures of me or in which I may be included intact or in part, composite or distorted in character or form, without restriction as to changes or transformations in conjunction with my own or a fictitious name, or reproduction hereof in color or otherwise, made through any and all media now or hereafter known for illustration, art, promotion, advertising, trade, or any other purpose whatsoever.

b) I also permit the use of any printed material in connection therewith.

c) I hereby relinquish any right that I may have to examine or approve the completed product or products or the advertising copy or printed matter that may be used in conjunction therewith or the use to which it may be applied.

d) I hereby release, discharge and agree to save harmless the photographer, his/her heirs, legal representatives or assigns, and all persons functioning under his/her permission or authority, or those for whom he/she is functioning, from any liability by virtue of any blurring, distortion, alteration, optical illusion, or use in composite form whether intentional or otherwise, that may occur or be produced in the taking of said picture or in any subsequent processing thereof, as well as any publication thereof, including without limitation any claims for libel or invasion of privacy or right of publicity.
e) I hereby affirm that I am over the age of majority and have the right to contract in my own name. I have read the above authorization, release and agreement, prior to its execution; I fully understand the contents thereof. This agreement shall be binding upon me and my heirs, legal representatives and assigns.

Dated: _____

Signed:_____
 (model)

Printed Name:_____

Address:_____

City/State/Zip:_____

Witness:_____

Whenever possible, on a shoot you pay for or do as a test or TFP/TFCD, you should try to get a written copyright license from the photographer. That enables you to make copies and use the pictures for your own promotion or for an agency. The first part of this license is the important part for you; a photographer may insist on including something like the second and third paragraphs as well. Whenever booking a shoot, be sure to make clear that you will want such a license signed. Most photographers will agree to it, although some test photographers may not.

This sample is written to narrowly give you the right to use the pictures for self promotion. However, it could also be written much more broadly, even to the point of giving you complete control over the use of the pictures. Such broad language must be negotiated with a photographer, however, and you can expect most of them to refuse it.

Sample **Self Promotion Copyright License**

This constitutes authorization for _____ ("*model*") and her representatives and assigns to reproduce photographs of *model* made by Photographer solely for self-promotion purposes, or to enable promotion of model by any model or talent agency or model listing service. This waiver of copyright applies to print, electronic or digital reproduction and/or publication in any form whatsoever.

Use of pictures to advertise any third party, product or service are not authorized unless approved by the photographer in writing.

This license applies only to photographs which have been retouched by the photographer. It does not under any circumstances apply to raw, proof or other unretouched images.

_____ Date: _____

Photographer Name

Photographer Signature

Sample **Agency Application Letter**

The following letter includes all the elements you might need to send to an agency. In many cases your letter can be simpler.

Really Big Agency, Inc.
111 Main Street, 4th Floor
Anytown, CA

Dear Ms. Sample,

I am very interested in being represented as a model by your agency. I have enclosed three snapshots of myself and my current composite card for your review. I have also enclosed a SASE for return of my pictures and card.

My stats: 5'9", 35-45-36, Dress size 4, shoes 7 ½, brown eyes and light brown hair. I am 18 years old and a high school graduate.

I have done several local mall fashion shows and appeared in three print ads for a regional retail chain. I am represented on a non-exclusive basis by Really Small Agency in Little City, Ohio.

Although I now live in Ohio, I have an aunt in your city and will be moving there next month. I was born in Germany and am a German citizen, but have my permanent US residency card and social security number.

I look forward to hearing from you and working with your agency. Thanks for your consideration.

Angela Applicant
222 Off Main Street
Little City, OH
Home Phone: 888-555-1234
Cell Phone: 888-555-4321

Sample Booking Policies

Really Big Agency (RBA) Booking Policies

Photography Rates: One hour minimum; sessions running beyond time booked are computed in fifteen minute increments. Booking length must be specified at the time of booking and shall constitute the minimum billing time. RBA and model must be informed as to the client, advertising agency, end use, special use and product information at the time of booking.

Overtime: Day rates are for any eight consecutive hours; bookings running in excess of eight hours will be charged at time and one-half. Bookings or portions thereof before 9:00am and/or after 6:00pm are time and one-half.

Saturday: Time and one-half.

Sunday and Holidays: Will be negotiated.

Fitting Sessions: Full fee; one-half hour minimum. On set / on location styling and make-up: full fee.

Weather Permit: Must be stated at the time of the booking. Type of weather must be specified. Cancellation prior to booking day is at no charge, provided it is re-booked at the time of cancellation. Same-day cancellation is half fee, provided it is re-booked at the time of cancellation. Otherwise, regular cancellation rates apply.

Cancellations: More than one full work day in advance, no fee. Less than one full work day and rescheduled, half fee. Not rescheduled, full fee. At location, full fee.

Tentative Bookings: Clients holding tentative bookings will be given the right of first refusal.

Travel Time: Travel time to locations which are outside Manhattan will be billed at the full hourly rate unless otherwise negotiated. Travel time and rate must be discussed and confirmed prior to the shooting schedule.

Special Rates: Slips, peignoirs – rate and one-half . Bras, girdles, panties, pantyhose, men's underwear – double rates. Nudes – negotiated. **Editorial:** Negotiated.

Usage: All rights granted are contingent upon receipt of all fees including agency service charges. Rights released are only those specifically enumerated and marked on the release/contract-billing authorization provided by the models. All other rights are reserved. Use fees must be negotiated for billboards, posters, packaging, POP's, national retail magazine/newspaper ads, international uses, FSI's, stills for television, exclusivity, use of name and/or other similar special uses. All uses for print are for a one year period unless otherwise specified. If use fees have been negotiated, options for such use must be exercised within 60 days of the signing of the contract or said fees will be subject to re-negotiation.

Wardrobe: Models/talent for commercial print/film will provide a maximum of 3 "generic" outfits. Specific wardrobe is the responsibility of the stylist or client. Models/talent for fashion jobs will have the wardrobe provided by the client.

Releases: Contacts will be provided by the models/actors. All other releases invalid unless reviewed and signed by an officer of RBA.

Conflicts: Please check with RBA regarding possible product conflicts. We will provide you with the most accurate information available to us. We do not, however, guarantee or warranty the accuracy of the information.

Service Charge: A service charge of twenty percent (20%) will be added to all model/talent fees, use fees or renegotiated fees. Overdue accounts will be charged at the rate of 2% per month of the unpaid balance. In the event of non-payment, all collection costs (including any legal expenses and court fees) will be the responsibility of the client, advertising agency or their representatives.

Client Liability: In accordance with the custom and practice within the industry, model and RBA will accept the signature of the photographer, studio employee, or agent of the client as binding upon the advertising agency,

publication, or sponsor for whom this work is performed. Any and all parties contracting for models' services are considered to be acting as agent for the client specified in the RBA Model Release/Billing Collection Authorization. RBA reserves the right of recourse to the named client in regard to payment, use, etc.

Employer Liability: Models are not the employees of RBA.

Sample **Acme Model Agency** Voucher

1 Main Street, Anytown, USA

INVOICE TO		SESSION DATE	RIGHTS GRANTED BY THIS RELEASE EXPIRE ON:			
ADDRESS		MODEL				
CITY AND STATE	ZIP	RATE/HR.	START TIME / STOP TIME		TOTAL HOURS	AMOUNT $
ATTENTION OF		OT RATE/HR	START TIME / STOP TIME		TOTAL HOURS	AMOUNT $
ACCOUNT		TRAVEL RATE/HR	START TIME / STOP TIME		TOTAL HOURS	AMOUNT $
ADVERTISING AGENCY		OTHER-SPECIFY	START TIME / STOP TIME		TOTAL HOURS	AMOUNT $
PRODUCT		USE FEE To Be Billed Now (As per Additional Usage Below)				AMOUNT $
PHOTOGRAPHER		TOTAL IS *ALWAYS* SUBJECT TO A 20% AGENCY SERVICE CHARGE. *Model is not an employee of ACME*			TOTAL $	

CLIENT AGREES THAT ALL SESSIONS AND BOOKINGS ARE IN ACCORDANCE WITH AND SUBJECT TO THE MOST RECENTLY PUBLISHED ACME STANDARD BOOKING POLICIES AND PROCEDURES. AS PART OF MANAGER'S OBLIGATION TO MODEL, MODEL AGREES THAT THIS CONTRACT AUTHORIZES ACME TO BILL FOR HIS/HER SERVICES ON A SINGLE INVOICE WHICH INCLUDES AGENCY SERVICE CHARGES AND TO COLLECT SUCH SUMS AS ARE DUE HIIM/HER UNDER THE TERMS OF THIS CONTRACT. THIS CONTRACT AUTHORIZES ACME TO ENDORSE CHECKS MADE PAYABLE TO MODEL FOR THE WORK AND RIGHTS REFERENCED HEREIN.

THEREFORE, IN CONSIDERATION OF THE RECEIPT OF THE SESSION FEES, AND USE FEES NEGOTIATED WITH ME THROUGH ACME, I HEREBY SELL, ASSIGN AND GRANT TO CLIENT OR ADVERTISER (LISTED ABOVE) AND THEIR ADVERTISING AGENCY (LISTED ABOVE) THE RIGHT AND PERMISSION TO PUBLISH PHOTOGRAPHS, OR LIKENESSES OF ME IN WHICH I MAY BE INCLUDED IN WHOLE OR IN PART OR REPRODUCTION THEREOF IN COLOR OR OTHERWISE FOR THE PRODUCT LISTED BELOW. RIGHTS FOR SUCH PUBLICATION OR BROADCAST OR DISTRIBUTION WILL BE LIMITED TO THE MEDIA TYPE AND PUBLICATION TYPE LISTED BELOW. ALL RIGHTS GRANTED WILL EXPIRE ON THE EXPIRATION DATE LISTED HEREIN.

TERMS AND CONDITIONS: In accordance with the customs of the industry, Model, and ACME accepts the signature of the photographer or studio employee on this document as binding upon the advertising agency, publication or sponsor for whom this work is performed. No comparable model on this booking may be paid more in booking or usage fees than the model submitting this voucher. Unless otherwise negotiated and noted on this document, work performed outside Manhattan requires that transportation be furnished and travel time charges will accrue at the applicable hourly rate. If the models' photographs are used on television, in national consumer ads, or on product packages, posters, displays or billboards, special negotiated usage fees in addition to session fee apply. Usages are for a one year period unless otherwise specified. If a usage fee has been negotiated, options for such usages must be exercised within sixty days of the signing of this voucher or said fees will be subject to re-negotiation. Rates for bookings on Saturday, Sunday or holidays, as well as between the hours of 6:00 PM and 9:00 AM are subject to special negotiation. All booking and usage fees are subject to a 20% service charge which will be included on the ACME invoice. A finance charge of 1 1/2% per month will be applied to all invoices not paid within thirty days. Failure to make timely payment requiring legal action shall make client subject to payment for interest, costs and reasonable attorney's fees for collection. No release is valid until payment in full is received by ACME. All other releases invalid unless countersigned by model's manager. This voucher, when signed by both parties, shall constitute the entire agreement and understanding between them and shall be construed according to the laws the State in which Acme has its headquarters..

USE Included With Shooting (Session) Fee and Bonus

NONE Consumer magazine Consumer newspaper Consumer Package Consumer Catalogue Consumer Direct Mail Consumer Brochure Consumer Out of Home Consumer Point of Purchase Consumer FSI Internet Home Page Billboards or Placed Media CD ROM Television Advertising to the trade Editorial Stock Photography

Other/Description _____

GEOGRAPHIC RESTRICTIONS _____

TERMS AND PROVISIONS_____ FOR A PERIOD OF _____

Payroll Information

This job Will Will Not be Processed By a Payroll Company

Name and address of Payroll Company/Employer of Record_____

MODEL'S SIGNATURE c/o ACME MODEL AGENCY	CLIENT OR CLIENT'S REPRESENTATIVE
X date	X date

170

About the Author

Roger Talley has had a widely varied career, as a US Air Force officer, a systems engineer and business development manager for America's largest aerospace company, and a college instructor. He has degrees in Photography and Political Science, and a Master of Science in Systems Management. He brings the discipline of his education and experience to the sometimes tumultuous and subjective world of modeling. He has lived and worked in several countries in Europe and the Far East, as well as many American cities.

Along the way, Roger has appeared in print and television advertising, and worked as an extra in a made-for-TV movie. He attended the occasional go-see in New York just to keep current.

Roger's career as a professional photographer began in 1974, and resulted in hundreds of commercial and editorial publications. He has been writing about the modeling industry for magazines, and later the Internet, since 1982, resulting in numerous of articles. He has lived and worked in New York, Tokyo, Hong Kong, San Francisco, San Antonio, Dayton and Denver, and traveled widely to other modeling markets around the world. Finally in 2000 he became the president of R&L Model and Talent Management, Inc., one of the oldest and most respected commercial print modeling agencies in New York City. He retired from that position in January, 2006.

As an industry insider, Roger has seen first hand the things he writes about, in a way that only photographers and agents can. Now that he is retired after a long career he wrote this book to share what he has learned, including the behind-the-curtain details that other agents, journalists and authors have never publicly shared before.